ARTISTS
IN LOVE

ARTISTS IN LOVE

FROM PICASSO & GILOT TO CHRISTO & JEANNE-CLAUDE
A CENTURY OF CREATIVE AND ROMANTIC PARTNERSHIPS

BY VERONICA KAVASS

EDITED BY KATRINA FRIED DESIGNED BY KRISTEN SASAMOTO

WELCOME BOOKS NEW YORK

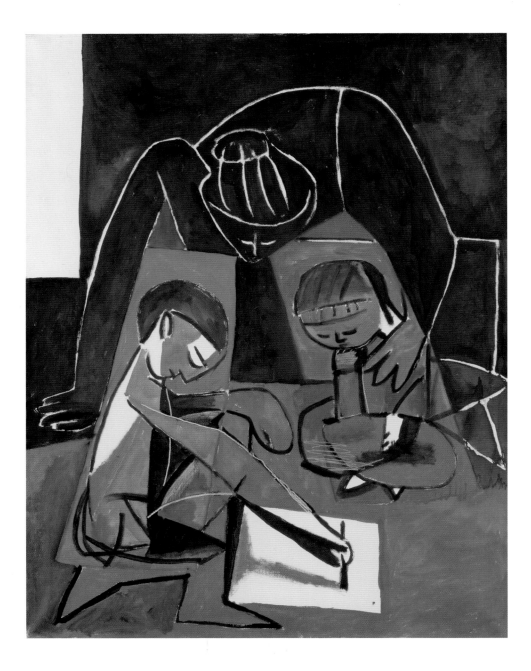

For L. J. H. and my mom, Carmen.
V. K.

Pablo Picasso
Claude Drawing, Françoise, and Paloma, 1954
Oil on canvas
45⁷/₁₀" x 39"

CONTENTS

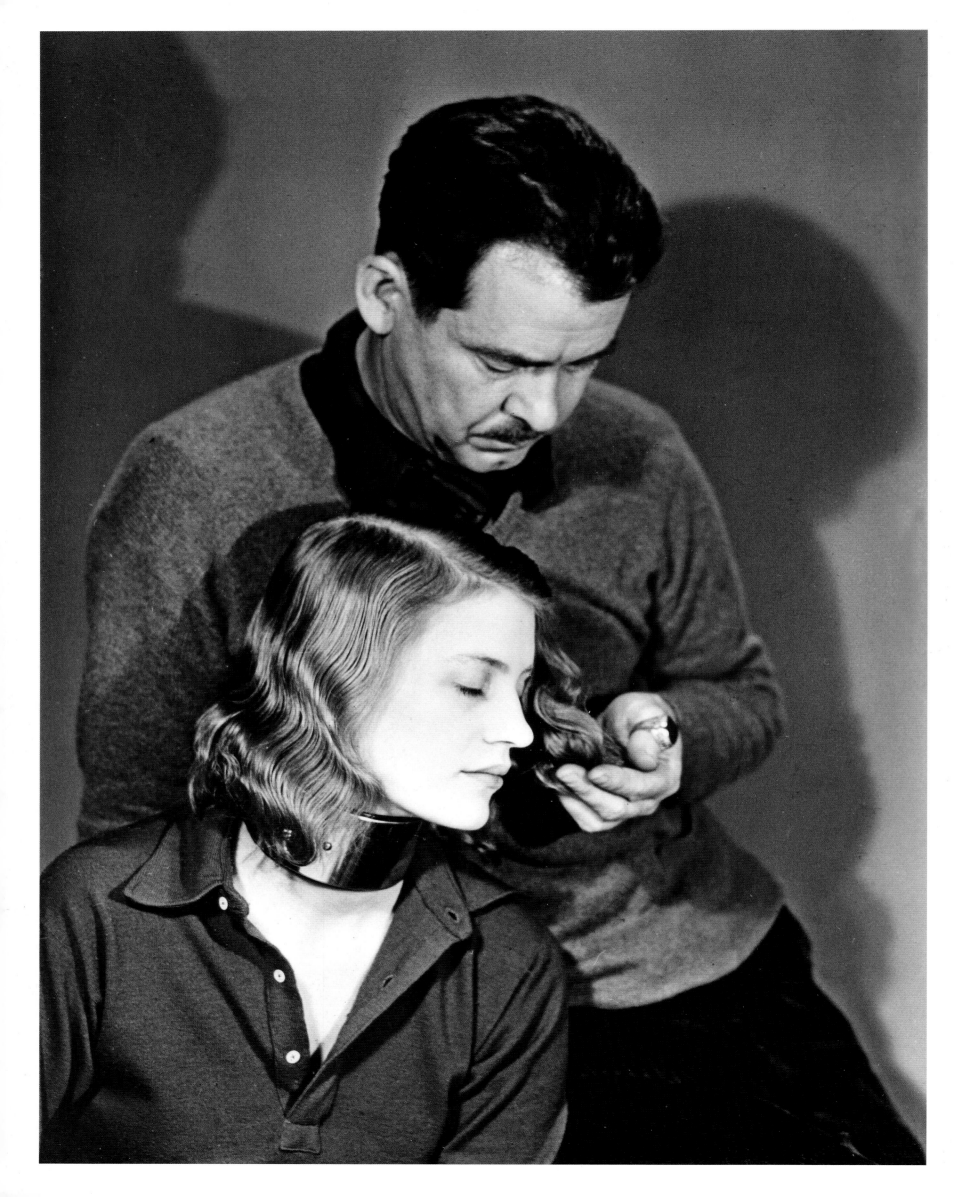

INTRODUCTION

IT WAS DIFFICULT FOR ME TO DESCRIBE THIS BOOK DURING ITS making. First, I always hesitated to use the loaded word *love*. Although when I did (because I always had to), I enjoyed watching the reaction on the listener's face. Often it was a smile of some sort—a smile that revealed a positive association with the idea of love or, more often, one that relishes in the darkness that love stories sometimes reveal. Other times, I was met by a searching look, as if they were trying to understand correctly what the hell I meant by "love." On two occasions, people asked if I was an advice columnist. A local art academic told me that he thought the biographical draw in art history was problematic, that it celebrates the individual, thus distracting from the greater historical narrative. To that, I smiled, because I think highlighting the potential "problematic" zone within an exhaustively researched, highly intellectualized subject only brings it more to life. And that is essentially the purpose this book serves: to revitalize these artists and their works, to present the way they, as partners, collaborated, influenced one another, or guarded their art from a lover's influence, or how they used muse-manipulation to come into their own, or sacrificed their art for the other's. This compilation of portraits and their accompanying artworks map trajectories that each of the artists took and how love for or from another visual artist played a crucial navigational role.

Would we have seen Max Ernst's deserts, his full spectrum of settings, without Tanning by his side, enthusiastic to live and paint out in the middle of nowhere, surrounded by skulls? It seems fairly certain that Abramović would have eventually killed herself through her early brutal performances, thus not living long enough to become the "grandmother of performance art," if she hadn't started working with Ulay. Of course, Krasner lured Pollock into the barn and on the wagon (for a spell), during which time they both created their most iconic works. McGough pulled McDermott out of the past—at least enough to become a celebrated artist in the present. Without Doyle's invitation to join him on a residency in Germany, would Hesse have taken the pivotal trip back to her homeland, to the setting that inspired her to transition into sculpture? Apply the "what-if" treatment to any one of the couples in this book and tell me the biographical tangents are mere distractions from the greater narrative.

This brings me to my starting point with this project. Are you curious to know which artist led me into this web? I did not start at the chronological beginning, with Kandinsky and Münter. It really had to be the right person, my own white rabbit: Lee Miller. A seductive, ghostly beauty who holds

Man Ray
Lee Miller in a collar (with William Seabrook)
Black and white photograph

the keys to strange rooms (including Hitler's apartment, oddly). The type of person you want to follow but not fall in love with. I remember thinking that when I saw her retrospective of photographs at the Victoria and Albert Museum in 2007. It felt appropriate, also, to enter the subject of artists in love through the heart of erotic surrealists in Paris. From there, I traveled to Mexico (not literally, but through books and art) to Frida Kahlo: a frenetic story about a fragile woman who was designed to withstand all forces of misfortune—and still laugh. In working on this project Kahlo became a role model for me. I never would have expected that. When I saw the monumental exhibition of her work at SF MOMA in 2008, one of the most personally challenging years of my life, her paintings only irritated my own psychological wounds. Two years later, after I had healed, I realized through reading her letters and studying her art that she was one of the funniest people on earth. Each of the vignettes in this book reveals some odd discovery I made while researching and writing it, although no aspect of my own autobiography is overtly included. That which is, is coded, written over, like a Rauschenberg painting.

Another conversation I found myself in when describing this book took on the form of a correction: "No, it isn't a book about art and love. It is a book about artists who were in love, who made art about other things. Well, sometimes *about* love, yes, but not exclusively." When considering art that is about love, *The Kiss* comes to mind. Rodin's version of *The Kiss*, especially. I made the decision not to include the story of Rodin and Claudel because I wanted to begin with modernism. Rodin was certainly a progenitor of modern art, but never possessed the pioneering spirit that, for example, Picasso did.

You will notice the chronological order of the stories is based on the year the couples joined forces, so to speak. If it were based on the year one of the two artists first became a hit, the book would have started with Picasso's *Les Demoiselles d'Avignon* (his 1907 painting depicting five nude female figures in a brothel). Picasso's archive of women could have taken up half the book by itself, therefore I chose only one—Gilot. Of all of his first-string loves, she certainly provided the best account of their relationship in her memoir, *Life with Picasso*. With Gilot as his partner, Picasso is situated in a later era of his life, falling after de Kooning's *Woman I* and Pollack's drips, two rival abstract expressionists who hailed Picasso as their king influence.

I certainly experienced heartbreaks in piecing this book together. There are losses, ones that resulted in me taking long angry walks in the woods. Most noticeably, Carl Andre and Ana Mendieta. It was no surprise Andre denied us the right to use his work. But I never cast him in an evil light—just as a brilliant man-child who presented one half of a heavily toxic relationship that ended in the tragic and mysterious death of his wife. He never read the story. Just graced

us with a firm refusal. We decided to run the story regardless, with the work we had chosen for Mendieta, seeing that her estate had granted us permission. But when they were informed of Andre's decision, they revoked their approval. Which goes to say, for all of the people who relish in the darkest of love stories, this book cannot present you with that particular one. Though if you are looking for something in that vein, allow me to point you in the direction of Yves Tanguy and Kay Sage.

Towards the end of the project, when nearly all the stories had fallen into place, there was a final tremor in Saul Steinberg and Hedda Sterne's inclusion. From one moment to the next, with as much forewarning that an earthquake can offer, this tremor grew into something seismic, something that ripped Sterne's art right out of the layout. Granted, the process of obtaining image permissions for artworks is very tricky. Any estate, for whatever reason, can withhold exposure. When Sterne's estate pulled the plug, we were left with a blank space where her work should rightly be. This is the only case where an artist's work is not represented. Consider this absence—which disturbed the development of the book—as one of my biggest woes. When deliberating what to do about this loss, I remembered that I was open to maintaining the Andre and Mendieta story despite Andre's absence. Ultimately, I really wanted this story to be included in this compilation. I apologize for the incompleteness of it.

Artists in Love ends with the Kabakovs' *Ship of Tolerance*. The Kabakovs designed "total installations" that recalled what life was like under the oppressive reign of the Soviet Union. Though Ilya Kabakov had been making art that addressed the subject for decades prior to marrying Emilia, it was fitting to punctuate the book with a couple who became a single unit the year the Berlin Wall fell. The *Ship of Tolerance* embraced a global mentality, an artwork born out of love that positioned itself to exist in a non-fixed location, unanchored and free to sail to seas unknown. In my eyes, there is something reassuring about the mystery of that ending with regards to both art and love. The overarching arc could have ended on the note that love ultimately sabotages art. But that would have been depressing and, more importantly, untrue. And it would have been painfully contrived if it ended with a story that made the proclamation that art and love will continue to triumph hand-in-hand forever and ever, happily ever after, amen. Instead, the conclusion to this love story is as open to interpretation as every great work of art ever made. It allows you, the reader, the lover of art, the lover of love, possibly the lover of artists in love, to sort out the meaning of it all for yourself.

— VERONICA KAVASS, June, 2012

WASSILY
KANDINSKY
GABRIELE MÜNTER

> "*When Kandinsky fell in in love with Münter he let life go off-kilter for some time.*"

BETWEEN THE LINES, AMONGST THE HILLS

GABRIELE MÜNTER COULD NOT KEEP A CAP ON HER "INNER LIGHT." This was a dangerously alluring quality to possess in 1902, when she started painting at the German avant-garde Phalanx School run by Wassily Kandinsky. According to Kandinsky, it was the awareness of one's own inner being, the vibrating core of spirituality, that allowed the artist to conquer the evils of materialism. He had articulated his unique observation of the evolution from the outer to the inner as "accurately represented by a diagram of a large acute triangle divided into equal parts . . . with an artist found in each division, as a prophet of their environment."[1] It seemed outlined quite clearly for him—except the part where he had to diagram how to have an affair with a student, keep his wife-cousin content, and still remain a "prophet" within his realm. That was not very easy to balance by dividing into perfect, unequal parts, but when Kandinsky fell in in love with Münter he let life go off-kilter for some time.

During Münter's first summer at the Phalanx School, Kandinsky took his class on a lengthy excursion to Kochel, a village in the foothills of the Bavarian Alps. Elated by the setting (and her crush on Kandinsky), Münter would break out into song or laughter whenever she felt so inclined, delightfully noting in her diary that it would make Kandinsky shift uncomfortably. One could say her spirit rubbed off on him for he started to flirt like a little boy, doing things like reaching for her bicycle handlebar to

Wassily Kandinsky and Gabriele Münter in Stockholm in the winter of 1916.

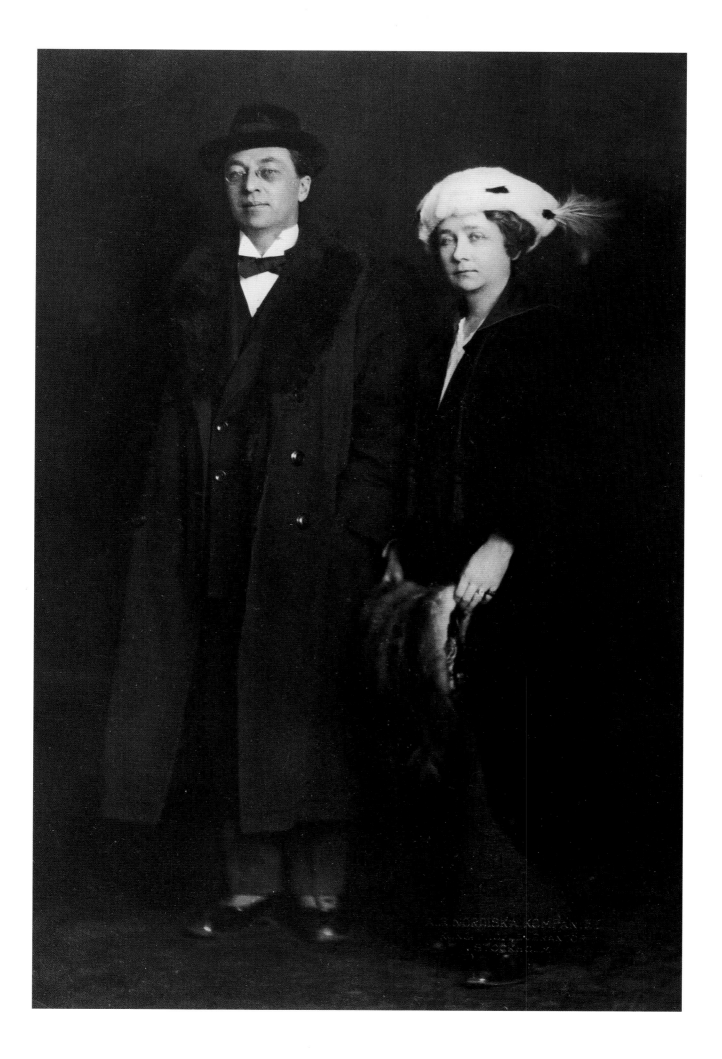

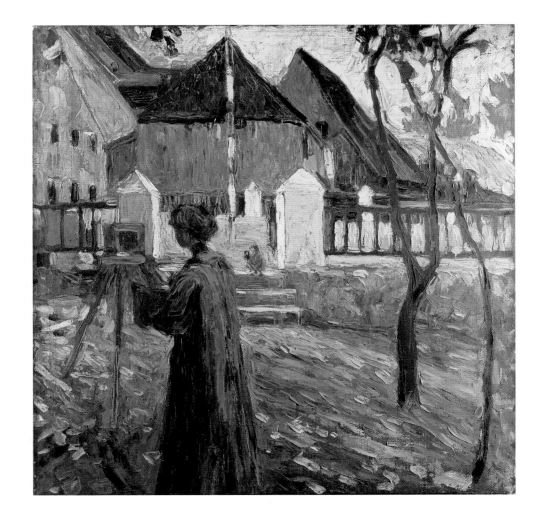

Wassily Kandinsky
Gabriele Münter Painting in Kallmünz, 1903
Oil on canvas
23″ x 23″

Kandinsky painted this portrait of Münter during a summer painting retreat in 1903, the year she enrolled in his Phalanx school. There is significance in the detail that it is of her back and, very likely, painted unbeknownst to her. Kandinsky was married at the time and determining the nature of his developing friendship with Münter. Two years later, after he had left his wife, he painted another portrait of Münter, this time of her facing forward.

Gabriele Münter
Kandinsky, circa 1910
Oil on canvas

Münter painted numerous portraits of Kandinsky during the years they spent in the village of Murnau on the foothills of the Bavarian Alps. During 1910, when this painting was made, the two had just moved into the house where the Blue Rider group began—and where Münter would remain until her death. Whereas Kandinsky had a natural inclination towards the abstract, Münter found it hard to resist the urge towards realism.

knock her down. It was harmless, playful summer fun. But when his wife Anja announced her visit to Kochel, he requested that Münter leave, telling her "You are a hopeless pupil. All I can do for you is guard your talent and nurture it like a good gardener, to let nothing false creep in!"[2] Whereupon she left to moon over Kandinsky from her brother's house in Bonn, eagerly waiting for letters and postcards signed off with "Your comrade, K."

"Dear K! (That is how you sign yourself & what else am I then to call you),"[3] she once wrote back, perhaps a bit miffed by his "camaraderie" and his occasional, "My wife sends her regards." They struggled in recognizing what was written in between the lines of their letters. Both were so vested in being artists, in touch with their inner selves, and, yet, guilty over their magnetism for another. After they started a physical relationship in the fall of 1902, Münter wrote to express anxiety over the dalliance. Her words carried punch and hit the sensitive Kandinsky quite hard, turning him a bit schizophrenic in response: "You can't get rid of me that easily! Perhaps you don't love me very much, but you do love me, that I know. Very well! I propose the following: for a time we will be just good friends, not carrying-on in secret, when I visit you I will be good, will not breathe a word about love. . . . But I do this out of love for you, you must know that. Your friend, K."[4]

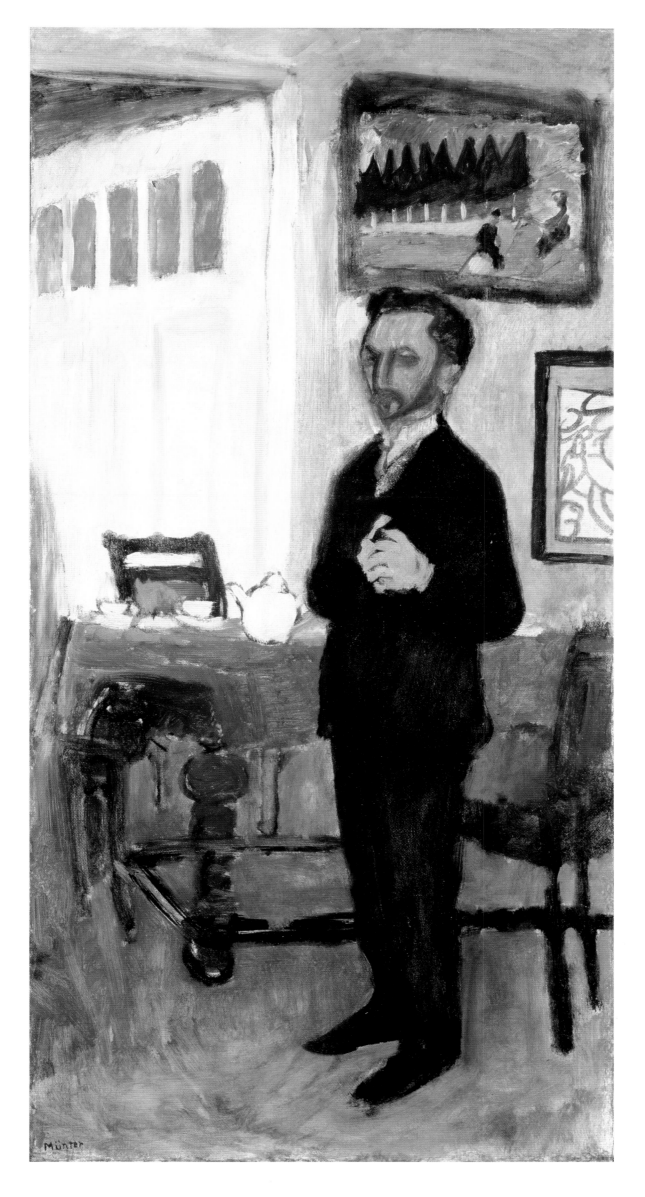

After a continuous push and pull of guilt and confusion, Kandinsky left his wife in June of 1904 to be with Münter. Their newfound coupledom was in time to greet another summer season of painting, cycling, and kissing amongst the hills of southern Germany. For the first five years they were nomadic, in search of a home together (or maybe not). There isn't much in terms of archived correspondence during this stretch since they were in one another's constant company. But there are paintings that tell a story. Specifically on Kandinsky's side, for Münter's work is difficult to find. It is also possible she didn't paint much but observed her mentor instead. He teasingly chastised her for being "lazy." Today she is known as the "lost German expressionist."

> " *Kandinsky founded the Russian-German art collective the Blue Rider to fuse his high regard for the color blue (the color of spirituality) and the symbol of the horse rider, who constantly witnessed the shifting landscape the way Kandinsky wanted to capture it.* "

Based on what is available of Münter's art, their painting styles were very similar. Which is not to say they mimicked one another, but their work during this period seems to share a common language, one based on their shared "spiritual pursuit." Their tendency towards abstraction hadn't yet hit a point that veiled their awe and wonder with pretty little villages and seashores. For example, Kadinsky did several literal portraits of Münter, and she in turn captured Kandinsky standing tall and handsome.

In 1908, the couple happened upon the town of Murnau, where Kandinsky fell in love again, this time with a villa. "To this love he has remained faithful," Münter reflected in her diary in 1909.[5] She bought the house that year, affectionately referring to it as "The Russian's House." From the comfort of his new nest, Kandinsky founded the new Russian-German art collective the *Blaue Reiter* (Blue Rider) to fuse his high regard for the color blue (the color of spirituality) and the symbol of the horse rider, who constantly witnessed the shifting landscape the way Kandinsky wanted to capture it. As the collective gained momentum in The Russian's House by 1910–11, Münter was absent, visiting family in other parts of Europe and obsessing over her uneasiness with the relationship. *When am I going to be Mrs. Kandinsky?*

Kandinsky never married Münter. World War I dissolved his collective and forced him to leave Germany and return to his native Russia in 1914. The letter writing between them became increasingly wounded on both ends, with

Wassily Kandinsky
Study for *Almanac of the Blue Rider*, 1911
Watercolor, gouache, and black ink

The *Blaue Reiter* (Blue Rider) artist collective was formed by Kandinsky and Münter with other artists such as Franz Marc, Alexej von Jawlensky, and Marianne von Werefkin. A majority of the discussion regarding the Blue Rider and its sense of spiritual purpose took place in Kandinsky and Münter's villa in Murnau. This is the first design that Kandinsky proposed to serve as the cover of the Blue Rider almanac.

Gabriele Münter
Still Life with Vases No. 2, 1914

The year Münter painted this abstract still life, the Blue Rider group disbanded. Kandinsky spent long stretches traveling without Münter. Her letters to him reference a lack of motivation to paint—and a longing for him. Yet it was during this period, on the verge of their separation, that she found her way into a style of abstraction that contained a distinct dialogue with Kandinsky's work.

> " *They met one last time in Stockholm in 1916,*
> *posed for a photograph, and parted ways.* "

occasional desperate requests from Münter to arrange their marriage license while he was in St. Petersburg. Financial and political woes were heavy on Kandinsky's side and he became quite fed up with her: "What a drain it all is on strength, nerves etc.! Please, please, let that now be an end of this dreadful affair."[6] They met one last time in Stockholm in 1916, posed for a photograph, and parted ways—Kandinsky into a new marriage with the young Russian Nina von Andreyevskaya and Münter into Scandinavian exile, where she sank into a two-year depression.

When Münter returned to her "Russian's House" in Murnau, she oversaw and protected all of Kandinsky's pre-war drawings and paintings. Requests from him to have the work returned to Russia were denied and an exhaustive legal battle took over. It became her personal little museum to their past. When the Nazis stormed through Germany, picking through private art collections, Münter fiercely protected all the work from the confines of her Murnau house. She lived the rest of her days in Kandinsky's beloved villa, surrounded by the Blue Rider paintings, preserving a significant era of Kandinsky's oeuvre until she willed it to a Munich gallery upon her death in 1957.

Wassily Kandinsky
Composition, 1915
55 3/10" x 47 3/5"

" In the shadows of Paris' cabarets and cafés, Sonia Delaunay and her husband Robert absorbed energy for their significant contribution to the beginnings of modern painting. "

SONIA &
ROBERT

DELAUNAY

THE LIGHT AND THE DARK

BY 1910 THE LAST FEW HESITANT GODS AND GODDESSES OF ANCIENT Greece resettled comfortably in the luminous paragon of simultaneity that was Paris. The notion of the "simultaneous" was a visual language that drove artists to capture various movements in a single moment through a prism of language based on color theory and experimentation of form. Meanwhile, the Eiffel Tower was the new Zeus and one's gaze traveled up to the sky more regularly, knowing it would meet the "benevolent colossus, planted with spread legs in the middle of Paris."[1] In this pre–WWI era, light was really only profound when it emerged from the dark. In the shadows of cabarets and cafés, where light filtered through amber liquid, bouncing off gaudy jewelry, inspiring new patterns, Sonia Delaunay and her husband, Robert, absorbed energy for their significant contribution to the beginnings of modern painting.

Coined by the rabble-rouser, modernist poet Guillaume Apollinaire, the term Orphism was applied to describe a more spirited reinvention of cubism in the early twentieth century.[2] Upon seeing Robert Delaunay's paintings of Paris and his series of "windows opening simultaneously," the poet deemed the work a revival of Orpheus, the ancient Greek mortal with a hypnotic, melodic voice, who lost his wife to the underworld in an attempt to outwit Hades. But that is not the whole story behind his adoration of the paintings.

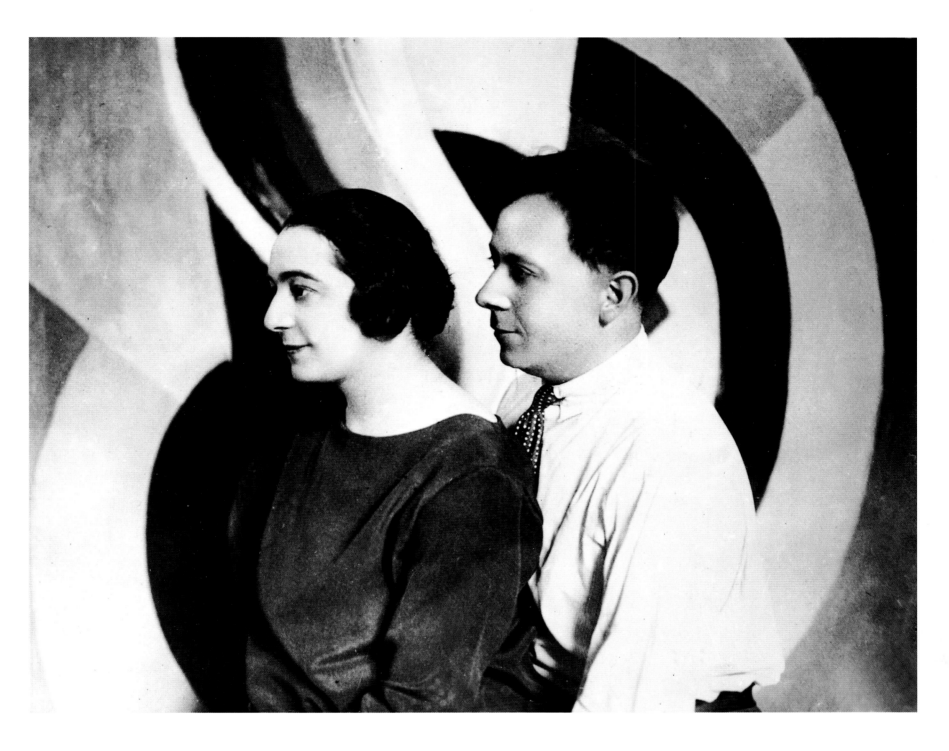

Sonia and Robert Delaunay, circa 1910.

In 1912, after Apollinaire had been released from jail under the suspicion that he had stolen the *Mona Lisa* from the Louvre, the Delaunays warmly invited him to live with them in their apartment. When the poet found himself a room that, from floor to ceiling to every arrangement of furniture, looked like a cubist painting, he realized he was at the epicenter of the Paris art scene and settled in for two months. Although they were labeled—and to this day continue to be known as—"Orphists," neither of the Delaunays were keen on the term. They considered themselves pure artists and their bond was largely based on their ability to balance one another out. If in any instance they were mistakenly associated with Orpheus and his long-lost wife Eurydice, it would

Robert Delaunay
The Eiffel Tower, 1911
Oil on canvas
79 1/2" x 54 1/2"

Robert Delaunay was a self-taught painter who started to gain attention with his depictions of Parisian architecture, beginning with the Gothic church of St. Séverin in Paris' Latin Quarter. He was drawn to the way light fractured through stained glass windows and investigated techniques to recreate that effect in his paintings. *The Eiffel Tower* was the last recognizable structure in his work before he delved deeper into abstraction.

Robert Delaunay
Windows Open Simultaneously 1st Part, 3rd Motif, 1912
Oil on canvas
22 3/8" x 48 3/8"

The *Windows Open Simultaneously* series demonstrates Robert Delaunay's evolution from the realistic to the abstract. Unlike his previous representational depictions of the Eiffel Tower, here the silhouette of the iconic Paris landmark is but a shadow amidst an abstract prism of color blocks. Made just a year after Sonia's appliqued cloth blanket, *Couverture*, the influence of his wife's work is apparent. The *Windows* series offers insight into an era of great synergy for the couple. Both studied color theory, inspired one another, and created an inviting domestic atmosphere for other artists of their generation to join.

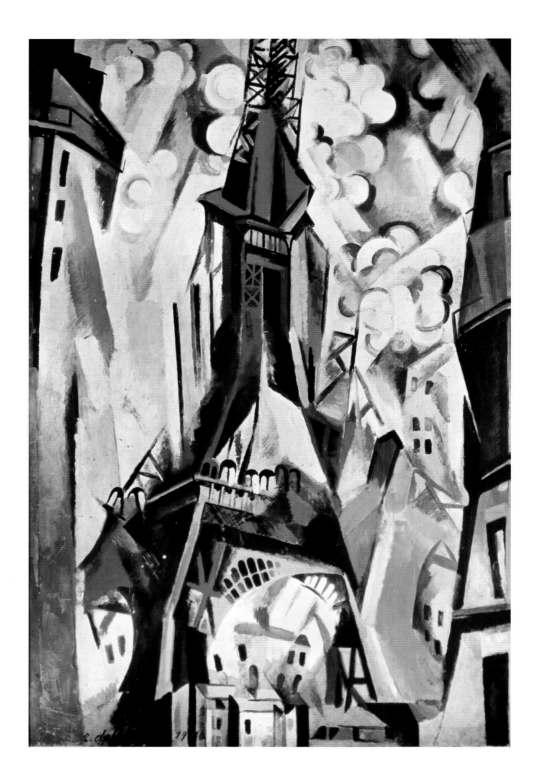

be difficult to determine which of the two Delaunays would be following the other towards the light.

The couple was a sensation during a particularly vigorous zeitgeist, when animated conversations broke at the first glimpse of day in the cafés and trickled off at cocktail parties (usually in their apartment) by night, the loudest characters—like Apollinaire—always drunkenly expounding heady theories on what made art important. Although modernism was eradicating its connection to the traditions of the past, the Delaunays remained loyal to the idea that "in the Western polarizing of the mind and body, men are rewarded for being

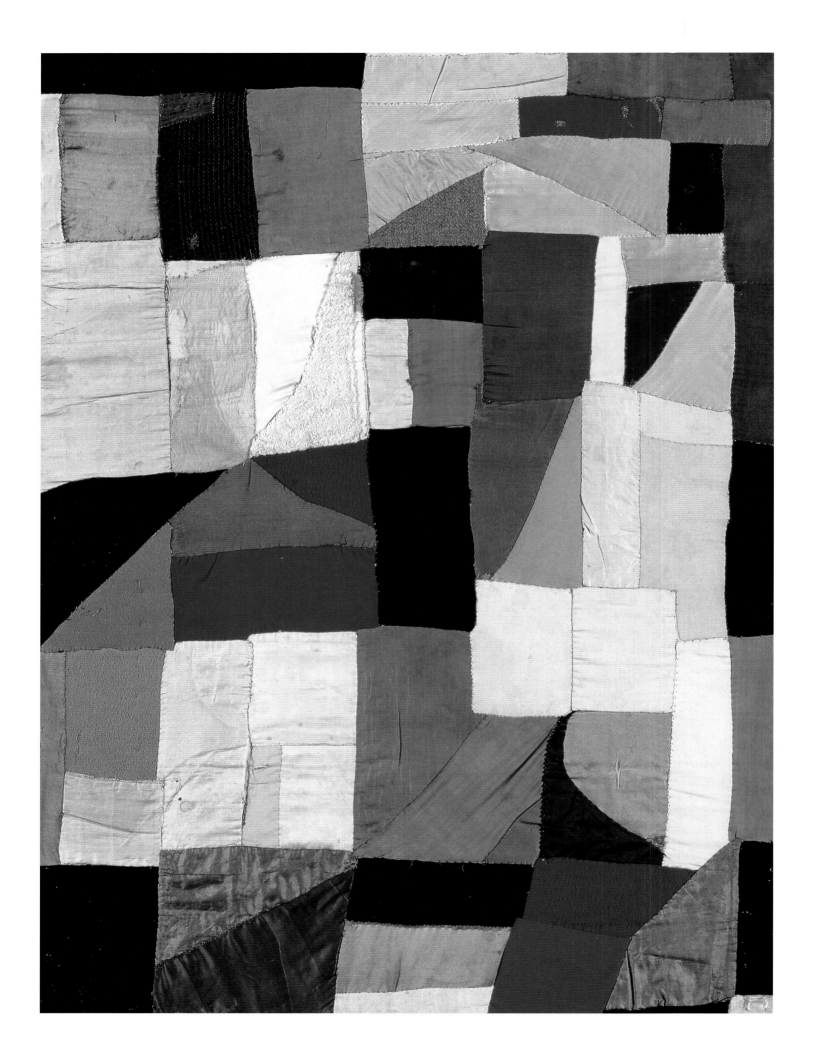

> *Most suspected Sonia was the brains behind their artistic enterprise, but she always saw Robert as the progenitor of their aesthetic, the one who 'came up with it.'*

intellectual and theoretical, women for being intuitive and procreational."[3] Thus, Sonia was content to sit quietly in a dark corner, watching like a cat, analyzing the movement of color in a room, while her husband, under the spotlight, spoke at great lengths about ideas "that were complicated in his own head."[4] He was known for rattling on and on, sometimes impressing listeners (and readers) with the beautiful rationale behind his work—"First of all, I always see the sun! The way I want to identify myself and others is with halos here and halos there, movements of color. And that, I believe, is rhythm."[5] But, more often than not, he just came off as nervous and ultimately confusing. In an interview nearly thirty years after his death, Sonia explained: "Robert was not secure at all."[6]

In 1911, when Sonia learned she was pregnant, she started working on her first significant abstract piece. Unlike other works of art being made at the time, *Couverture* was not a painting or a sculpture; it was a quilt. Currently protected by the prestigious Centre Pompidou in Paris, it was originally made for her little son's bed. Even though it contained a useful purpose, she never saw it as a mere decorative piece; it was art. She drew inspiration from an atavistic ritual of peasant women from her native Russia (although she was never a peasant; quite the opposite). Robert saw it as a sweet gesture, but buzz generated over the quilt. The intellectuals saw it as no less than a cubist painting. So Sonia went on to extend the atmosphere of a painting by using a needle and thread to cover lampshades, carpets, and walls in bright colors outlined through carefully considered fragmental shapes. She designed dresses that created a poetic landscape in a room, "enhancing the natural movement of the body and producing a moving surface of shimmering color."[7]

Most suspected Sonia was the brains behind their artistic enterprise, but she didn't allow herself to be isolated. She saw Robert as the progenitor of their aesthetic, the one who "came up with it."[8] Even when he grew resentful of her amidst her widespread success, she ignored it and continued to speak highly of their duality, "We were two moving forces. One made one thing and one made the other."[9] When there was no longer any sign of the Delaunays shedding their Orphic skins for all of Paris to see, they were archived as a power couple who loved to paint, worked hard, and transformed atmospheres—side by side.

Sonia Delaunay
Couverture, 1911
Appliquéd fabric
43 7/10" x 32 1/3"

With her abstract work *Couverture*, a blanket for her infant son, Sonia Delaunay established herself as the first cubist to paint by assembling and joining together pieces of fabric. She did not sacrifice artistic integrity because the art object was going to be used (even spit up on) rather than merely admired on a wall. In fact, her merging of art and utility was considered pioneering by her fellow cubists.

HANS (JEAN) ARP

SOPHIE TAEUBER-ARP

CHESSBOARDS OF THE NIGHT

> *Hans Arp and Sophie Taeuber fell into a permanent maudlin love trance and took the cabaret stage as the dada king and queen.*

WHEN THE SPIRIT OF WORLD WAR I RUINED THE MOOD OF ART CAPITALS like Paris and Berlin, Zurich lured their evacuee artists into its nocturnal nexus, the Cabaret Voltaire. The password at the door was "da-da." The more one said it like a baby, the better. Founded in collective distrust of modern society and a hatred for intellectualism, the dadaists embraced infantile behavior in search of "elementary art" and "true beauty." For a few years, Zurich was a sonorous freak show where poetry, dance, and painting occurred in lawless unison. Girls in frou-frou skirts kicked up their legs while artists recited angry, rollicking manifestos. In its fluttery 1915 advent, Hans Arp[1] and Sophie Taeuber fell into a permanent maudlin love trance and took to the cabaret stage as the dada king and queen.

Hans recited his poetry, which he called "cloud pumps," while Sophie's masked face nosedived through the crowd in dramatic curvilinear movements. No matter what art was on display—even if it was the noble Kandinsky's—all eyes were on Sophie. The club founder, Hugo Ball, stumbled to describe it: "She was a young lark lifting the sky as she took flight. . . . The indescribable suppleness of her movements made you forget her feet were keeping contact with the floor."[2] And her eyes? Occasionally peeking out from inside her self-designed "tribal" mask, she maintained a steady fix on Hans. When he spewed about the madness of Europe's power-hungry threat

Sophie Taeuber-Arp and Hans (Jean) Arp in Ascona, Switzerland, 1925.

that would numb the collective artistic mind, Taeuber gracefully danced, encouraging the audience to chant, while she held his gaze. Her spirit extended to everything she touched and, as she was a master in textiles, she created the marionettes, masks, and set designs that defined the aesthetic of their era. Sophie made a series of pear-shaped "dada head" wood sculptures, clever portraits of Hans, which the dada big wigs could set their hats on when they walked into the cabaret.

Early into their relationship, when Hans denounced "oil" as an artistic medium, Sophie presented him with other materials. Together they made "duo-collages" by throwing pieces of paper into the air and allowing gravity to map their placement "without cerebral intention."[3] As with their work *Pathetic Symmetry,* Sophie would render their design in embroidery or cross-stitch. She also placed all her choreographic aspirations into their shared two-dimensional rhythm. The use of new materials was key to their experimentation in

Hans (Jean) Arp and Sophie Taeuber-Arp
Symétrie pathétique, 1916–17
Embroidery on cotton
30" x 25 1/2"

Together the Arps created "duo-collages," in which Sophie would translate Han's designs into tapestries. *Pathetic Symmetry* is referred to frequently in descriptions of the work that came out of the dada era. In Jean's reflections of this period, he wrote, "We humbly tried to approach the pure radiance of reality. I would like to call these the art of silence. It (the joint work) rejects the exterior world and turns toward stillness, inner being, and reality. . . . We wanted our works to simplify and transmute the world and make it beautiful."

Sophie Taeuber-Arp
Tête Dada (Dada Head), 1920
Painted wood
11 3/5" high

Taeuber-Arp's *Dada Heads* were the most figurative works she was making at the time (along with the masks she designed for her fellow dada artists to wear at the Cabaret Voltaire). The original *Dada Head* was a portrait of Jean. The rest, as well as the masks, were inspired by Oceanic and Northwest Coast Indian artifacts.

" *Sophie made a series of pear-shaped wood sculptures, which the dada big wigs could set their hats on when they walked into the cabaret.* "

investigating the spontaneous. Sophie never ceased to impress Hans with her ability to give a "direct palpable shape to her inner reality."[4]

Dada inevitably lost its flare and became a bit of a joke. Zurich would never be Paris to the European bohemian community and—like many of his comrades—Hans migrated into the growing Parisian surrealist scene. Besides, Hans had only gone to Switzerland to escape the military enlistment that would have confronted him in Paris. He didn't realize he'd fall madly in love. Despite their marrying in 1922, Sophie wasn't able to immediately join Hans in France. She relied on the economic security of her textile teaching position in Zurich. Although she continued being an artist, she barely made any work during the time she and Hans were apart in the early 1920s.

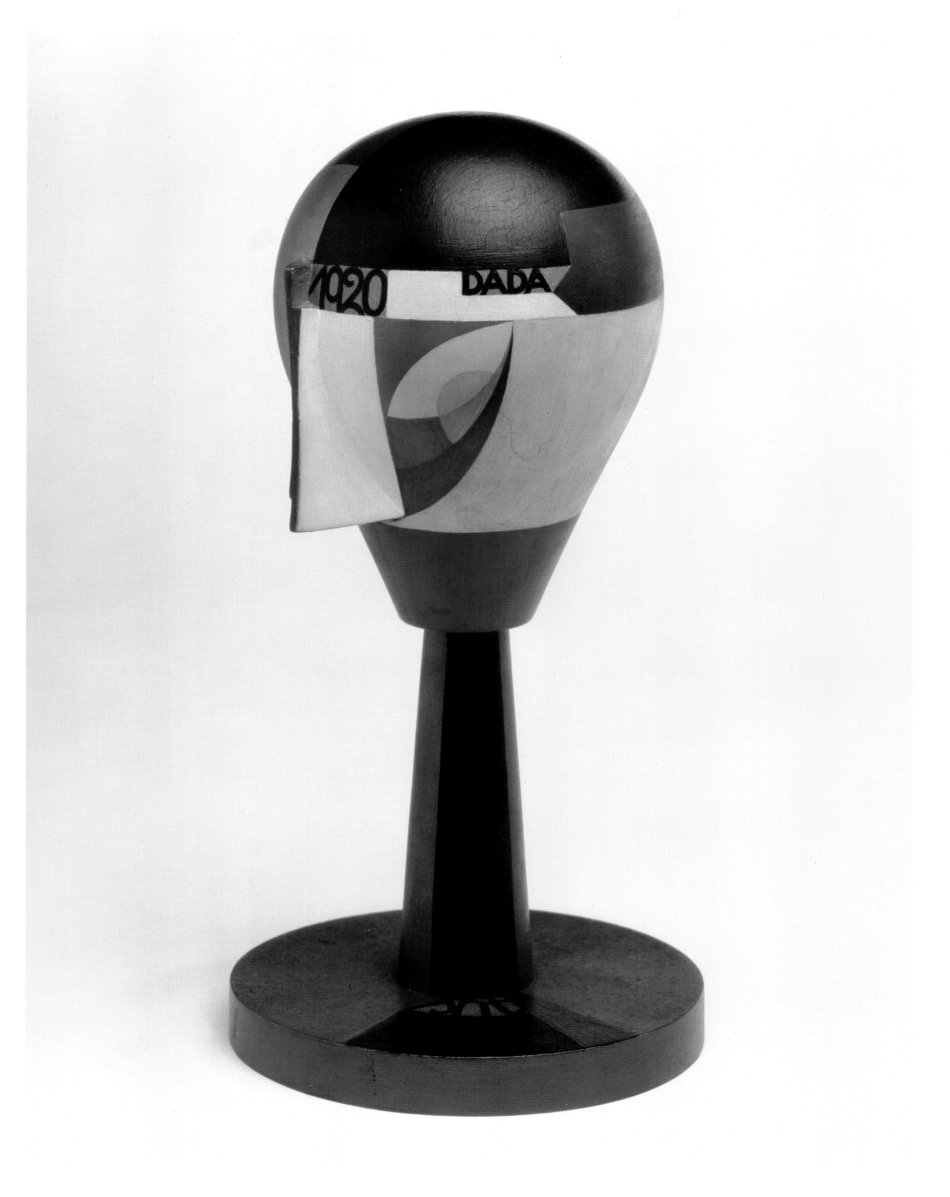

Fortunately, that which kept her in demand in Zurich allowed her to leave it: her artistic skill. When a Strasbourg architect, Paul Horn, commissioned the Arps to design a mural in his home—giving Sophie creative control—she was paid enough to join Hans in "Muedon," their little Bauhaus-inspired nest on the outskirts of Paris.

> " *In 1940, the encroaching Nazis forced the Arps to desert the stillness of their perfect-couple existence.* "

They spent twelve prolific, amorous years in the Muedon house, Hans on the ground floor and Sophie on the second, both delving into various continuations of the abstract/cubist narrative. If one were visiting Hans in his studio, one might never know the light-footed Sophie was above, inexhaustibly exploring her command of vertical and horizontal lines that determined her enmeshment with the circle. Hans joined her in drawing circles, eventually transferring them, curiously enough, into black-and-white *oil* paintings. Hans would step away from their pieces feeling quite proud—calling them "chessboards of the night." Later in life he would bitterly claim that "men in their vanity demolished and soiled" their work.[5] Referring to his critics being less impressed with their work than they themselves were, the Arps simply avowed never to use oil again.

In 1940, the encroaching Nazis forced the Arps to desert the stillness of their perfect-couple existence. Sophie became aggressively anxious about this. "The limpid geometry of her works gave way to networks of rapid, gestural lines that knot in spirals and shoot lightning straight across their compositional fields."[6] She started giving her work titles like *Last Lines on Chaotic Background*. She—who loved the circle and did not indulge in the finite—started creating endings to her lines.

As they unhappily drifted back to Switzerland, she lost a connection with the materials she touched. Her interactions finally came to a tragic halt when she fell asleep next to the toxic leak of a malfunctioning oven in a friend's house back in Zurich. Upon her unexpected death, Hans disappeared into a monastery. While his artistic motivations became paralyzed, his poetry offers a glimpse into his time in solitude. "It vanishes, it vanishes, in its own light. / It vanishes, it vanishes, in its purity and gentleness."[7] One wonders, in his poem "Sophie," how many times he wrote the word "vanishes" before he accepted that eventually he had to just stop, and move on.

Hans (Jean) Arp
Positiv-Negativ Figuren, 1962
Coloured woodcut
$8^1/4''$ x $8^1/4''$

Arp designed this woodcut of abstract male and female forms especially for the 1962 exhibition that highlighted his collaborative years with Sophie at the Musée National d'Art Moderne in Paris.

Stieglitz put O'Keeffe on display the way a scientist reveals an exotic creature in a pen for other experts to stare at while scratching their chins.

ALFRED STIEGLITZ & GEORGIA O'KEEFFE

THE HUNGRY AND THE STARVED

IN 1915, A BESPECTACLED, DISQUIETED ALFRED STIEGLITZ SAT ALONE in his "291" gallery space and pondered his next step as New York City's leading intellectual pundit. He had spread himself thin as an artist, a dealer, an editor, and a proselytizer—a combination that resulted in a lack of funds and an irritating buzz in his head. He made audacious decisions, such as turning on his own artistic medium to celebrate the modernist paintings of Picasso and Matisse for being "anti-photography." Curating painting shows allowed him to tiptoe around the central infuriating concern of his own work. He found that he could ensconce his psychological self-flagellation by "selflessly" promoting the work of others. After visiting his gallery, Georgia O'Keeffe—then a twenty-seven-year-old art teacher—wrote her good friend from South Carolina, "I believe I would rather have Stieglitz like something— anything I've done—than anyone else I know of."[1] And it was upon sight of her charcoal drawings, spread out by said friend on the floor before him, that Stieglitz ceased pondering his next step, clasped his hands together in excitement, and uttered the words, "Woman Pictures!"

What Stieglitz deduced from O'Keeffe's drawings that day ushered in the challenge she would face for the rest of her blossoming career. His contrived interpretation of *Specials* (which was her title for the series) was sensationalized amongst intellectuals when he hung the drawings on the gallery walls—without asking her permission. He put her on display the way

Alfred Stieglitz and Georgia O'Keeffe at his family estate in Lake George, New York, 1929. Photograph by Alfred Stieglitz.

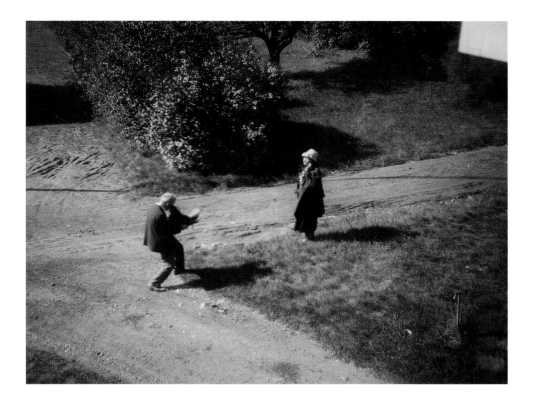

Alfred Stieglitz photographing Georgia O'Keeffe, 1924. Photograph by Arnold H. Rönnebeck.

He—the first photographer in the world to capture the night—blew the dust off his camera and obsessed over his new subject.

Alfred Stieglitz
Georgia O'Keeffe, 1919
Palladium print
$7^1/_5''$ x $9^1/_5''$

When Stieglitz and O'Keeffe began their relationship in 1916, he took daily photographs of her. The subject, process, and result inspired him to produce over 300 portraits of O'Keeffe over the course of two decades. The first image he shot of her showed her hands resting in front of her clothed chest (this was prior to their affair). Once they became romantically involved, he focused mainly on her nude figure, photographing every part of her body with endless fascination, maintaining a constant obsession with her hands.

a scientist reveals an exotic creature in a pen for other experts to stare at while scratching their chins. He pointed at the works and claimed, *Behold, the woman! The woman feels the world through her womb.* The association with anatomical abstraction was undeniable—the "puckers and folds within the shape and its sheer visual weight and centrality invite us to make it over into a body part."[2] But the emphasis on the psychoanalytic approach and the title *Woman Pictures* made her feel pigeonholed. She traveled to New York City to ask in person who gave him authorization to hang her pictures. Stieglitz slyly replied, "No one." "Take them down! They are mine!" she demanded. Upon which he replied, "You have no more right to withhold these pictures than to withdraw a child from the world, had you given birth to one."[3] To this, she responded by staring at him without flinching, her eyes burning into his being. His mouth formed a smile under his thick mustache. A year later they embarked on a feverish love affair.

The clouds parted for Stieglitz. He—the first photographer in the world to capture the night—blew the dust off his camera and obsessed over his new subject. "Stieglitz's *Portrait of O'Keeffe*—a series of more than three hundred photographs—was made over a period of two decades, but most of

the individual pictures were made in the first years of their affair, when the besotted, insatiable Stieglitz seemed compelled to photograph his lover inch by inch and moment by moment."[4] Everything that was supposed to matter at that time lost gravity—their twenty-three-year age difference, Stieglitz's marriage to another woman, O'Keeffe's disregard for societal mores, their unabashed sexuality. Many of the nude photographs he took of her during this idyll exposed her as headless—close-ups of her breasts, her hands.

Should it come as a surprise that during his worship of her femininity she would want a child? When she brought the subject up early in their affair, he acted shocked. "But your art is your child!" It is hard not to imagine her stretched-out figure recoiling at this remark. Regardless, she was so blissfully in love at that time, the initial rejection of the idea didn't dissuade her from eventually marrying him in 1924. She traded her charcoals in for watercolors and experimented with moody tones (fuchsia and blue). *Music, Pink and Blue No. 2*—a reference to her love of music—was a clear prelude to her iconic floral abstractions.

> " *For O'Keeffe, like everything in her new Southwestern landscape, Stieglitz became a hazy form, something she had to squint to see off in the distance.* "

The lust, of course, faded. Although O'Keeffe was a continuous portrait subject throughout their life together, Stieglitz spent less time looking at her and more time focused on the clouds. He found a new solace in resting supine on the hill at his family's estate at Lake George, pointing his lens to the heavens. "These are my spiritual equivalents,"[5] he would tell his audience. Eventually a new young thing emerged from his listeners—Dorothy Norman, a twenty-one-year-old, well-to-do bride. O'Keeffe was heartbroken over the affair, which continued until Stieglitz's death in 1946. But her grief also presented her with an opportunity to search for a new sacred place—the dry desert of New Mexico. They wrote one another letters—Stieglitz, sounding like a boy without his mother, begged for her to return. In response, she pleaded with him to let her stay. As he aged, her absence created a painful void in his life. For O'Keeffe, like everything in her new Southwestern landscape, Stieglitz became a hazy form, something she had to squint to see off in the distance. She had always absorbed the space between them, between birth and death, entrances and exits.

Georgia O'Keeffe
Music, Pink and Blue No. 2, 1919
Oil on canvas
35" x 29 1/8"

Music, Pink and Blue No. 2 is one of O'Keeffe's early abstract paintings. Her particular mastery of composing flowing lines took on a new form when she transitioned from charcoal to oil. Her intensely physical relationship with Alfred Stieglitz at the time certainly influenced the swell of motion and the curving lines. When her work started being exhibited and written about, the voices (all male), exclaimed that her art represented the female mindset and sex. O'Keeffe disliked this interpretation, even though Stieglitz had established it.

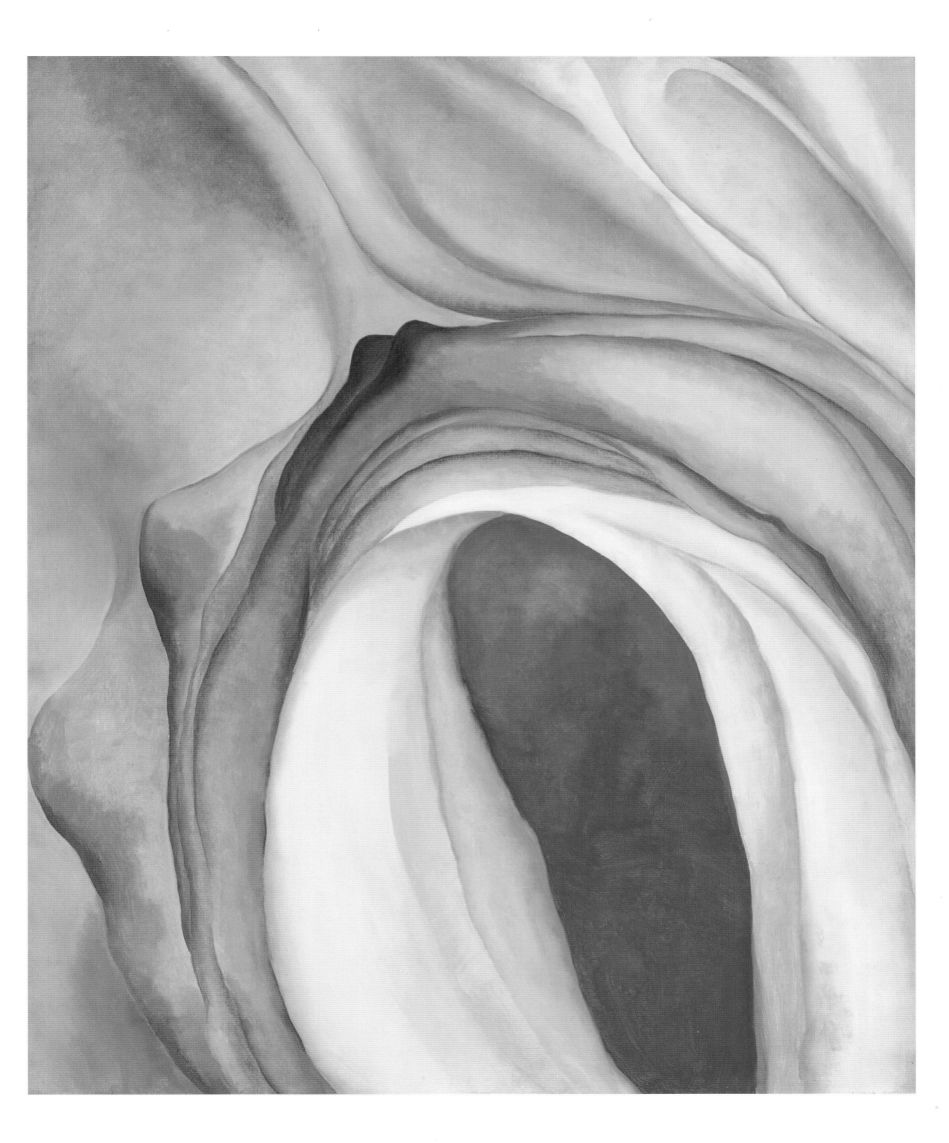

JOSEF & ANNI ALBERS

BREAD AND BUTTER

> *Josef and Anni met at the Bauhaus school—the educational institution that married form and function, where 'art could not be taught,' but craftsmanship could be.*

THE COZY VERSION OF THE JOSEF AND ANNI ALBERS STORY TAKES place in a kitchen, their favorite room in the house, the best place to get to know them as people. But *cozy* is not the first word that comes to mind when considering the Alberses. *Nested squares, crisp geometry*, and *punctilious order* are more likely candidates. Josef and Anni met at the Bauhaus school—the educational institution that married form and function, where "art could not be taught," but craftsmanship could be. This is where Josef trained young artists how to master technique, equipping them with the tools to be "free." He was especially known for his glass and furniture design (even though there was an anti-authorship code and distaste for competition at the school, he possessed superb talents, *unique* even within the uniform aesthetic to which it belonged).

So precise was Josef as an artist, Elaine de Kooning once observed that he could "keep a white linen suit immaculate throughout a painting session."[1] The grandson of a hardworking carpenter and the son of a proud housepainter and "tinkerer," Josef's practicality would seem a natural extension of his upbringing in a strong artisan community in the Ruhr region of Germany. "When I think that I might have been born into a family of intellectuals! It would have taken me years to get rid of all their ideas and see things as they are. And I might have been awkward with my hands," he has said of his family's influence on his work.[2] It was this background that formed one of the main pillars in German art at the time.

When Annelise Fleischmann (before she adopted the more condensed "Anni") arrived at the Bauhaus in 1922, she readily traded in her affluent upbringing, full of its little luxuries, to be an artist. Before attending the radical school (which was still not radical enough to place women on an equal platform as men), she saw the world as a tangled mess. Bauhaus was the only place that contained a sense of purpose. It was a laboratory for ideas, a place where one could explore and experiment within the safety of the institution. There, she lived in a simple room, wore neutral colors, and only took one bath a week. When her family paid her a visit in their fancy car, she shooed them away and

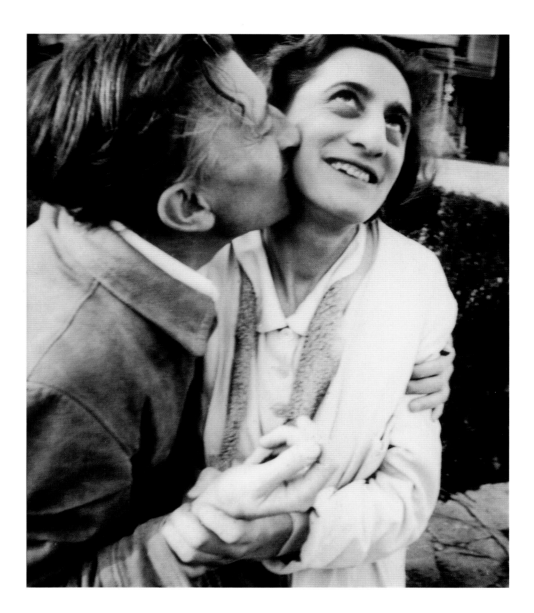

Josef and Anni Albers at Black Mountain College, circa 1935.

told them to park out of sight so that it wouldn't call any attention to her.

As a first-year student, she tried to sign up for Albers' stained-glass workshop, but it was full. Furthermore, the disciplines of carpentry, painting, and metalwork were considered too physically demanding for Anni, who suffered from a neurological disorder that caused muscle atrophy. Consequently, she resorted to weaving, which she considered "sissy" at first, but to which she applied herself with dedication. Under the oversight of artist and instructor Paul Klee, whom she revered, Anni excelled as the best weaver in her class (again, Bauhaus frowned upon superlatives, but she was, and continues to be, regarded as one of the finest textile designers of the twentieth century). Weaving was, in fact, among the only courses that Josef Albers did not teach. Yet the two were drawn to one another by virtue of their mutual talents and shared philosophies about life and work.

A few months after marrying in 1925, the Alberses travelled to northern Italy on their honeymoon. Josef's dream, upon entering Bauhaus, had always

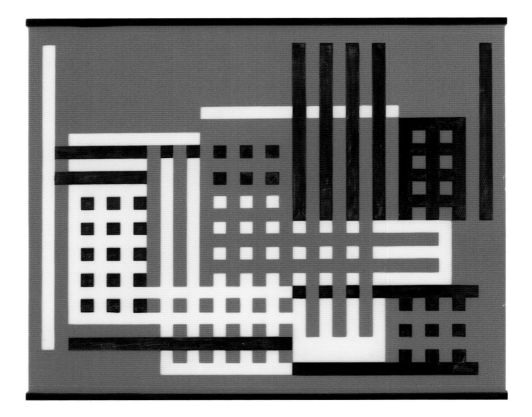

Josef Albers
Factory, 1925
Sanblasted flashed glass
14¹/₄″ x 11¹/₂″

Raised in the Catholic, craftsman-filled village of Bottrop, Germany, the young Albers designed stained glass windows, his initial passion as an artist. When he started training at Bauhaus, his lack of financial resources left him to scavenge for glasswork materials at the Weimar town dump. His refusal to study any other discipline during his first year nearly got him expelled. But an exhibition of his scrapyard assemblages at the conclusion of his second semester so impressed the Bauhaus Masters they encouraged him to continue with his exploration of glassworks. By 1922 he was running his own glass workshop, where he began creating pieces like *Factory*.

> *The rigid standards of Bauhaus living flew out the window when World War II flared up. Germany was no place to be an artist—especially, as in Anni's case, a Jewish one.*

been to make "glass pictures" (his first public art commission, in 1917, had been for a stained glass window in his hometown church), and Tuscany offered a surfeit of new inspiration. "Albers had a particular passion for Duccio and his first gift to Anni was a print of one of Giotto's frescoes. But it was the white-striped architecture of Florence's Duomo and other church facades that was most immediately translated into a new series of sandblasted glass pictures, with their horizontal and vertical geometric lines."[3] Italy's influence on the Alberses' aesthetics is equally visible in the asymmetrical grid designs of Anni's textiles during the period that followed.

In 1928, the Alberses hosted Josef's boss, Ludwig Mies van der Rohe and his mistress, Lily Reich, for a dinner that would unexpectedly prove a definitive example of the Bauhaus ethos. Anni was responsible for making everything flawless that evening. She even used her mother's butter curler to turn the slab of butter into perfectly round balls. Within minutes of arriving at the Alberses' functional, non-ostentatious apartment, the two guests covered their mouths in horror. *Dainty balls of butter!* In the eyes of the Bauhaus, that small detail highlighted wealth. Better she should have set the slab on the table just as it was. Again, Anni was humiliated by evidence of her class status. It was a big deal because everything one did—in the context of work and life—was thought to matter.

The rigid standards of Bauhaus living flew out the window when World War II flared up. Germany was no place to be an artist—especially, as in Anni's case, a Jewish one. In the United States, Black Mountain College in North Carolina was forming as a new, experimental type of educational

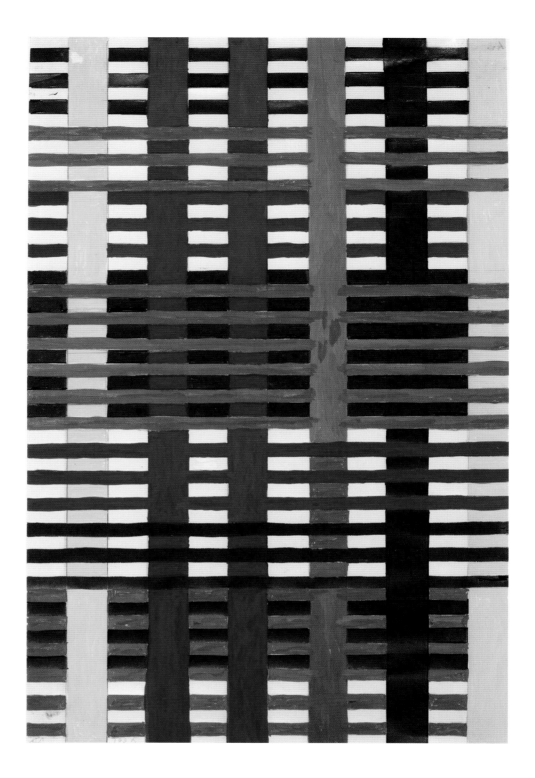

Anni Albers
Study for wall hanging, 1926
Gouache with pencil on photo offset paper
15″ x 9³/₄″

While Anni Albers designed many textiles, such as draperies and rugs, to serve functional roles, her wall hangings were intended to exist purely as art objects. An early example of her exploration of asymmetrical patterns, this study was created after she and Josef returned from their honeymoon in Italy, where they were both strongly influenced by the graphic decorative facades of Florence's architecture.

training ground, which took in a number of the intellectuals fleeing from Europe. When the founders elected Josef Albers to be the school's first art teacher, they knew he didn't speak a single word of English. This was not, in the least bit, considered a defect. Black Mountain selected him because, even across the Atlantic, he was known for being one of the "greatest teachers in actions . . . that as soon as you started to take his class, you [saw] a vision."[4] Albers started his first class, and several subsequent classes, by announcing: "I want to make open the eyes" and this made complete sense to his committed students. The Alberses taught at Black Mountain for thirty years,

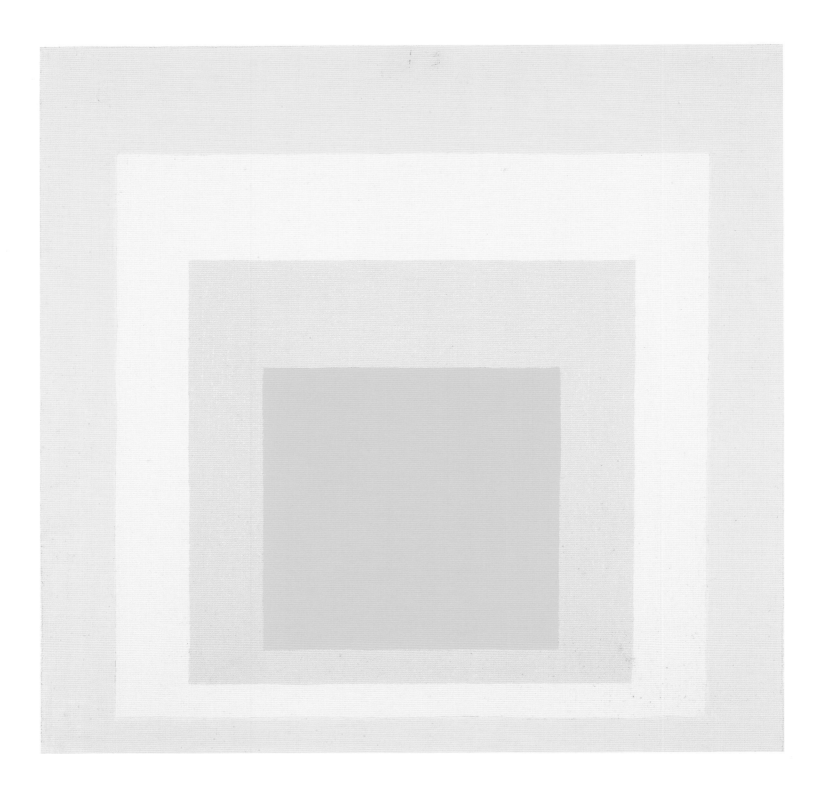

Josef Albers
Study for *Homage to the Square, 2 Grays Between 2 Yellows*, 1961
Oil on masonite, 22" x 22"

Inspired by the way his carpenter father had painted doors, Albers painted the now iconic nested cubes in his *Homage to the Square* series by starting in the center of the canvas. Each geometric composition was the basis for an exploration of the interaction between various colors.

indulging in frequent road trips to Mexico, a country they both fell in love with for its craft culture. Despite their dislike for excessive objects in their life, it took every molecule of their shared willpower not to bring back pots and tapestries. And if they did, they stored their acquisitions in a secret place, where only they could see them. Their American homes always exhibited complete austerity and function. Bauhaus never left their systems.

After the Alberses moved to Connecticut to teach at Yale in 1950, Josef began his famous *Homage to the Square* series. For twenty-five years, he painted a succession of squares within squares, as a way to investigate optical

Anni Albers
Study for *DO II*, 1973
Gouache on paper (blueprint)
18¹/₄″ x 18¹/₂″

After publishing her treatise *On Weaving* in 1965, Anni Albers shifted into focusing on screen-printing. She experimented with various geometric constellations, which appeared to take her husband's research in color theory into more complex optical arrangements.

relationships between the human eye and colors. They were, in his strive for simplicity, a meditation. Anni, now working in printmaking, followed his lead, taking on a slightly more complicated approach, which was probably influenced by her eye for weaving and the floor pattern of Giotto's chapel entrance. Their dedication to minimalism tended to intimidate outsiders. When journalists spoke to them, they often elevated their language into an abstract, intellectual zone that made Josef's eyes glaze over. When they'd ask him *how* he painted the square, he'd say glibly, "I paint the way I spread butter on my pumpernickel!"[5]

FRIDA
KAHLO

DIEGO RIVERA

COMPAÑEROS

IN LETTERS TO LOVED ONES IN MEXICO, FRIDA KAHLO RAPIDLY unraveled her impressions of the United States as an indulgent, clueless, and vulgar place—specifically a *porquería* or a *cochinada*.[1] She'd include tiny macabre self-portraits under her affectionate sign-off. As an obedient new bride in 1929, she accompanied her gringo-sensationalized husband, Diego Rivera, while he brought his politically revolutionary art to America's mother cities. Fascinated with aesthetics of American industry—mass production, assembly lines, gargantuan machinery—Rivera, the proud communist, approached the journey as though he were walking into the belly of the beast. When he stepped off the ship, a genius bulldozer with springs popping out of his back, Kahlo stood firm at his side. Rivera rubbed his rich-boy worker's hands together and embarked on what Americans like to call "taking the world by storm."

In San Francisco Kahlo wrapped her fingers tightly around her paintbrush. She was inspired by newness—not based on exploring an unfamiliar place but on discovering a different shade of longing than the one she had experienced as a bed-ridden child in Mexico. In each place she recognized she was still trapped, and felt an infuriatingly inaccessible sense of purpose surrounding her. She possessed a closer relationship to her potential death than to her ongoing life. Through painting, Kahlo confirmed the walls of her imprisonment, her own body a creaky cabinet of curiosities that kept pace

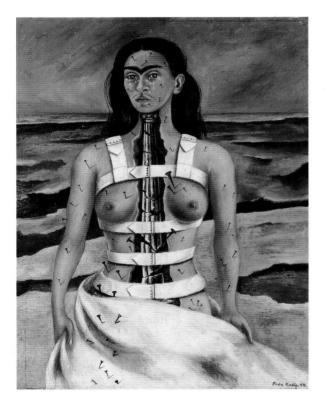

[opposite]
Frida Kahlo and Diego Rivera, Mexico City, 1934. Photograph by Martin Munkacsi.

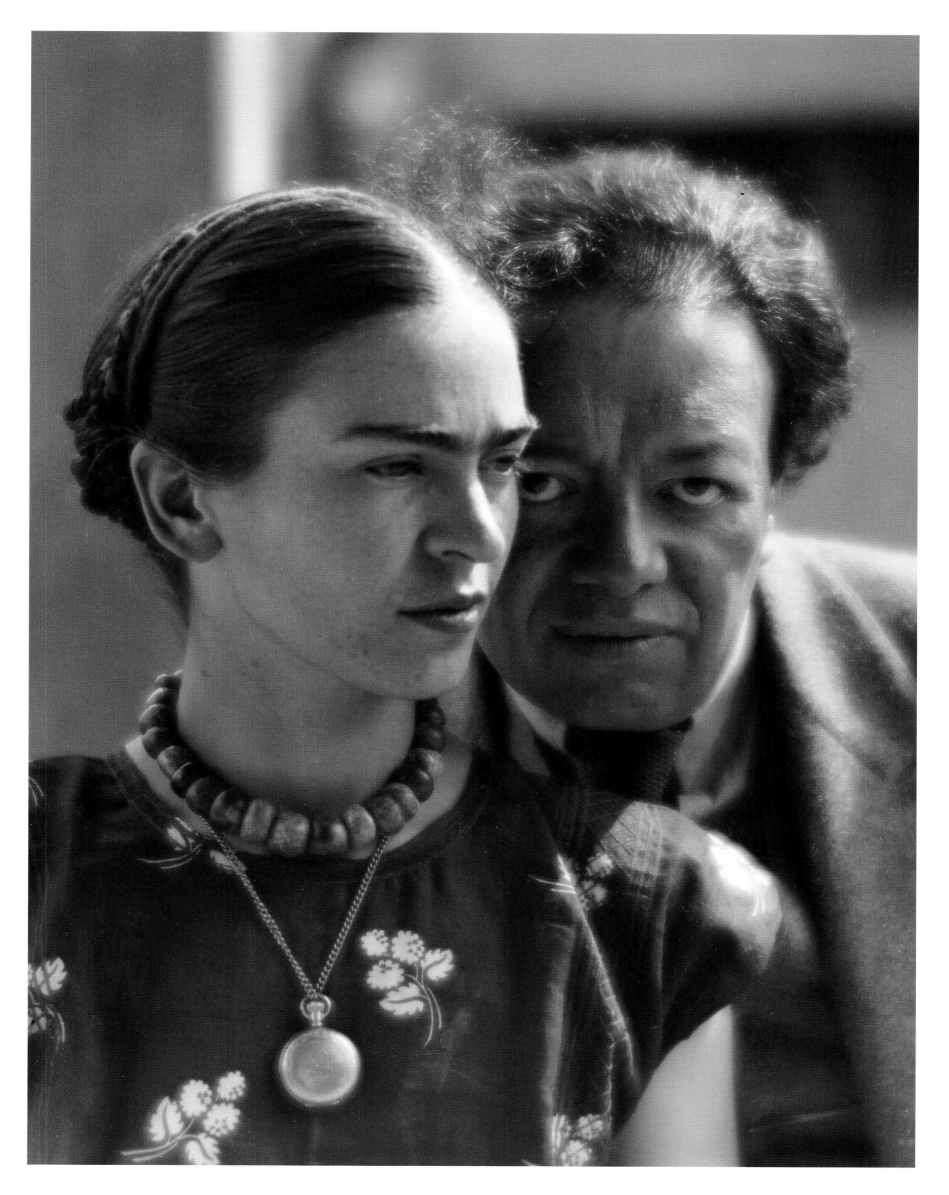

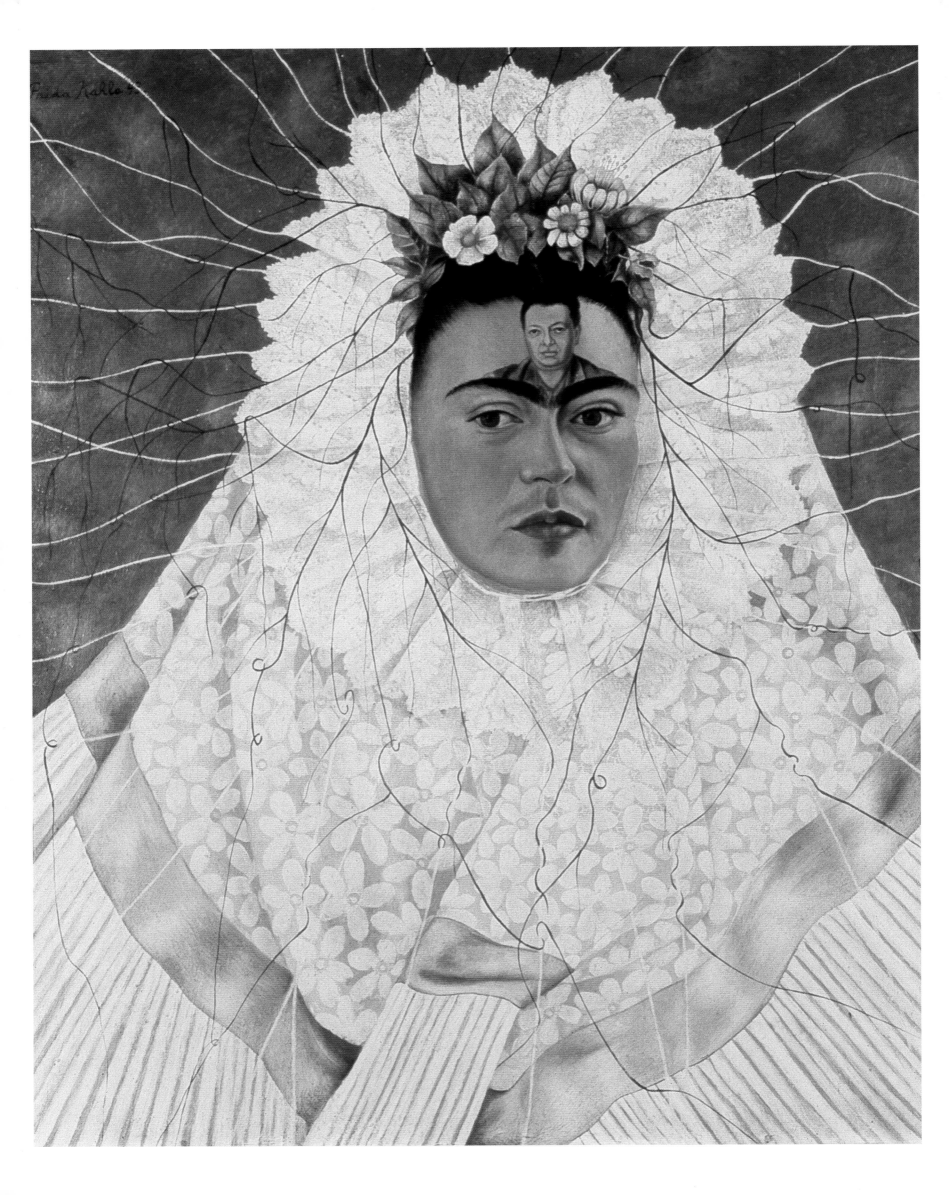

[page 42]

Frida Kahlo
The Broken Column, 1944
Oil on masonite
15 $^{11}/_{16}$" x 12 $^{1}/_{16}$"

From the time of her tragic bus accident at age eighteen, Kahlo endured numerous surgeries and chronic pain that continued throughout her life. Themes of physical and emotional suffering were common in her works. Painted during a time of particularly poor health, *The Broken Column* is a self-portrait of Kahlo being held together by steel and nails, bleeding from wounds and swaddled in a white sheet, similar to the iconic portrayal of Christ. Here she experimented with her role as a passive martyr, avoiding emotion and movement so as to not completely rupture from the inside out.

[opposite]

Frida Kahlo
*Self-portrait as a Tehuana
(Diego on My Mind)*, 1943
Oil on masonite
29 $^{7}/_{8}$" x 24"

Kahlo started working on this self-portrait a few months after Rivera filed for a divorce in 1939. She is clothed in a Tehuana dress as an homage to Rivera's admiration for traditional Mexican costumes. Rivera's face appears as her third eye, a reference to her obsessive suffering surrounding his constant infidelity—she could not take him off her mind. Kahlo's Tehuana gown expands into a spider web, one that Rivera is trapped inside of.

with the thundering, elephantine feet of her lover. To others, her paintings were analogous to her long swishing skirts that gave her an air of freedom, like she could float off at any moment—when in reality the skirt existed to keep her sickly leg ensconced.

In New York City she encountered frequent lulls filled with restless sighing and occasional canvas stabbing. Bibulous companions observed it as melodramatic self-criticism or an attempt to throw a wrench in her ongoing—albeit never-ending—social reality of being the wife of a famous artist. But Kahlo could feel the presence of something growing, something potentially larger than the 300-pound Rivera.

> "*Impervious to his affairs, even the one with her own sister, eventually she began to see her husband, whom she married twice, as a* compañero, *her inner eye.*"

Rivera was the second artist, following Henri Matisse, to have a solo show at the Museum of Modern Art in New York. Originally from Guanajuato, a Mexican town known for tragic love stories and, consequently, opera, he was sensual and seductive even as a young boy. He would reach for what he wanted and run his hands over paint, walls—and the curves of every woman within reach. Art being a game, he was a master gambler. Drunk with the ideals of the *Communist Manifesto*, he trusted his people and his gut. Many of his decisions were clever, but choosing young Kahlo to be his bride was a jackpot move. Her maternal, albeit tempestuous, presence in his life indubitably advanced him.

Kahlo loved Rivera's physique. Once describing his chest to a journalist, she said wistfully, "I would say that if he had disembarked on the island governed by Sappho, he would not have been executed by her warriors. The sensitivity of his breasts would have made him acceptable. His peculiar and strange virility would make him desirable in the territories ruled by empresses eager for masculine love."[2] But if their marriage was the fulcrum of Kahlo's life, leaning towards her own art meant letting Rivera continue to be groped and coddled in a sea of willing empresses—and watching him get carried away from her.

There were many other women, one after another, giggling behind the doors of Rivera's pink Bauhaus-style studio that was connected to Kahlo's "Blue House" by a narrow bridge. It was cartoonish, the everyday rerun: Rivera waking up in his house, filled with guilt, crossing the bridge to shyly

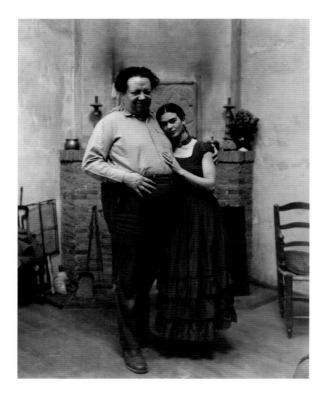

Frida Kahlo and Diego Rivera, 1931.
Photograph by Paul A. Juley.

Diego Rivera
Detail from *Dream of a Sunday Afternoon*
in the Alameda Park, 1947–48
Fresco
50' x 13'

This is a fraction of the epic fresco Rivera painted featuring the breadth of Mexican history, from the Aztec era to the Revolution of 1910. Various real and mythical characters populate the mural, with Rivera, depicted as a mischievous young boy, at its center. To his right stands the famous engraver José Guadalupe Posada, one of Rivera's main mentors. Poised above him with her hand resting maternally on his shoulder is Kahlo. Her expression is all-knowing and she holds a Yin-Yang, the ancient Chinese symbol for duality. Completed six years before her death, here Rivera presents Kahlo as a nurturing maternal figure. With his two most important influences pushing him forward, he holds the skeleton hand of Dame Catrina, the "Elegant Skull," best known as the primary icon for the Day of the Dead.

knock on Kahlo's locked door to no answer, taking heavy steps down the stairs to knock on the downstairs door and ask her butler to fetch her, only to be rejected. Turning around on his heel, he would hear Kahlo damning him from inside the house. But at some point in the afternoon, while painting and grumbling to himself, her upstairs door would open a crack. And sometimes it meant she, too, wanted a go at the curvaceous young beauty she spied in his studio (Kahlo was almost as good at seducing women as her husband was). She preferred women as sexual escapades rather than as friends. Her deepest relationships were with men, and she would reach the point with some—such as Leon Trotsky—where she nearly fell in love, but Rivera trumped them all. He would get angrier about her affairs with women than men—perhaps because he was such a colonizer of that territory. No woman devastated Kahlo in their dalliance with her husband as much as her own sister, Cristina. It was an earth-shattering and nearly unforgivable act of treachery—leading to one of the most suicidal bouts in her life.

> *"When the time came to be with Kahlo at her deathbed, the skeleton inside Rivera stopped laughing, the chaotic noises of Mexico sounded like they were being drowned under water."*

Time, which is crucial in healing the lacerated bond between true lovers, lovers who are incapable of loving others, solved this issue for Kahlo and Rivera. After many flings, tears, and her elevated status as a worldly artist, a surrealist painter, she established a stronger relationship with Rivera. Impervious to his affairs, she eventually began to see her husband, whom she married twice, as a *compañero*, her inner eye. Instead of a lover, he became her fellow artist.[3]

Kahlo and Rivera referred to death—in art and conversation—on a daily basis, always, with a curl of a smile or a sneer on their faces. Part of their culture was to try to laugh at—or with—death. Mexican history was practically illustrated by a festive skeleton. In Rivera's Mexico City–based mural *Dream of a Sunday Afternoon in the Alameda Park* (1947–48), a boyhood version of himself holds hands with a lavishly dressed female skeleton, while Kahlo stands behind him, appearing filled with an eternal sense of life. But when the time came to be with Kahlo at her deathbed, the skeleton inside him stopped laughing, the chaotic noises of Mexico sounded like they were being drowned under water. In that final moment, of her final breath, when she could no longer hold Rivera's hand, all of Mexico turned black and white.

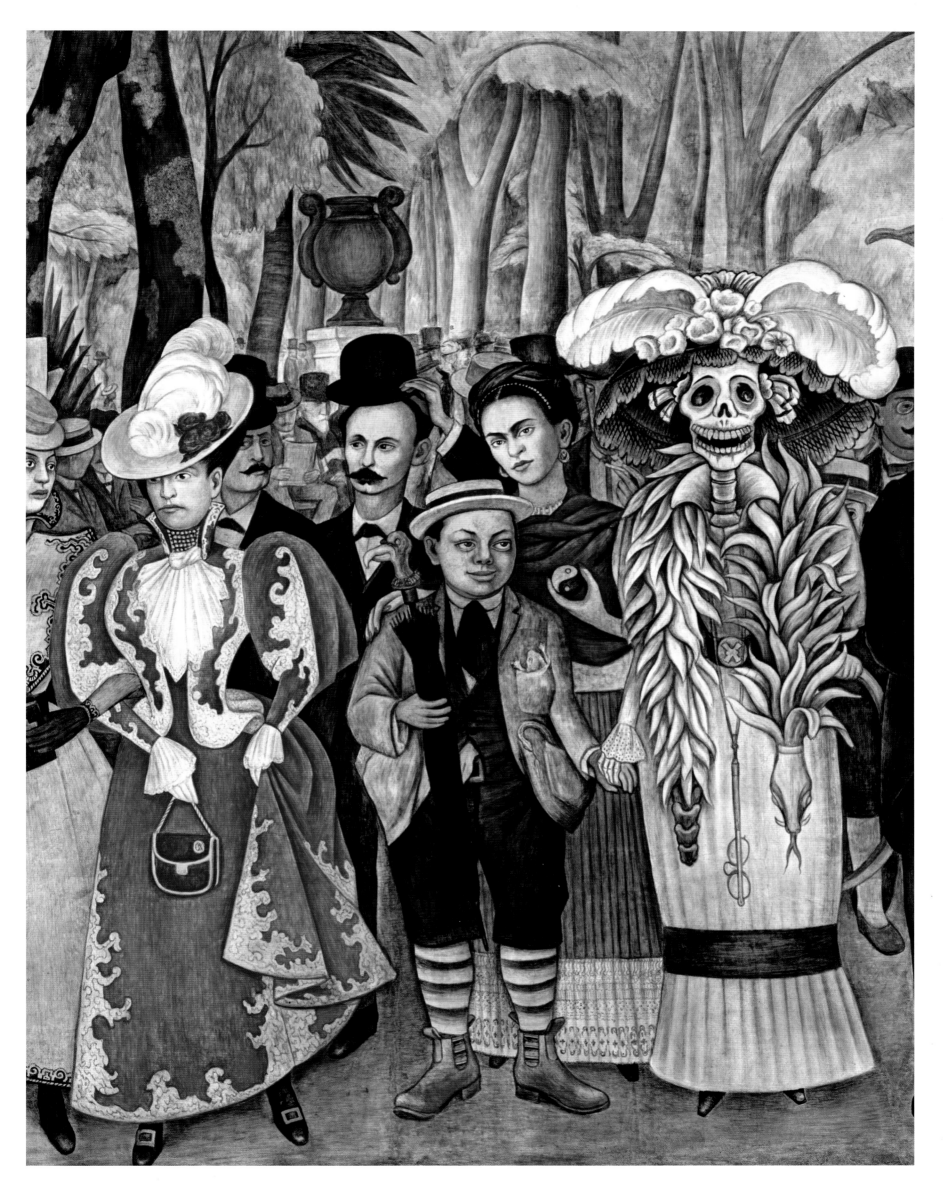

LEE MILLER & MAN RAY

> *In the dark room, they stood side by side,*
> *Ray breathing deeply, Miller concertedly calm.*
> *Until a mouse ran over her foot and she gasped . . .*

THE EYE AND THE LIP

THE NINETEEN-YEAR-OLD LEE MILLER STOPPED MAN RAY IN PARIS IN 1929 just as he was about to flee the sweltering metropolis for the coast. Surrealism had reached a feverish pitch and Miller had come to learn from its maestro. Just a few introductory words were spoken, yet the brief exchange resulted in Miller joining Ray on his summer holiday. When they returned, she settled into Ray's nest on 31 bis rue Campagne-Première. She did everything he asked her to do: *Bend over this way, now that.* The early lessons were effortless for her, a continuation of what she had done with her photographer father in Poughkeepsie, New York, as a teenage girl. Miller trusted Ray's photographic dissection of her body, his inclination to present her as a phallus, his way of reducing her to a pair of slightly opened lips.

When she graduated to the level of going off on her own with the camera, she'd float along the gray streets of Paris, studying the edges of shattered glass and ripped window screens. She took an assignment in a hospital where she found a severed breast left over from a mastectomy. She brought it to the French *Vogue* magazine headquarters and set it on a plate with a fork and

Lee Miller with Man Ray in her studio in Paris, 1931. Photograph by Theodore Miller.

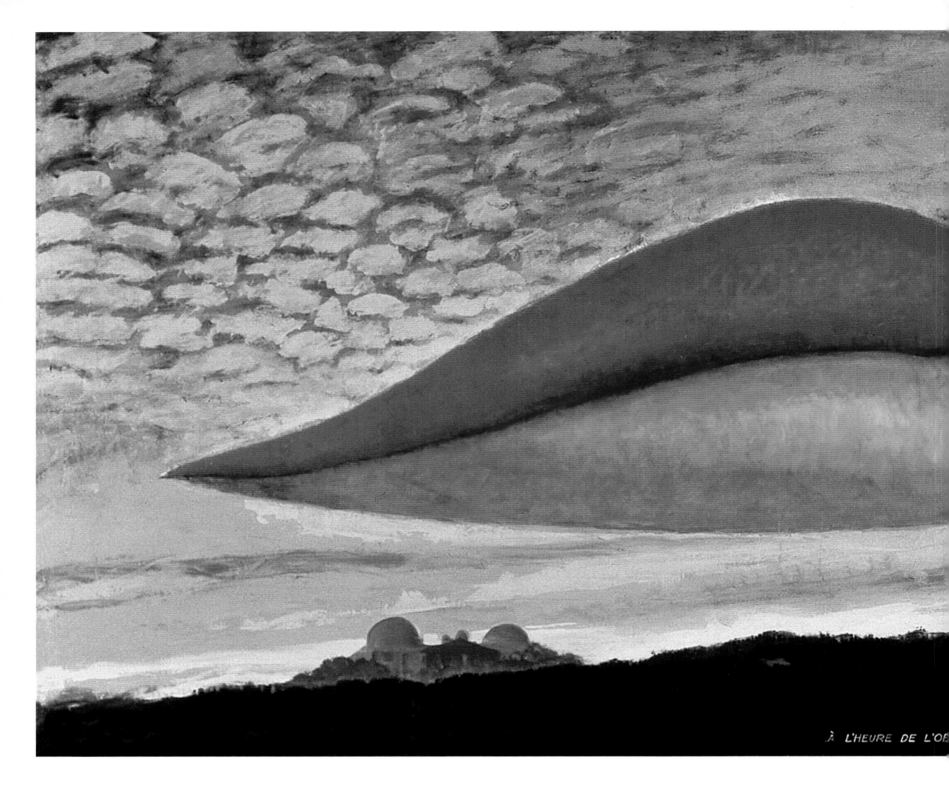

À L'HEURE DE L'OI

Man Ray
Observatory Time – The Lovers, 1934
Oil on canvas
39 2/5" x 98 3/5"

While living with Miller in Paris from 1929 to 1931, Ray's favorite time to photograph his muse was while she slept with her lips slightly parted. Especially after their disagreeable split, Ray found Miller's lips to be the hypnotic signature of the most romantic and erotic era in his life. In 1934, after she had moved back to New York, he painted a portrait of them floating in the sky and called it *Observatory Time – The Lovers*.

knife on either side, salt and pepper shakers within reaching distance. "Ready for dinner?" she asked the editor, and she snapped one of her iconic surrealist contributions.

Sprawled over the pile of threadbare oriental rugs amongst strewn chess pieces, she slept in Ray's home while he crept around her and snapped pictures. In the morning she'd tower over him in the kitchen. As she slowly drank coffee and worked, Ray couldn't find an elegant way to get out of her shadow, so he gradually settled into it. They worked together on his commissioned portrait assignments. In the darkroom, they stood side by side, Ray breathing deeply, Miller concertedly calm—until one fateful day when a mouse ran over her foot and she gasped. She rushed to switch on a light while

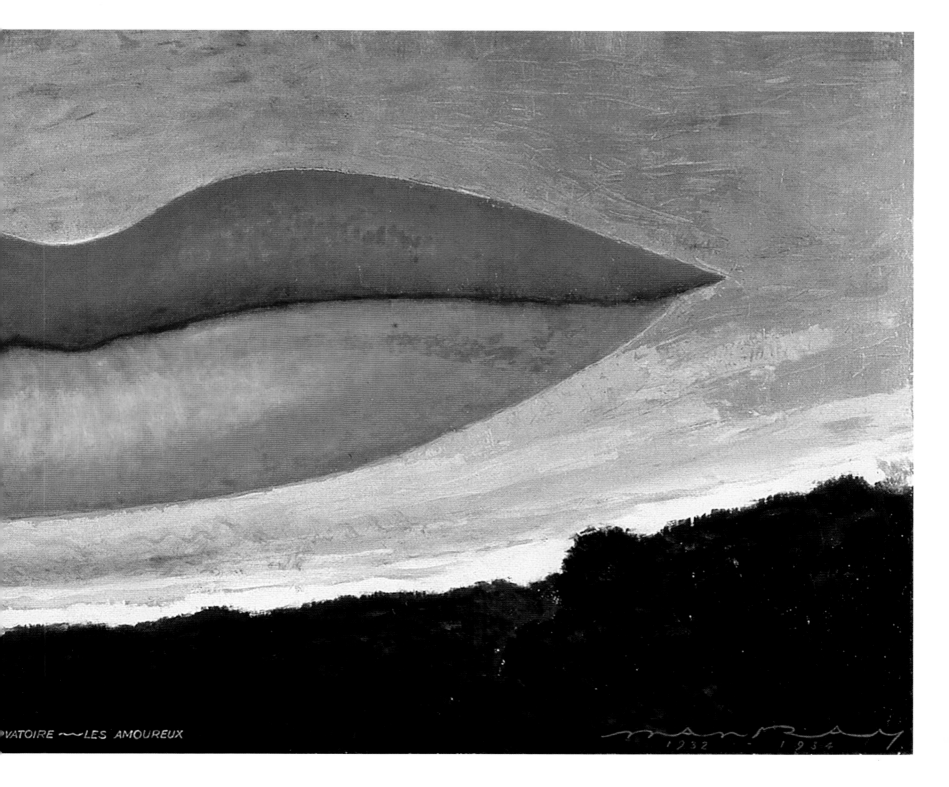

VATOIRE ∼ LES AMOUREUX

man Ray 1232 · 1934

> *"Miller trusted Ray's photographic dissection of her body, his inclination to present her as a phallus, his way of reducing her to a pair of slightly opened lips.*"

twelve nudes of singer/actress Suzy Solidor were developing. This accident, which they subsequently labeled "solarization," had transferred black into white and white into black, creating a peculiar and alluring outline of a figure. Duchamp's image was the next to be solarized and then Ray conducted a series of "dream anatomies."

The later lessons and demands were impossible for her: *Tell me the truth*.

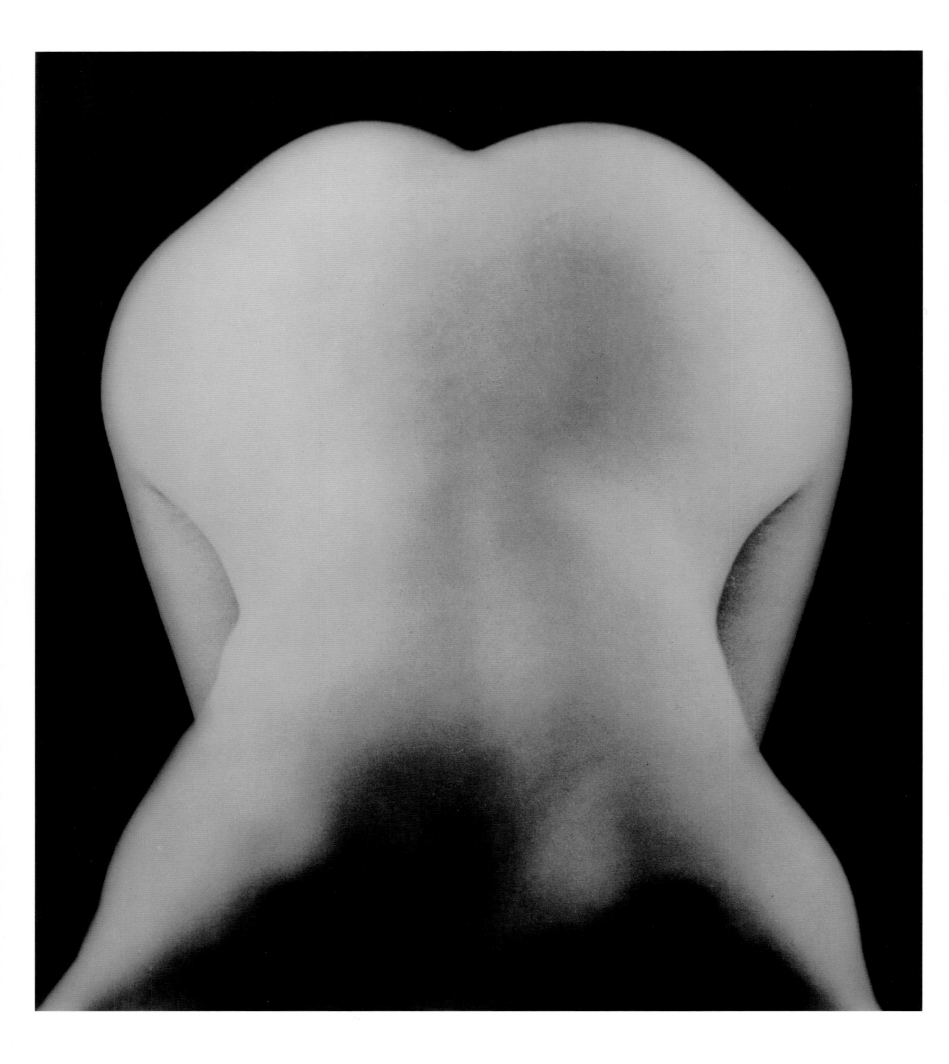

Lee Miller
Nude Bent Forward, 1930
Gelatin silver print
7" x 8"

By the time Miller had photographed this self-portrait she had been living and working with Man Ray in Paris for two years, and had observed and assimilated his method of photographing women's bodies to resemble objects. Miller had a knack for following in his footsteps, but here she took it a step further by keeping her arrangement much simpler. For example, Ray had relished in turning his former lover Kiki's back into a violin by painting *f*-holes onto the photograph. Here, Miller literally turns his depiction of the violin on its head, avoiding embellishment, resulting in a subtler, more haunting and dramatic aesthetic.

Lee Miller bathing in Adolf Hitler's bathtub in Munich, Germany, 1945.
Photograph by David E. Scherman.

This portrait of Miller bathing in Hitler's apartment was taken by *Life* photojournalist David E. Scherman a few days after Hitler's death. At the time, Miller was a war correspondent for *Vogue* and had been documenting Germany's downfall in Europe with Scherman. A portrait of Hitler sits on the edge of the bath, Miller's combat boots are on the floor in front of it, and her clothes and watch are on a chair. On the table, there is a small statue and a call-button box. When the photograph resulted in great controversy, Miller shrugged off the excitement by explaining there was nothing more to it than the simple necessity to bathe. It was common for Miller, who had been exposed to trauma from a young age, to glide through horrific settings.

Don't leave me. Ray claimed his sovereignty over her identity as she scooted off across the Atlantic to be a star in New York in 1932. So distraught was Ray by her abandonment, he posed for his own camera with a gun in his hand, a noose around his neck, and a bottle of poison at his side. In America, Miller called her studio the "Man Ray branch of photography." Ray could hardly believe her audacity. She went on to publicly advise others on how to learn from the greats. "Absorb him," she said.

> *The later lessons and demands were impossible for her:* Tell me the truth. Don't leave me.

Fifteen years later Miller would collapse in Hitler's empty bed while conducting war coverage for *Vogue*. Her blue eyes closed, her blond hair crimping up against the pillow—who better to slumber in the deceased Führer's bed than the Aryan woman of his dreams? And one wonders what the former surrealist muse dreamt about that night. Ray was not there to capture her expressions in her sleep, and surrealism had already well faded out of the limelight.

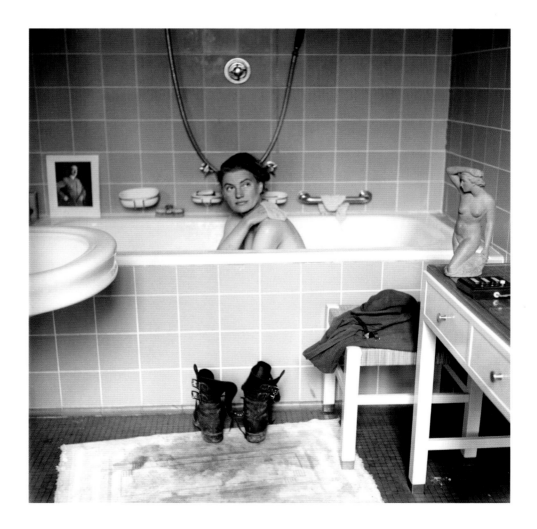

> " *Not a day had passed in Nicholson's life when art was not made or discussed. Hepworth offered a continuation of that rhythm—for she 'detested a day of no work, no music, no poetry.'* "

BARBARA HEPWORTH
BEN NICHOLSON

SPACE-MAKERS

WITHIN THE CONFINES OF ENGLAND, ONE CAN NEVER TRAVEL TOO far from a mysterious stone circle. Nor can one get too lost in the countryside without seeing signs of human intervention. The British possess a special relationship to mystery, spiritualism, and nature. Ben Nicholson and Barbara Hepworth were both born into that mindset, and their art, though never explicitly, hummed with a certain unworldliness that fit into the quiet disposition of their mother country.

The two met in 1931 during a working holiday in Happisburgh in Norfolk. At the time Hepworth was married to another artist and had a little son, Paul. It was she who had made the arrangements to rent the house on the beach that her father had taken her to every summer. When they met, Nicholson and Hepworth were mirror images of one another, both featuring equally huge foreheads held up by tall, willowy frames. Nicholson watched her slip out of the house at dawn to collect stones and seaweed from the beach; he could see she was a true visionary. Being the son of two serious artists, he *knew*. Nicholson fondly remembered the way his mother aggressively scrubbed

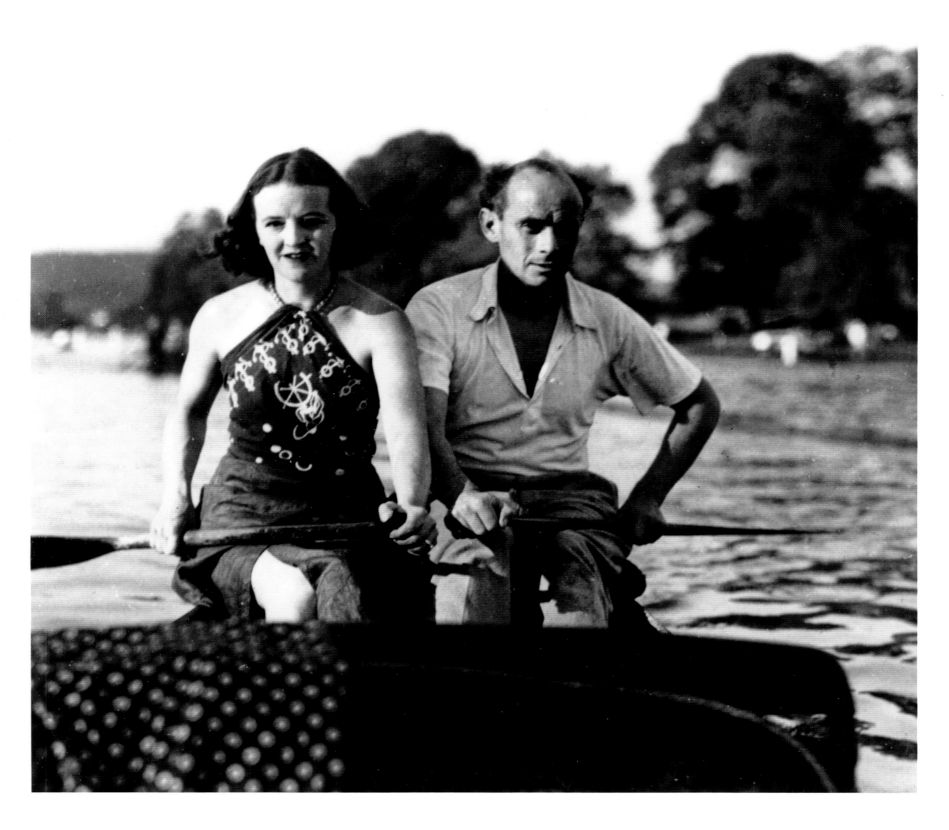

Barbara Hepworth and Ben Nicholson, 1933.

the kitchen table whenever art theory was discussed in the house, and the way everyone exalted his father's paintings. Not a day had passed in his life when art was not made or discussed. Hepworth offered a continuation of that rhythm—for she "detested a day of no work, no music, no poetry."[1]

Incidentally, neither of their spouses were present when Nicholson showed up to the beach where Hepworth resided as a warm hostess. The waves thumped against that house while everyone made art during the day and settled into wool blankets and candlelight by night. Her husband popped up

Ben Nicholson 1933

once while Nicholson was there, but felt disconnected from the environment and hurried back to his mistress in London. Their marriage had simply "gone off orbit" according to Hepworth, and they soon divorced quite amicably. In Nicholson's case, his artist wife, Winifred, had no interest in severing the relationship, but that proved to be a hopeless cause. "Where Winifred had been

Ben Nicholson
profile, 1933
Linocut
17 1/8" x 15 3/8"

While Nicholson is best known for his abstract works, for a brief period at the beginning of his romance with Hepworth, he created a series of linocuts based on her profile. They were made during a time when he was first exposed to Hepworth's studio practice, in which she was often found carving the human head and variations of the figurative out of stone.

Barbara Hepworth
Two Heads, 1932
Cumberland alabaster

Hepworth once wrote about the practice of sculpture, "Carving is interrelated masses conveying an emotion; a perfect relationship between the mind and the color, light, and weight which is the stone, made by the hand which feels. It must be so essentially sculpture that it can exist in no other way, something completely the right size but which has growth, something still and yet having movement, so very quiet and yet with a real vitality."[2]

strong and motherly, with some financial security stemming from her family . . . Barbara was strong but girlish, a slender creature who might have stepped out of some pre-Raphaelite painting but who was armed with circumspect ambition."[3] When Nicholson and Hepworth were, more-or-less, free to be together, they embarked on a whirlwind tour of France, visiting all the studios of artists they revered—the Arps, Picasso, Brancusi, Braque.

> " *Hepworth didn't just represent romance to him, but all of art.* "

In France, while Hepworth carved, Nicholson began to create a series of linocut reliefs of Hepworth's profile. "Her profile appears again and again—the last time we see the human image in his paintings."[4] Sometimes the outline of her features existed alone, other times it was accompanied by a second profile (his). Sometimes a third face appears, intimately floating amongst the others—possibly a mirror reflection, for Nicholson was ceaselessly mystified by their portal nature. His white undulating lines on black shared stylistic representations of man in ancient Greek art, but also appeared transcendental, like the memory of a human fixed in space, composed of stardust. Hepworth didn't just represent romance to him, but all of art. He held Hepworth on

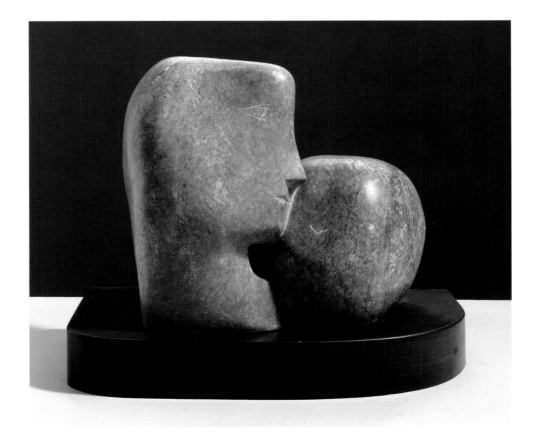

Ben Nicholson
1935 (white relief), 1935
Oil on carved board
40" x 65 1/2"

Nicholson believed that the only way to
understand the universe, which he perceived
to be a construction of the human mind,
was through religion. He viewed his art as
a representation of his own exploration,
with his white reliefs as his greatest
achievement in that regard. "As I see it,"
he once explained, "painting and religious
experience are the same thing, and what
we are all searching for is the understanding
and realization of infinity—an idea which is
complete, with no beginning, no end, and
therefore giving to all things for all time."[5]

that pedestal just as he saw art and religion as synonymous (he was a devout
Christian Scientist). As he stated in a major manifesto a year after visiting
France, "Painting and carving is one means of searching after this reality, and
this moment has reached what is so far its most profound point. During the last
epoch a vital contribution has been made by Cézanne, Picasso, Braque, Brancusi,
and more recently by Arp, Miró, Calder, Hepworth, and Giacometti. These artists
have the quality of a true vision which makes them a part of life itself."[6]

Hepworth was the only woman's name included on Nicholson's list, but
there was a strange reluctance by her to claim ownership of that fact—"A
sculptor carves because *he* must," she once said.[7] Clearly Hepworth was
a minority, being a woman, but any struggle in that regard is not visible
in her work. She didn't feel a female artist was debilitated by her domestic
responsibilities like cooking and cleaning. Maybe she expected that people
would look at her smooth, stone-shaped sculptures and see the touch of a
woman, a mother. The sculptures did not look like the product of a blade or a
sharp object, but more like they had been carefully molded by water and wind,
all severe angles worn away, punctuated with her trademark of a perfect hole
large enough for someone to slip a hand or entire body through.

While living in London with Nicholson before World War II drove them
out into the countryside, Hepworth diligently whittled down slabs of stone

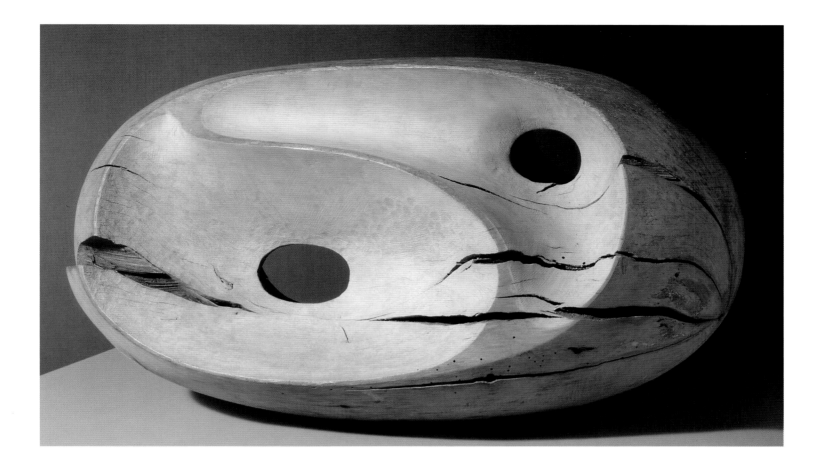

Barbara Hepworth
Tides 1, 1946
Partly painted wood (holly)
13 1/4" x 25" x 11 3/4"

Ben Nicholson presented this sculpture to the Tate Gallery in London in 1975, the year Hepworth died in an accidental fire in her studio in Tate St. Ives. Hepworth had discarded the unfinished *Tides I* when the wood started splitting; Nicholson held onto it, even after their marriage dissolved in 1951.

and carved wood at the same pace that her stomach swelled. Three tiny humans were wrestling inside her for space. Nicholson had shifted into doing entirely white reliefs—white rectangles with white discs cut out of them. He was uncovering new terrain while Hepworth's head was fogging up with the cloud of pregnancy. One day in October "Ben had complained a little bit that I seemed withdrawn and concentrated over my pregnancy. But suddenly I said 'Oh dear,' and in next to no time I saw three small children at the foot of my bed—looking pretty determined and fairly belligerent."[8]

> "*Her sculptures did not look like the product of a blade or a sharp object, but more like they had been carefully molded by water and wind.*"

The euphoria of delivering triplets was followed by the difficult reality of being two artists trying to survive in wartime. On the one hand the couple was deemed among the best modernist artists in England, but on the other, the public just scratched their heads in confusion. "Britain seemed immovably wedded to the idea that good art was pleasant, pretty, and unproblematic art," thus occasionally placing their abstract art in the category of being

Hepworth and Nicholson's triplets—
Simon, Rachel, and Sarah, circa 1943.
Photograph by Ben Nicholson.

inaccessible.[9] This issue never once, even for a second, deterred them from being artists. Not even with a trio of ceaselessly hungry babies.

Space was always the primary concern for the two of them. Both revealed an aesthetic that delineated a methodical albeit poetic balance between space and form in their work. They investigated similar terrain, except Nicholson mostly focused on the layers of a flat surface, while Hepworth worked in three dimensions—inverses of one another. After having their triplets, Hepworth shifted the tension she applied to carving materials. It became more about her relationship and movement with the material itself, and less about the natural world that surrounded them. As a consequence, the sculptures embodied a craving—the *need*—for there to be fluidity amongst all the elements. The sound of the hammer was music to her ears—the audible signifier that she was creating space.

> "*In her* Pictorial Autobiography *Hepworth narrates her life journey—until she reaches the year 1951, the year she said, 'After 23 years, everything fell apart.'*"

To keep the roof firmly placed over all the noise and movement of their lives, Nicholson paused his abstract explorations to paint landscapes (which sold with far more regularity than the white-on-whites). By this point they were living in St. Ives, a setting that Nicholson would transfer to the canvas. They looked like a very happy family, busily making art and ambling along the countryside, their beaming foreheads aesthetically tying them to the alien quality of their native Stonehenge. But as life moved on, it changed, and through change there can be significant loss.

In her *Pictorial Autobiography* Hepworth narrates her life journey, her dedication to her work, the children, the constant movement of everything—until she reaches the year 1951, the year she said, "After 23 years, everything fell apart."[10] She said no more than that, then leapt into the future, marking the end of the Nicholson chapter. Even in its brevity, there's a perceptible sadness. She, who had devoted much of her life to molding things together, keeping everything in place, would experience the earth split beneath her. Around then, after Nicholson scuttled off and shortly after her first son died in a plane crash, she'd stare up at the sky and want, more than anything, to know what it was like out there in outer space, imagining what she could do if, say, she could rest her hand on the moon itself.

Ben Nicholson photographing Barbara
Hepworth's reflection in a mirror, circa 1932.
Photograph by Ben Nicholson.

JACOB
LAWRENCE
GWENDOLYN KNIGHT

NORTH AND SOUTH

JACOB LAWRENCE DIDN'T REALIZE IT AT FIRST, BUT HE WAS PART OF a historic exodus. In the early part of the twentieth century, nearly one million African-Americans, including Lawrence's parents, fled the oppressive clutches of the South in search of a better life in the North. Although his mother and father were living in Atlantic City, New Jersey, by the time Lawrence was born in 1917, he would feel the atavistic tug throughout his upbringing. As a child, the notion that life was supposed to get better when you move from one place to another was ingrained, yet for the Lawrence family it did not get better—not when they relocated to rural Pennsylvania, where his father, a cook by trade, abandoned his young wife and children, and not in Philadelphia, where his mother would be forced to put him and his siblings into the welfare system while she sought work in New York City. In fact, things did not truly begin to get better until the thirteen-year-old Lawrence arrived in Harlem in 1931, "where the death rate was twice that of the entire city of New York, where undertaking was the most profitable business."[1] It was, as Langston Hughes famously wrote, the "Harlem of honey and chocolate and caramel and rum and vinegar and lemon and lime and gall."[2] There, at the intersection of the Harlem Renaissance and the Great Depression, the transformation of the

Gwendolyn Knight and Jacob Lawrence, 1979.

'He had beautiful skin and long beautiful eyelashes that anyone would die for,' Knight recalled about the first time she saw Lawrence.

African-American community was planting its seeds. There, Lawrence's mother pushed him through the doors of the Utopia Children's Center, to keep him off the streets after school while she cleaned apartments for lousy pay.

Utopia was a refuge amidst the chaos, where Lawrence was first exposed to arts and crafts, and discovered his interest in painting. His teacher, Charles Alston, one of leading members of the Harlem Renaissance, quickly spotted talent in the quiet boy. Alston guided Lawrence through his earliest explorations of art and remained his instructor and mentor for years to come, first at Utopia, then at the 306 Workshop, a Works Project Administration

(WPA) arts center run by Alston, where Lawrence would begin to explore the history of African-Americans in his work. He immersed himself in the public library's Schomburg archives, where the accounts of slavery and the Underground Railroad were being amassed. Harriet Tubman, W. E. B. Dubois, Booker T. Washington—he learned about all of them and pieced the story together, the real story of what his parents and their parents before them had gone through. Deeply affected by these heroic narratives, Lawrence felt it was his duty to chronicle them visually, with his "expressive cubism," as he called it.

> " *In 1940, he was awarded a grant to paint his seminal* Migration of the Negro *series, a collection of sixty small panels, each depicting a frozen moment in the epic northward journey of African-Americans.* "

Gwendolyn Knight had a very different life experience. She was born in Barbados, where her native, dark-skinned mother had been crippled by a hurricane. Her father, who died when she was a child, was a white man who accepted her as his daughter without hesitation. She was from a "family of free thinkers." In 1920, when she was seven years old, upon her mother's insistence, Knight migrated with a Barbadian family to St. Louis, to be greeted by a very foreign white substance—snow. She did not remember overt racism, rather she has described her Midwestern upbringing as being enclosed in a supportive black community. When she moved to Harlem, also at the age of thirteen, unlike Lawrence, who observed the suffering, mortality, and corruption happening around him, Knight immediately felt its vibrancy, its cultural revival. It motivated her to dance and paint. She lived in a building with jazz musicians. Out front, a limo waited for Ethel Waters to emerge each day. Lawrence and Knight were living in the same neighborhood, yet they were in completely different worlds. Eventually, they would be brought together by painting in the same art studio.

"He had beautiful skin and long beautiful eyelashes that anyone would die for," Knight recalled about the first time she saw Lawrence in Alston's studio.[3] She was four years older than him, working on a WPA project under Alston, designing murals in the children's wards of hospitals, and studying with the celebrated sculptor Augusta Savage. Lawrence, at seventeen, wasn't yet old enough to join the WPA. She discovered him while he was painting his first series, *Toussaint L'Ouverture*, named after the "Black Napoleon" who led the slave revolution in Haiti. He was focused and serious, working on his

Jacob Lawrence
The Migration of the Negro, #18: The migration gained in momentum, 1941
Tempera on gesso on composition board
12″ x 18″

Although they were divided up in sixty small panels, Lawrence painted his famous *Migration of the Negro* series as though it were one painting. He would work on one image, then coat another, then add detail to another, keeping them all in process at the same time, applying his brush and tempera paint to them in a collective manner until they eventually were all complete.

> "Knight worked very differently than Lawrence. Her paintings were much lighter, less planned— representational of her sui generis upbringing."

paintings even while everyone chatted around him. This entranced Knight. Getting to know Lawrence led to an intense period of her painting a series of portraits of him—a clear sign of her enchantment.

Lawrence was accepted into the Easel Division of the Federal Art Project, a subdivision of the WPA, in 1938 and, over the next year and a half, produced two narrative series that portrayed the lives of abolitionists Frederick Douglass and Harriet Tubman. In 1940, he was awarded a grant from the Rosenwald Foundation to paint his seminal *Migration of the Negro* series, a collection of sixty small panels, each depicting a frozen moment in the epic northward journey of African-Americans. Knight put her own painting aside to help Lawrence arrange and gesso the many panels, which resulted in the first solo exhibition by an African-American at the Museum of Modern Art.

After Lawrence and Knight married in 1941, they took a year-long honeymoon in the South. Neither had ever been before. They wanted to experience both the urban *and* rural South—New Orleans and Virginia. It was the year Mardi Gras was cancelled because of World War II. The normally vivacious city felt kind of . . . dead. But it was tropical, like Barbados—and Knight felt an instant kinship. She worked very differently than Lawrence. Her paintings were much lighter, less planned—representational of her *sui generis* upbringing. "History seemed, in some ways, an impersonal project for her. She remained interested in her own spontaneous responses to things, and in the energy generated by responding to that moment."[4] In the olio that was New Orleans, she sat in parlors and painted people.

In Lenexa, Virginia—where Lawrence's mother came from—they stayed in a farm shack, shared an outhouse, and gathered their food from the fields. Lawrence stared out at the land and saw the slave ghosts of the past, the nameless silhouettes that appeared in his panels. Once a week, the old woman who lived on the property—one of his distant kin—invited the whole town over for a chicken fry. When Lawrence and Knight tried to tell them about the Harlem Renaissance, they looked at them like they were crazy. When they told them about Harriet Tubman and the Underground Railroad, the great migration, urbanization, the townspeople set their chicken down on their plates, squinted their eyes to study their faces, and asked, "Are you some kind of *communists*?"

Gwendolyn Knight
The Boudoir, 1945
Tempera on board
17 7/8" x 12"

Knight painted the people she met—often females—presenting them in their most familiar settings. She did not indulge in portraying heavy subject matter or searching for greater meaning through her subjects. In this regard she greatly differed from Lawrence, who never painted people within a spontaneous moment just for the pleasure of it.

> *The whole scenario was an anomaly—Sage's blind love, Tanguy's malevolent clownish behavior, and the uncanny parallels between their work.*

YVES
TANGUY
KAY
SAGE

SEPARATION ANXIETY

THIS STORY BEGINS WITH ANDRÉ BRETON, THE VEXATIOUS RINGLEADER of the Parisian surrealists. Being the author of the first edition of the *Surrealist Manifesto*, he liked to play judge over who qualified as a surrealist artist. When he did not approve of those who sidled into his circle, he relished in their cruel dismissal. Unfortunately for the definitively surrealist painter Kay Sage, she was married to Breton's best friend, Yves Tanguy, yet Breton refused to consider her a part of their group. According to him, surrealist female artists needed to be muse material: preferably gamine, seductive *femme-enfants*. Sage was none of those. She was middle-aged, wealthy, and confident about her art. She spoke in a "profane, tough-guy vernacular" which made Breton wince.[1] Tanguy, a first-string surrealist, jovially called Breton "Papa" and allowed him to verbally abuse his new love interest (and sugar mama) in their rooftop apartment. It was a strange triangular dynamic—Breton calling her names, Tanguy laughing, and Sage, hard as a rock, completely gooey-eyed over Tanguy.

Sage had seen Tanguy's painting *Je vous attends* (I Await You) at the 1936 International Surrealist Exhibition in London. She recognized the barren and surreal landscape depicted by Tanguy—she'd been inside it before, through her own paintbrush. Post-apocalyptic was not a popular term then—but that is

Yves Tanguy with Kay Sage (10 of 11),
Connecticut, 1947
Photograph by Irving Penn.

Kay Sage
Tomorrow is Never, 1955
Oil on canvas
37⁷/₈" x 53⁷/₈"

Painted the year Tanguy died, *Tomorrow is Never* depicts Sage's signature monolithic structures, which appear to emerge, unfinished, from a forgotten wasteland. The year she painted this, she wrote, "I have said all I have to say. All there is to do now is scream."

[pages 72–73]

Yves Tanguy
Multiplication of the Arcs, 1954
Oil on canvas
40" x 60"

The last painting Tanguy completed before his death turned out to be his masterpiece. Accounts of his behavior at the time recall a man who worked at a rapid and constant pace (which contrasted his usual manner of allowing passionate conversations to distract him during a day of painting). It was as though he knew his time was limited and that *Multiplication of the Arcs* would encapsulate his lifelong career.

what it was—very life after death. Twenty years later, after Tanguy passed away, Sage realized the "you" he was awaiting was and had always been her. Although it was painted before they met, Tanguy had, through his knack for "psychic automatism,"[2] tapped into a dreamscape that melded his childhood on the rocky Brittany coast of France with the future isolation that followed death, a place that only Sage would be drawn to. The closest they came to experiencing an environment that physically resembled that dreamscape during their lifetime happened to be their wedding day in Reno, Nevada, in 1940.

> "*Sage recognized the barren and surreal landscape depicted by Tanguy—she'd been inside it before, through her own paintbrush.*"

Once married, they moved to a pleasant farmhouse with a pond in Woodbury, Connecticut, which Sage bought with solitude in mind. This isolated bubble was popped by Papa Breton when he paid them a rueful visit and laughed at their new setting. His bitterness towards Sage intensified based on her generous efforts to transport the surrealists to America during the height of World War II. *How dare she?* Breton "never missed an opportunity to denigrate her to Yves."[3] This weighed on Tanguy, giving him rein to ridicule her in front of his friends. A majority of the surrealists disliked her precisely because she was a strange robot with expendable income, programmed to unconditionally please Tanguy. The whole scenario was an anomaly—her blind love, his malevolent clownish behavior, and the uncanny parallels between their work.

Up until she met Tanguy, Sage had recorded all of her thoughts and experiences in a journal—a process of documentation. After they met, this stopped—almost as though she had stopped seeing or noticing life happening. The fragility of eyes, sight, and perception was an obsession amongst surrealists (read George Bataille's *Story of the Eye*, watch Salvador Dalí's *Un Chien Andalou*). In that regard, she was, through and through, a surrealist. So much so that one of the leading father figures of the movement (Breton) had a bit of an Electra complex with her.

All of it goes to say, her love for Tanguy was alarmingly maternal. His reaction was childlike, a brand of disrespect that sons have towards their mothers when they realize they've been allowed to go too far with them. Perhaps he started to catch on to that, because when asked later in his life what he thought when he first saw her work in a Parisian salon in 1938, he answered, "Kay Sage—man or woman? I didn't know. I just knew the paintings were very good."[4]

Despite their foundation of mutual artistic respect and an eerily similar

Yves Tanguy
Je vous attends (I Await You), 1934
Oil on canvas
28 1/2" x 45"

I Await You was Sage's introduction to Tanguy's work. It represented the quintessential surrealist landscape, which tended to be environments that appeared completely uninhabitable. Tanguy, a self-taught painter, became captivated by the ideas that defined surrealism while reading the poet Jacques Prévert during his military service in Lunéville.

Kay Sage
Le Passage, 1956
Oil on canvas
36" x 28"

This painting offers the rare instance of Sage including the figurative in her work. *Le Passage* has been referred to as a self-portrait, perhaps of a more youthful Sage contemplating the emptiness the future held in store for her. It is one of the last paintings she made before going completely blind and, consequently, committing suicide.

" *Sage's ashes were scattered along the Brittany coast, to join Tanguy's, which had long been washed out with the tides.* "

aesthetic, they never felt compelled to collaborate, or even share walls in an exhibition space. They were both adamant about being divided in that realm. They especially didn't like being referred to as "a team."[5] Tanguy needed his autonomy and Sage needed Tanguy. This structure collapsed when Tanguy died unexpectedly of a cerebral hemorrhage in 1955 (one year after completing his masterpiece, *Multiplication of the Arcs*). At first, Sage's survival of this tragedy was dependent on her ability to paint. But when the cataracts in her eyes took over, a failed surgery left her almost completely blind, and painting became pointless—life ended as far as she understood it. In 1963 she shot herself in the heart, successfully killing herself after a failed suicide attempt four years earlier. The note she left read, "The first painting by Yves that I saw, before I knew him, was called *I'm Waiting for You*. I've come. Now he's waiting for me again—I'm on my way."[6] Her ashes were scattered along the Brittany coast, to join Tanguy's ashes, which had long been washed out with the tides. It was all a part of his vision that *suffering softened stones*.[7]

Elaine was the most bewitching member of the art world's 'boys club' de Kooning so revered— and she inspired him to take his art into the one domain he had completely failed at: women."

WILLEM & ELAINE
DE KOONING

A WOMAN IS A WOMAN IS A WOMAN

ELAINE DE KOONING WAS NOT THE POSTCARD-PERFECT AMERICAN wife. No bouncy skirt or blinding white smile. No comforting pot roast waiting in the oven at dinnertime. Cigarette in one hand, paintbrush in the other. She drank like a sailor and outwitted most of the men around her in the New York art scene. Everyone was in love with the "pure lily maid of Brooklyn" who was destined to become the wife of an abstract master. Prior to meeting her, Willem de Kooning did not view romantic relationships as wife auditions. He was dating a circus performer and a modern dancer at the same time, occasionally convincing them to co-exist as a threesome. He enjoyed their company, but even when madly in love, found women completely befuddling. Besides his commitment anxiety, he struggled when trying to capture their spirits on canvas (he ripped up all his portraits of women in the early days). De Kooning joked about their role in his life, once saying, "You have to take them home at 3 A.M. Then you lose a day of work. And you are left with lipstick-stained cigarette butts in ashtrays."[1] But when Elaine Fried floated into his stark Chelsea apartment with a few friends, she completely floored him. She was the most bewitching member of the art world's "boys

Elaine and Willem de Kooning, 1953.
Photograph by Hans Namuth.

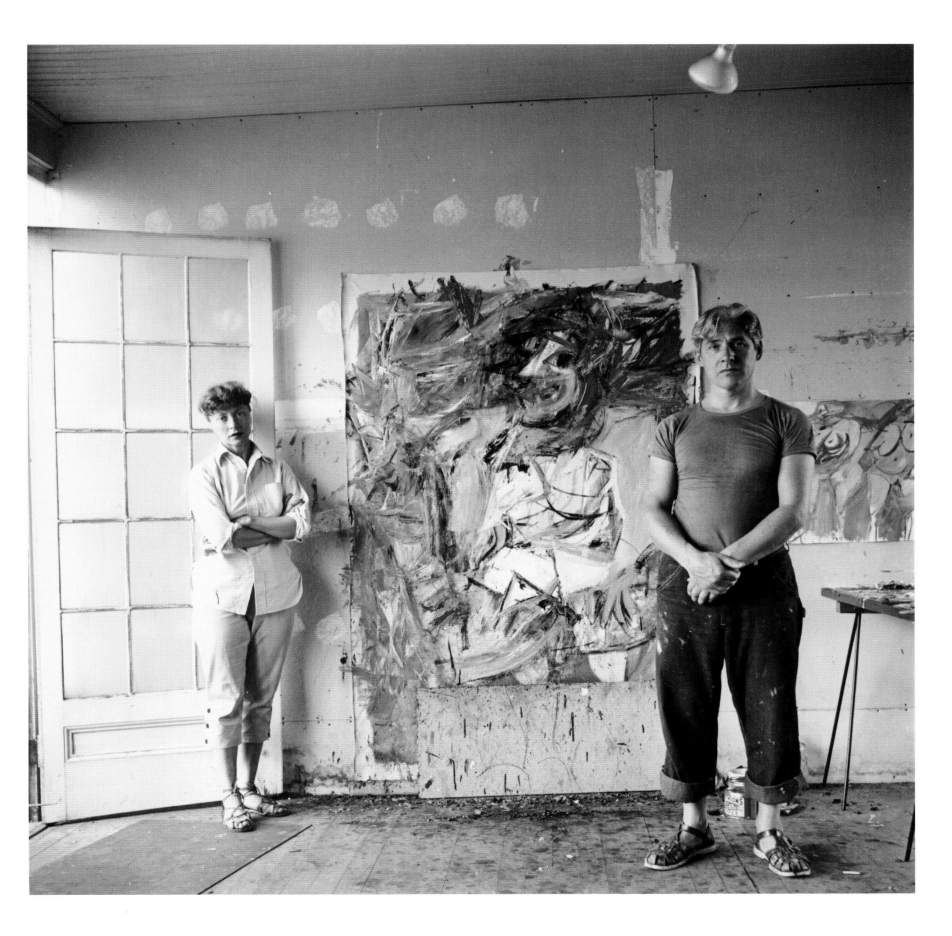

club" he so revered—and she inspired him to take his art into the one domain he had completely failed at: women.

When they met, de Kooning was focusing on his abstract portraits of men, inspired by the brotherhood he formed in New York after migrating from Rotterdam. The sailors, fellow coworkers, and artist confreres had applauded and pushed him along as a painter. Despite their undeniably positive positions in his life, homages such as *Self-Portrait with an Imaginary Brother* demonstrated his irrepressible suspicion of people he became close to. Even a new brother had to be given the highlighted distinction of being "imaginary." De Kooning's constant uncertainty infused him with the self-conscious quality that would define his art. When he spoke at the Museum of Modern Art, he repeatedly referred to his motives as "desperate" and process as "trembling."[3] He said, "One is utterly lost in space forever. You can float in it, fly in it, suspend in it, and today, it seems, to tremble in it is maybe the best. . . . The idea of being integrated with it is a desperate idea."

> " *Elaine was focused on her socializing, art writing, and portraits of athletic, rich, and/or powerful men—which, yes, included the occasional portrait of her own husband.* "

Besides being an artist, Elaine possessed a solid critical eye (she became a regular art writer for *Art News*). She identified de Kooning's exasperation in painting the female form to be a significant stumbling block. As Freud suggested, "The origin of the creative impulse lies in frustration, a sense that reality is impervious to desire."[4] Besides her ability to intellectualize the positive aspects of the quandary, she was aware of her own power over him, how crazy he was about her. She sat for him for hours so he could paint her—first with a priority for technical perfection and then with added chaos. "In his dusky gray paintings of men, there had been a subdued, immanent rose. Now a blushy tint—perhaps the reflection of Elaine's hair as well as body—became bolder and more fleshy. Soon powerful erupting pink would belong to de Kooning the way a certain blue belonged to Matisse."[5]

There was no grand celebration when they married in 1943—just City Hall, cocktails at a nearby bar, and then returning to the studio to work. Elaine was a no-frills bohemian bride, but she was a bit disappointed by the anticlimactic nature of her wedding day. "Bleak," she described it, "but amusing."[6] In time she started to feel trapped with him at the studio despite the fact that he had

Elaine de Kooning
Portrait of Willem de Kooning
Oil on panel
38 7/8" x 25 1/2"

Elaine was known for her individual portraits of men. They were painted to capture their personality and aura, along with presenting them as sexual subjects. In her most well-known portrait of de Kooning, the abstract expressionist master's face is nothing other than the smudged absence of expression. Faceless men were a trademark of her style, which she referred to as her "gyroscope men." In response to questions regarding her uniquely bold representation of men, she said, "Women painted women: Vigée-Le Brun, Mary Cassatt, and so forth. And I thought, men always painted the opposite sex, and I wanted to paint men as sex objects."[2]

designed it to be "the most beautiful house in the world" with a bedroom painted soft pink especially for her.[7]

Being extremely social made it easy for Elaine to escape him on a nightly basis. In the company of all their friends, she raved about de Kooning's genius and acted as if she knew what he was doing every minute of the day. By the same token, when a handsome man invited her to spend a month sailing, she fluttered off on the adventure, assuring Bill it was platonic. He brushed it aside and continued to paint. When Elaine returned from her sailing trip, they were evicted from their studio and had to share an extremely small apartment on Carmine Street. Whenever he sold a painting, Elaine spent the proceeds on fashionable clothes, never letting the reality of her poverty show when walking Manhattan streets. Elaine acted completely oblivious to de Kooning's desire for children or, at least, home cooking. She was focused on her socializing, art writing, and portraits of athletic, rich, and/or powerful men—which, yes, included the occasional portrait of her own husband. When he went so far as to ask for wife-y behavior, she'd laugh in his face—which led to one of their favorite shared expressions: "Vat ve need is a vife."

The acclaimed and controversial *Woman* series was created when his marriage to Elaine was at the end of its rope. As though they were ripping through the canvas from behind, more and more women emerged in de Kooning's heavy impasto abstractions. Hypnotized by advertisements of "ideal" women, de Kooning cut and pasted the bleached smiles out of magazines onto his canvases. Each portrait became increasingly violent, as their wild eyes grew larger and breasts popped. The vision of a beautiful woman was overpowered by her teeth, the frenetic energy that surrounded her, and the confrontational posture, coming right at you from the canvas. When *Woman I*—a painting he devoted an excruciating amount of time to, adding layer after layer—was lionized upon its completion in 1952, de Kooning had lifted the spell that kept him trapped in a constant tension with his abstract version of the figurative. It was not just about Elaine, or his unpredictable Dutch mother, but "about a relationship, suggesting two figures locked in a struggle . . . the artist present in the slashing and furious brushstroke."[8] Elaine offered to pose standing next to it, appearing relaxed with a cigarette in hand. She was always in step with whatever attention her husband received, acting

Willem de Kooning
Woman I, 1950–52
Oil on canvas
6′3″ × 4′10″

The most iconic of all his "women," *Woman I* was considered, by some, to be a betrayal of his role as an abstract artist due to its figurative nature. In response, de Kooning famously said, "Flesh was the reason oil paint was invented." The painting would have remained unfinished and abandoned, however, if it hadn't been for a studio visit paid by the art historian Meyer Shapiro. He focused his attention on *Woman I*, inspiring de Kooning to drag it out of its hiding place in his studio and complete what would become known as one of the most disturbing and important paintings to emerge from the postwar period.

like everything he did was an inside joke between them. She shrugged off the subject matter like it was yesterday's news: "A woman is a woman is woman."

In 1969, after de Kooning had a daughter with another lover, Joan Ward, and after both he and Elaine suffered through individual battles with alcoholism, a drawn out separation, and not seeing one another for years at a time, they were still husband and wife. And there came a point—even while he was enamored with his perfect (married) woman, the Egyptian beauty Emilie Kilgore—that de Kooning needed his wife to take care of him. Elaine first returned to his life geographically, settling into a house of her own in East Hampton. She was enrolled in Alcoholics Anonymous and convinced de Kooning to try it himself. No luck—as he found the confessional storytelling to be monotonous and uninspiring. He recognized his addiction to be the largest mire of his life, but liked to metaphorically whip his own back to try stopping. Despite efforts, he'd always end up back on his bike, an old man with a sweet smile, en route to buy beer at the country store.

> "*After de Kooning had a daughter with another lover, and after both he and Elaine had suffered through individual battles with alcoholism, and not seeing one another for years at a time, they were still husband and wife.*"

As he grew older, falling deeper into the deterioration of dementia, Elaine tried to cover up his illness in social situations. When people stopped by and witnessed him speaking nonsense, she laughed out loud, in her classic way of making it seem like it was all a bit of comedy that she was privy to. While trying to take care of him in 1989 (from down the road, with a fixed view of his will), she died of emphysema—departing eight years before de Kooning, who lived on, against all odds, to the age of ninety-two.

The greatest moment in her career, when she had been commissioned to paint portraits of President John F. Kennedy in 1962, slipped silently into the shadows of de Kooning's *Woman I*.

Elaine and Willem de Kooning, circa 1980s.
Photograph by Hans Namuth.

CHARLES & RAY
EAMES

PROBLEM SOLVERS

> *Eames's marriage proposal arrived in the mail, on Cranbrook letterhead, stating:* Dear Miss Kaiser, I am 34 (almost), single (again) and broke. I love you very much and would like to marry you very soon.

EVERY SINGLE THING, DOWN TO THE TINIEST FLECK OF DUST, MATTERED. Every card in a deck. Every petal on every flower of every bouquet. Every single thought that came out of every head within a contained creative space. It wasn't about all of those free-floating components needing to be perfect, but about recognizing that they all contributed to a shifting balance—which sometimes approached perfection. To sit in a room controlled, or rather, overseen, by Charles and Ray Eames was, essentially, to sit inside their jointly connected brains. Their shared consciousness of scale endowed them with the ability to imagine a particular intersection within time and space from, say, the perspective of an insect, or an asteroid drifting in outer space, or an amorous gaze across a candlelit table. The Eameses were portals into a sort of wholeness that could be found through the powerful hum of singular objects.

In 1940, Charles Eames was working on his first award-winning chair design at the Cranbrook Academy in Bloomfield Hills, Michigan, with the architect Eero Saarinen (who had discovered Eames in the *Architectural Digest* spread on St. Mary's Church in Helena, Arkansas, which featured his first mass chair design in the form of small-town pews). As he rounded this significant corner in his career, he met a wide-eyed student, Ray Kaiser, who was, for a short time following their encounter, always found by his side, huddling over drawings or analyzing a ceramic structure. She never really seemed to be flirting with him, per se—just showing enthusiasm for whatever he was working on, and offering suggestions that he, the professor, hadn't considered yet. Ray had just moved to Detroit from New York City, where she had studied under the painter Hans Hofmann for six years. (It was, incidentally, in Hofmann's studio that she met fellow painter Lee Krasner, who would remain one of her closest friends for life.)

Ray's nickname during that period was "Buddha." The letters she sent to her ailing mother in Florida described Orson Welles's broadcasts, dance classes in Martha Graham's studio, and her frequent purchases of unnecessary vintage spoons and ramekins (which would follow her wherever she moved).

Charles and Ray Eames at their home in the Pacific Palisades, circa 1970s.

Ray Eames
To Hofmann, Love Buddha, 1940
Painting with pen, paper, and tissue paper
6³/₈″ x 11″

Ray had trained as a painter under Hans Hofmann in New York for six years before she transitioned into design. During this time, her nickname was Buddha. When an interviewer asked her forty years later how it felt to give up painting, she answered, "I never gave up painting; I just changed my palette."

By the time she applied to Cranbrook, she was done with New York. Done, as in frustrated. Though she loved painting, she did not love the hyper-criticism that surrounded the art scene at the time. She particularly did not appreciate one viewer's implication that she was merely ripping off Miró. As her writer grandson explained it, "Ray was not copying Miró but turned out to have taken a journey that produced similar results."[1]

Shortly after she fell in love with Eames, Ray found herself back in New York, keeping her distance, probably frozen with fear that she was getting involved with a dashing, albeit married, designer with a young daughter. As he made haste to get a divorce (one that had been in the works for years before he met Ray) their relationship developed through letters—in which they started planning to move to Los Angeles together. There was no security of a stable life in California—no sense of where to live or how. But it made complete sense— partially for that reason. For a couple for whom evidence of their romantic beginnings is scant, it was a wildly romantic move to consider. Eames's marriage proposal arrived in the mail, on Cranbrook letterhead, stating: *Dear Miss Kaiser, I am 34 (almost), single (again) and broke. I love you very much and would like to marry you very soon. I cannot promise to support us very well but given the chance will shure* [sic] *in hell try.*

On July 5, 1941, Ray and Charles moved into the Highland Hotel in Hollywood. John Entenza, editor of *Arts & Architecture* magazine and the

sponsor of the Case Study Houses project, recommended them to the parents of the Austrian architect Richard Neutra, as they owned a low-rent apartment, at the top of a 65-stair walkup, in his newly designed building. Once the newlyweds moved in they got right to work with their homemade plywood-molding machine, which they named *Kazam!*. At night they drank wine out of chemistry beakers and tested their pet machine with wood from the movie sets Eames worked on. Through this process, they created their first mass-produced design—a leg splint for injured men on the World War II battlefield. When the U.S. military ordered 5,000 of them, they realized they needed a larger space.

In 1943 they found a shabby, rodent-overrun warehouse at 901 Washington Boulevard in Venice, one of Los Angeles's beach communities, where they established their creative nexus. The Eames Studio was a universe onto itself, filled with toys, chairs (at one point a fiberglass rocking chair), splints, archery experiments, model train sets, wood-chip bouquets. It was there where they created the LCW (Lounge Chair Wood)—termed the "Best Design of the Twentieth Century" by *Time* magazine in 1999—which resulted in MoMA exhibiting Eames's "organic furniture" in 1946 (although they called it *The Furniture of*

Ray Eames
Room installation design for "*An Exhibition for Modern Living*," 1949
Collage

Ray and Charles designed this room for Alexander Girard's *An Exhibition of Modern Living*, which was commissioned by the Detroit Institute of Art in 1949. Ray drew this design to include the ideal arrangement of their signature pieces, including her totem sculpture on the right, and their molded plywood chairs and storage units.

Charles Eames, leaving Ray out of the equation). Despite Charles' distaste for being known as a "chair designer," he also felt uncomfortable with being called an artist. So what were they? "Problem-solvers."[2]

Perhaps their greatest work (partially measured by the greatest use of a collaborative artwork) was the Eames House, which the couple started to construct in 1945. First known as *Case Study #8*, it began as a challenge presented by *Arts & Architecture* magazine to world-renowned architects to design homes that would suggest the ideal postwar American digs. In consideration of the magazine's primary audience, Charles and Ray worked on a house that would suit the hypothetical older upper-middle class couple who had just pushed their birds out of the nest. This was not an unusual task, as they were masters of adapting their ideas and aesthetic to meet a client's request. The quintessential example of this was their 1959 film *Glimpses of the USA*, a military-sponsored multiscreen film presented in Moscow as part of the American Exhibition as a way to one-up the American position in the Cold War pissing contest. That said, when they agreed to take on the challenge, they made it clear that the military would not be able to view the film before the Moscow screening—a scenario which would never happen today. The result was an

Charles and Ray Eames
Eames House
Pacific Palisades, California

Located on a dramatic bluff between Malibu and Santa Monica, the *Eames House* has been meticulously preserved as museum, existing just as it was when Charles and Ray lived and worked within its prefabricated walls. It maintains the arrangement of objects that allowed the Eameses to dwell in perfect aesthetic balance. The Hans Hofmann paintings still hang from the ceiling alongside the famous tumbleweed they had used as a decoration in their first Los Angeles apartment. Every ladder step and candlestick contributed to their nest, the exterior of which appears like a gargantuan Mondrian painting peeking out through the surrounding eucalyptus trees. Exterior photograph by Tim Street Porter.

> *Perhaps their greatest work (partially measured by the greatest use of a collaborative artwork) was the Eames House, which the couple started to construct in 1945.*

attempt to bridge gaps, rather than build more walls. It began with the voiceover, "The same stars that shine down on Russia shine down on the United States."

The Eameses were storytellers who specialized in assigned settings. For *Case Study #8* they were given the opportunity to choose that setting—and, as a result, they became the story's ending. The Eameses fell in love with the land they based their project on. They returned there again and again to picnic on the meadow that overlooked the Pacific, while waiting for the arrival of the war-recycled steel they'd use to build the frame for *Case Study #8*—which would be assembled in less than two days. In that time they established it as theirs. All the building materials were prefabricated and bought off the shelves. It was not the postwar American home one imagines—a triangle sitting upon a square at the end of a cul-de-sac. It consisted of two boxes of glass—one for work and one for living—joined by a bridge. "Evenings it is like a little jewel, set behind the row of trees dropped to black by the end of the gloaming. Later still, when the traffic fades enough to reveal the sounds of the sea, you begin to hear the crash

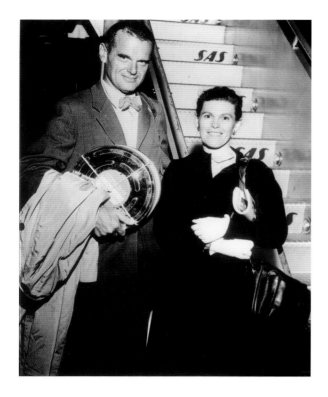

Charles and Ray Eames boarding a plane for the American National Exhibition in Moscow, 1959.

Charles and Ray Eames
Production art from *Powers of Ten:
A Film Dealing with the Relative Size of
Things in the Universe, and the Effect
of Adding Another Zero*, 1977
Documentary short film, 9 minutes

Powers of Ten is a film that seeks to explore and reveal the impact of scale, a constant concern for the Eameses throughout their career. Of the dozens of films Charles and Ray made, it is their most well known and critically successful. From designers to filmmakers, the Eameses approached every creative challenge with equal intensity. Curator Donald Albrecht perfectly summarized the enormous scope of their creative achievements when he stated: "Charles and Ray Eames started by designing a simple molded-plywood chair, and they ended by tackling the challenge of explaining the nature of the universe."[3]

of waves and it startles you the first time each night. And every once in a while, in a certain season, the mist makes it so you can't see one end of the house from the other."[4]

The endless energy that fueled the Eameses' work life did not always flow over into their married life. Where Charles was the dimpled Californian designer in sunglasses and bandanas loosely tied around his neck, Ray was a "delicious dumpling in a doll's dress" who always wore her hair up in a bow.[5] And as shattering as it may have been for him to see her pained by his affairs with different women, he wasn't going to turn down the constant accessibility to amorous stimulation from others. Women were simply crazy about him.

Charles and Ray were, in many ways, an oddly matched pair. Yet their mutual affection and confidence in one another's talents were transparent to all who entered their protected circle. At their dinner parties, when Ray served visual desserts like bouquets of flowers, Charles feasted his eyes on her arrangements and then glanced at her with genuine admiration. She held everything together and he knew it. And because *she* knew it, whatever cracks there may have been in their romantic foundation, it continued to support the towering structure of the life they had built together.

Though they are probably best known for their chairs, the Eameses made 125 films together. It was their way to explore "the uncommon beauty of common things."[6] Together they could make sudsy water flowing over a parking lot look like the Northern Lights. The office was constantly situated for filmmaking projects—some of which were educational, most of which seemed to delight in their fascination with a certain object or experience at a given time. "*Powers of Ten* is a recapitulation of the Eameses' work, process, and philosophy without being a repetition of it. The 1977 movie was really a punctuation mark on an extremely long journey of thinking about scale."[7]

The film opens with a couple having a picnic near Lake Michigan, the man laying back to rest, facing the sky for an afternoon nap. From there the camera—in a single eight-minute-long shot—pulls back from above them, zooming out continuously until it has reached the farthest reaches of the universe. And then it boomerangs back to the picnic spot, and zooms into the man's hand until it reaches a tiny quark within a single human cell. *Powers of Ten* was their last major project together.

A year later, Charles passed away. When Ray was on her deathbed a decade later, she would ask a close friend every time she visited, "What day is it?" until the date arrived that marked the ten-year anniversary of Charles' death. On that day, Buddha was ready to go, "symbolizing them becoming one."[8]

LEE
KRASNER &
JACKSON POLLOCK

> "*As a partner, Krasner played the part of Pollock's personal Dian Fossey. When people asked him questions, as they often did, she'd volunteer the answers his silence left unsatisfied.*"

Lee Krasner and Jackson Pollock at their home in The Springs, New York, circa 1946. Photograph by Ronald Stein.

WHAT BEAST MUST ONE ADORE?

JACKSON POLLOCK ROLLS IN HIS GRAVE WHENEVER ONE OF HIS enthusiasts claims that his early, pre-abstract-expressionist paintings reveal the early markings of a genius. He was not a genius, so to speak, until 1939, when the twenty-seven-year old embraced his uroboric identity (*uroboros* being an ancient symbol depicting a serpent swallowing its own tail and thus forming a circle) through Jungian psychoanalysis. It was a byproduct of going to therapy to treat his severe alcoholism—something that had held him back his entire career. Then again, perhaps he would have never become a great artist if he hadn't been a drunk. His talent and his addiction ran on parallel tracks derived from the memories of his tumultuous childhood and tyrannical mother. Psychoanalysis positioned this troubled historical source as an altar in his life, a place he could go back to again and again. It whet his appetite to add intellectual and spiritual weight to his painting and, as a result, he became the eager pet of a cerebral Russian-American blood fetishist and art collector, John Graham. Pollock's vital mentor, who was "the kind of European scoundrel that transplant[ed] so well in American soil, being as pragmatic as he was magnetic and all but omniscient on the subjects of art and culture"[1] would give him his first major exhibition, sharing walls with Matisse and Picasso in 1942. This ego coddling fueled Pollock's passive-aggressive predatory ambition to achieve master painter status in the post-war American art scene.

As Pollock delved into the collective unconscious, he fell out of sync with the nation's collective consciousness (patriotism). After the bombing of Pearl Harbor, military enlistment was not a matter of question or hesitation— but Pollock did not want to trade his paintbrush for a gun. He begged his psychoanalyst, Dr. Violet de Laszlo, to write an official statement claiming his insanity. With his 4-F status established and the liquidation of the artist

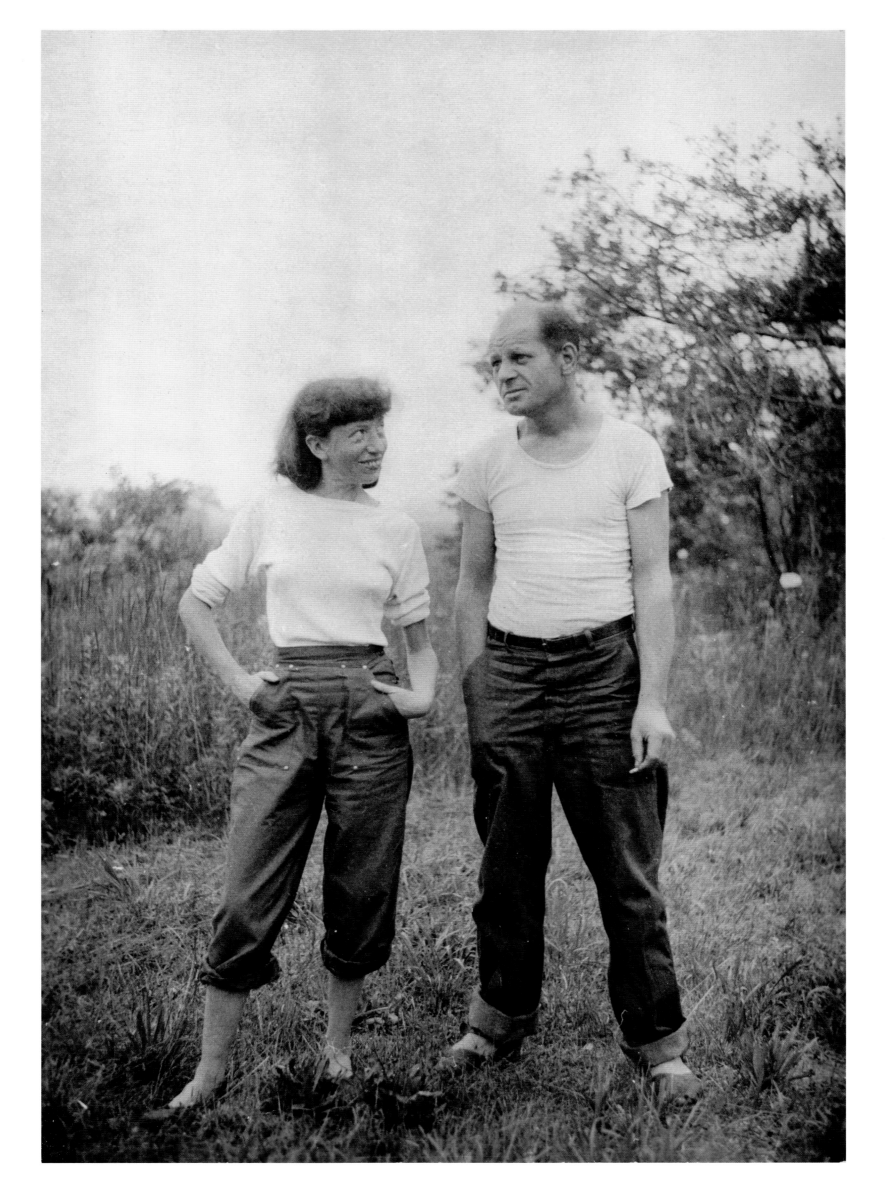

community, Pollock became an appealing candidate to fill the New Deal's desired quota for working artists. Hence the reason he was in his New York studio when Lee Krasner paid him a "spontaneous" visit in 1942. It was the way New York artists met back then and Krasner was especially vigilant about knocking on artists' doors and introducing herself as a fellow artist, and not just some *dame*. ("There were the artists and then there were the 'dames,'" Krasner once said about this time in the art world. "I was considered a 'dame' even if I was a painter too.")[2]

The Krasner-Pollock love story is wrought with romanticized half-truths, the beginning especially. First myth: spontaneous visit. The truth is, the day Krasner bounded up the stairs of Pollock's East Village building to boldly introduce herself, happened to be the first time Pollock actually *remembered* meeting her. They had danced together at an Artists Union party prior to that, but Pollock had been blacked-out drunk. This esteemed neighborly visit was the first occasion in which they had a real conversation, one for the books. Second myth: she did not fall in love with the artist before she fell in love with the man. They were both going to be featured as the "unknown Americans" in the Euro-heavy John Graham exhibition, and Krasner, always the networker, was shocked that she had not been properly acquainted with Pollock. Everyone was abuzz about him and she saw him, more than anything, as competition. As he shyly showed her around his studio, she started feeling oddly maternal towards him. He mumbled, where she spoke loudly. He was responsive to her strong, female character. "Why don't you have any books? You don't read?" she outright asked him. When he showed her his closet and drawers filled with books, she exclaimed, "Well, Jackson, this is mad! Why have you got these books pushed away and locked up?" He replied, "Look, when someone comes into my place, I don't want them to just take a look and know what I'm about."[3] As for his art—he was not her competition. She'd be the first to admit that he was her superior. From that moment on, Krasner asked everyone around her, "Have you seen Pollock's work?" as though it was some beautiful apocalyptic storm cloud sweeping into the city.

In 1942 the wealthy art patroness Peggy Guggenheim opened the *Spring Salon for Young Artists* to place a moratorium on European-influence and exalt the young American spirit. When she was asked to consider Pollock she naively waived his work aside (wasn't he a custodian in her uncle's museum?) but the ol' boys club—Piet Mondrian, James Johnson Sweeney, et al.—exclaimed, "Woman, open your eyes!" Besides the fact that his paintings made everyone tremble, he was the perfect character to represent the no-bullshit cowboy artist America needed at the time. Not having much of a mind of her own in art matters, she acquiesced—and shortly after became his steady patron. Krasner welcomed the

Jackson Pollock
Male and Female, 1942–43
Oil on canvas
6'1 1/4" x 4'

Male and Female was included in Pollock's first solo exhibition, *Art of This Century* at Peggy Guggenheim's gallery on November 9, 1943. His Jungian-influenced exploration of the female was highlighted in several paintings shown in this landmark exhibition, including *Male and Female in Search of a Symbol*, *The She-Wolf*, and *The Moon Woman*.

attention from Guggenheim, but she was also insulted by Guggenheim's overt dismissal of her. In Guggenheim's eyes, Krasner was Pollock's ball-and-chain, someone she had to talk through to get to Pollock.

To mark the shift in his life caused by Krasner moving into his apartment in 1943, Pollock painted *Male and Female*. He embraced her nurturing role in his life but also needed to distinguish that which he believed separated them—male as intellectual, female as sensual. Almost childlike in its depiction, the math equations were drawn on the male's straight-lined all-black figure, while the female was given colorful curves and cartoonish eyelashes. The art world admiringly referred to him as "primitive" based on his command of

symbolic and nonverbal expression. As a partner, Krasner played the part of his personal Dian Fossey. When people asked him questions, as they often did, she'd volunteer the answers his silence left unsatisfied. *Jackson feels this, he doesn't want that.* Whenever Pollock burst into violence mode, she could transport herself to the countryside of her mind and calm him down. And when that fictional space became crowded, she physically transported their lives to the Long Island countryside, where there was enough fresh air and empty time to be a brilliant artist from the inside of a barn.

> "*She started with a series of small canvases and allowed them to grow into a larger network called the* Little Images—*they were drips, but unlike Pollock's, they were 'controlled' drips.*"

After they married in a small church ceremony in 1945, they moved to The Springs, near East Hampton, in the midst of a dramatic winter. Finally having made her dream a reality, Krasner was cooped up with Pollock in a freezing old house stuffed to the brim with forgotten objects. Pollock would chain smoke by the stove while Krasner made the house a proper home. For a while, they had no car, no interest in stepping outside, no room to paint—just one another's body warmth. Nesting with Pollock out in the middle of nowhere allowed her to keep him under control—except when they received impulsive city visitors, whom she often turned away. Krasner cleared out an upstairs bedroom to create a studio for herself, where she was able to reverse her creative paralysis. She started with a series of small canvases and allowed them to grow into a larger network called the *Little Images*. Similar to Pollock's, it was a gravitational way of releasing emotion—they were drips, but unlike his, they were "controlled" drips.[4]

When spring started to thaw their encapsulated farmhouse existence, Pollock became, for a time, an ideal artist husband. He took long walks to explore the creek, coming back in time for dinner. His studio took over a barn on the other side of the lawn that was closed off from outside view (to avoid distractions) where he conducted the most productive four years of his life. The first of a long line of drip paintings emerged from this barn—and sold like crazy, soon defining American art. The biography *An American Saga*—which is notorious for claiming Pollock was gay—ironically credited Krasner for this stretch of painterly bliss: "Surely Lee's lavish support brought a degree of psychological stability and sexual fulfillment that made it possible for him to concentrate on work."[5]

Lee Krasner
Untitled, 1949
Oil on composition board
48" x 37"

Krasner's "little image" paintings experimented with the coded nature of language. In this work, the largest of the series, she pulled from her childhood immersion in Hebrew, which she had forgotten as an adult. She sometimes referred to the "little images," her tightly controlled sacred carvings, as "hieroglyphs." She began this series shortly after Pollock made his first loose action paintings on the floor of his barn studio.

> **❝** *The only one really
> left at his side who
> understood him was his
> wife, his second mother,
> his inexhaustible agent.* **❞**

Jackson Pollock and Lee Krasner in Pollock's
studio in The Springs, New York, 1950.
Photograph by Hans Namuth.

Jackson Pollock
Undulating Paths, 1947
Oil on canvas

While Krasner's work grew tighter and
more controlled in the late 1940s, Pollock
embarked on a series of huge untamed
canvases that became known as his drip
paintings. "Abstract painting is abstract,"
the painter once said about his work. "It
confronts you. There was a reviewer a while
back who wrote that my pictures didn't
have any beginning or any end. He didn't
mean it as a compliment, but it was. It was
fine compliment. Only he didn't know it."**⁶**

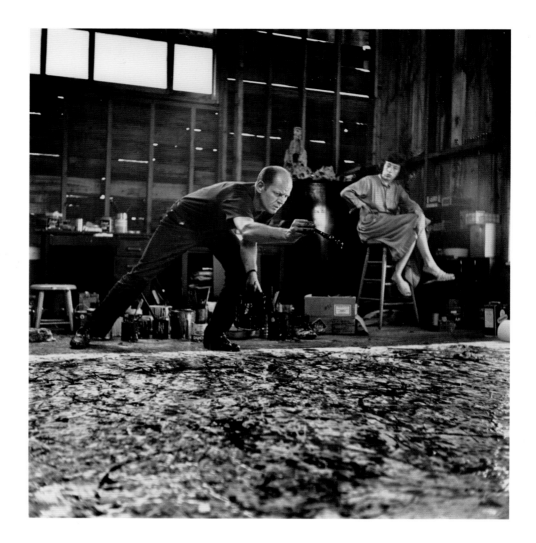

Pollock, always the human cyclone, scared all his comrades away. The
abstract expressionists were a tipsy bunch, but his intoxicated theatrics
interrupted their theoretical rants too often to invite him to parties anymore.
They appreciated the iconic Pollock frozen in the 1949 *LIFE* photographs,
featuring him arched over, throwing paint on the floor-pinned canvas as
though he were pulling an arrow out of a mythical beast (the article's head-
line was "Jackson Pollock: Is He the Greatest Living Painter in the United
States?"). As they cautiously backed away, his shadow grew larger in the
nation's spotlight, blinding him, blurring whatever clarity he may have had.
It was all left to sensation, making him feel more like a sell-out than an
artist. The only one really left at his side who understood him was his wife,
his second mother, his inexhaustible agent.

When Ruth Kligman, an Elizabeth Taylor–esque art world "star fucker"
fixed herself in front of Pollock, he didn't hesitate to pounce.[7] He tried to see
how far he could take their affair without upsetting Krasner—but his drunken-
ness didn't permit much in the way of discretion. Krasner's inner rage became
unleashed, but she was intelligent enough not to waste it screaming at the
barn where Jackson and Ruth romped the nights away. She unfurled it onto

her own canvas. *Prophecy*, the last painting she worked on while Pollock was still alive, was made by first collaging shreds of paintings that he had given up on (something she had done numerous times). After sewing the shattered corpse back together, she coated it in a thick layer of black paint, a reference to her own tendency to "black out" as an artist; once fully dry, she scraped away at it, creating breathing holes in the field of black incrustation. Only *then* would she be able to add her hand to paint violent abstractions of sexual body parts. *Prophecy* was different than the other versions of this process because she incorporated an ominous eye in the composition. When she invited Pollock up to her bedroom to comment on her painting, he said, "It's just fine. . . . But if I were you, I'd take the eye out."[8] She decided to reflect upon that potential deletion while traveling around Europe *alone*, giving Pollock a chance to see what it was like to live without her around to clean up his messes.

> *Following Pollock's death, Krasner fell into long bouts of depression and insomnia. Though she continued to make art, she never fully stepped out of the shadow of her husband's genius.*

In her absence, he drank heavily and crashed his convertible into a tree, killing himself and Kligman's friend. Kligman miraculously survived the accident, a stroke of fortune she took advantage of by writing a last-days-of-Pollock tell-all entitled *Love Affair* and striking up an affair with Willem de Kooning, Pollock's chief rival.[9] When Krasner returned to The Springs after Pollock's death, she found *Prophecy*, which she had left "staring out from her easel," now turned around "facing the wall."[10]

Following Pollock's death, Krasner fell into long bouts of depression and insomnia. Though she continued to make art, producing works that have been deemed her most successful by many critics, and even receiving her first full solo retrospective in 1983 (less than a year before her death) at the Houston Museum of Fine Arts, she never fully stepped out of the shadow of her husband's genius. In her pre-Pollock days, Krasner used to write bits of inspiration on the wall of her studio. The poet Arthur Rimbaud's "Season in Hell" was among them: "To whom should I hire myself out? / What beast must one adore? / What holy image attack? / What hearts must I break? / *What lie must I maintain?* / In what blood must I walk?"[11] Observing this, it is difficult to view Krasner as the victim of unfortunate circumstance. She seems to have known she was trading in happiness for real, wide-scale recognition. Yet justly or not, she is still most frequently remembered as the wife and widow of Jackson Pollock.

Lee Krasner
Prophecy, 1956
Oil on cotton duck
58 1/8" x 34"

Prophecy was waiting for Krasner when she rushed back to East Hampton from Europe upon receiving the news of Pollock's death. For a time, it frightened her to look at the canvas for reasons she could not articulate, thus referring to it as "an element of the unconscious." Fittingly, she revealed it to the public a few years later in a group exhibition called *The Human Image*. Mysteriously, it was omitted from Krasner's first major retrospective at MoMA in 1984, the year of her death.

MAX
ERNST
DOROTHEA
TANNING

THE DESERT IS NOT TINY

DOROTHEA TANNING LOVED THE WORD "TINY." THROUGHOUT HER memoir *Between Lives*, it pops up in nearly every chapter—*tiny* surrealist, *tiny* pots and pans, *tiny* memories.[1] It serves as a welcome staccato in the midst of her oft-caressed, curvaceous language. Reading her story is to imagine a woman wrapped in velvet, resting supine on the grass, taking drags from a long ivory cigarette holder, letting the smoke shape the words—but who now and then squeals with joy and refers to things as *tiny*! It is that bit of wide-eyed Midwestern girl that Max Ernst probably fell madly in love with. She was nothing like all the wives that came before. When they met in 1942 Ernst was one of the leading surrealists, especially known for his collages of beasts, women strapped against their will, destructive forces at work, ornate European bedrooms, and moonlit seas. He was there at the advent of modernism in Europe, steadily contributing to the sphere of artistic conversation that was fostered in Paris, relocated to the Cabaret Voltaire in Zurich as a result of World War II, and ultimately clambered onto the shores of New York. He arrived in the New World arm-in-arm with the queen bee of collectors, his wife, Peggy Guggenheim, who took over the New York art scene while Ernst combed flea markets and played chess.

Tanning was raised in Galesburg, Illinois, by a failed cowboy for a father and a failed actress for a mother. In their westward migration, her parents were soon zapped by the American mindset and settled in a small town where they could be stable and raise a family. Their quixotic sensibilities transferred into their first-born daughter, Dorothea. As a tiny surrealist she drew herself with leaves for hair and flying creatures for friends. Galesburg didn't take to her.

When she moved to New York in 1936, she stepped into a cab and said,

Max Ernst & Dorothea Tanning (1 of 2), New York, 1947. Photograph by Irving Penn.

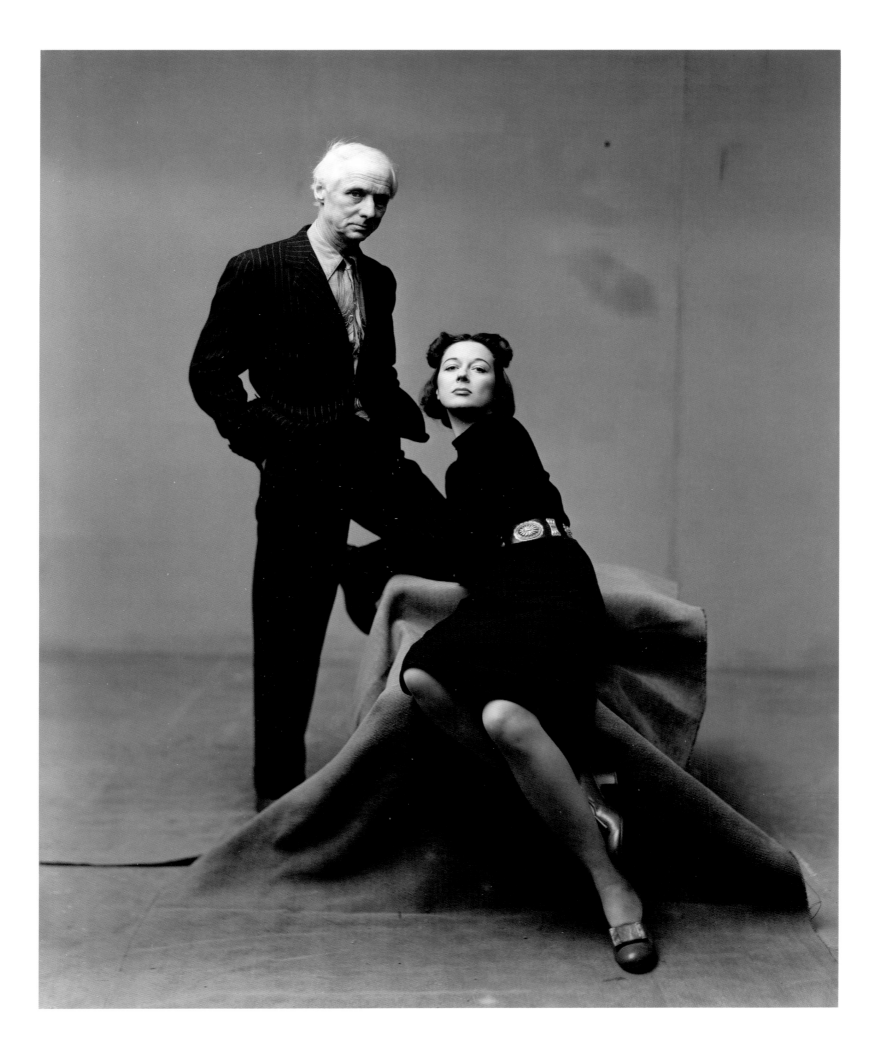

Max Ernst
. . . and the third time missed, 1929
Mixed techniques on collage, mounted on
cardboard
5^{1}/$_{2}$" x 4^{4}/$_{5}$"

In the 1920s Ernst created numerous collages
featuring nightmarish scenes, often in
bedrooms or on elegant city streets. The
women in his collages were frequently being
brutalized by masculine anthropomorphic
creatures, tied down and attached to medical
apparatuses or—as seen here—dissected by
architecture. These scenes were vivid keyholes
into his mind. Tanning's first introduction to
Ernst occurred through seeing works like this
one on the walls of MoMA during the 1936
exhibition *Fantastic Art, Dada, Surrealism*.

Dorothea Tanning
Birthday, 1942
Oil on canvas
40^{1}/$_{4}$" x 25^{1}/$_{2}$"

In an interview she granted ten years before
her death, when it was determined that she
was the last remaining surrealist on the planet,
she reflected on *Birthday*, the painting that
established her career: "Well, I was aware it was
pretty daring, but that's not why I did it. It was
a kind of a statement, wanting the utter truth,
and bareness was necessary. My breasts didn't
amount to much. Quite unremarkable. And
besides, when you are feeling very solemn and
painting very intensively, you think only of what
you are trying to communicate."[2]

"Greenwich Village, please." This is essentially what artists had to do when
they were drifting through the American expanse, searching for new creative
families. Like many others, she took a risk that could have easily resulted in a
prodigal son narrative. Within a month, she was quoting the *Bhagavad Gita*
and drinking with artists sporting Nietzschean mustaches. Her hometown
became *tinier* as New York swallowed her up. When she saw the 1936 MoMA
exhibition *Fantastic Art, Dada, Surrealism* she felt an urgency to know the
European artists represented in the show. She "struck out for Paris, armed
with letters of introduction to several prominent artists, among them Ernst,
only to find that most had fled the country, which was on the brink of war."[3]
Tanning, riding on their heels, made her way back to New York.

Even though she was merely painting for Macy's fashion catalogs, she
caught the eye of art dealer Julien Levy. It was his gallery on 57th Street that
had presented Lee Miller and Frida Kahlo in their first major solo exhibitions.
When the feline, stylish Levy found Tanning, she was like a floater on the
eye, something that occasionally flashed on the periphery. In other words,

not socially connected the way Miller and Kahlo had been. But he invited Tanning into his stable upon first sight of an untitled self-portrait she had painted on her thirtieth birthday (one of two-and-a-half paintings she had to show him). In it, she is standing barefoot in a magnificent tattered gown opened in the front, next to a hawk-winged monkey. By including the wicked mythical creature from Oz, Dorothea, unlike Dorothy, aligned herself with the other side—the dream. In the painting she stands in a room in front of a doorway that leads to an infinitum of doorways, and, with her hand still resting on one of the knobs, seems to be at home.

Ernst visited her apartment with a bouquet of flowers in hand. He had heard she was a good surrealist painter and wanted to invite her to be in his exhibition *Thirty Women*. How he loved women! *"La nudité de la femme est plus sage que l'enseignement du philosophe.* (A woman's nudity is wiser than the philosopher's teachings.) Max's words."[4] When he saw Tanning's self-portrait and learned she had not titled it, he named it for her: *Birthday*. The following week, he, his collection of exotic spoons, and his little dog, Kachina, moved into her place. When a collector—who envisioned himself becoming president of the United States—offered to buy *Birthday*, Ernst refused him. "How could you deny Dorothea the chance to be in the Oval Office?" the man asked. His answer was simple: "I love Dorothea. I want to spend the rest of my life with her. The picture is a part of that life."[5]

That life eventually became suffocated by New York. They needed air, visible stars. Ernst considered a painter lost when he "found himself. The fact that he went through his life without achieving this was his sole honor."[6] To get properly lost with Tanning, he wanted to go farther away than Long Island and Connecticut (where all their friends escaped to in August).

In 1943 they set out for a guest ranch ensconced in the mountains of Arizona. Ernst was drawn to petrified scenes, seeing the noticeable skeletal structure of a landscape. He had never lost his particular German Romantic inclination that inspired multiple paintings of the forest by night. Beauty was more powerful to him than the nightmares that haunted him. And once he discovered the austerity of the desert, he postured that the forest he had known choked the horizon—they were "wild and impenetrable, black and rust-brown, riotous, worldly, teeming with life, contrary, un-needy, cruel, ardent, and endearing, with neither past nor future."[7]

Max Ernst
Bryce Canyon Translation, 1946
Oil on canvas
20″ x 16″

Ernst initially painted Bryce Canyon to take part in a competition in which four painters (the other three being Jane Berlandina, David Fredenthal, and Dong Kingman) challenged Ansel Adams's photographic documentation of western national parks. Although Ernst was not inclined to paint landscape realistically, he painted this nocturne true to its actual appearance because it looked like a place from his dreams. As reported in *Time* magazine's "Camera vs. Brush," Adams won the competition.

> " *Anytime a certain itchy complacency descended on their isolated coupledom, she'd do something to impress him, such as picking a snake up off the ground with a casual gesture or he'd study her paintings and nod to himself, 'yes, she was a visionary, yes, he loved her.'* "

For a time, Arizona pushed the darkness away. Ernst painted the way the red-rock monoliths glowed at night. Unlike much of his former work, he did not need to enhance the dreaminess of the scape. The natural effect the desert had on the human eye was surreal enough already. Tanning, too, felt there was no need to embellish the landscape: "In that camera-sharp place where planetary upheaval had left its signature: the now placid monuments that, as far as anyone out there cared, had been there forever, I would undertake—"dare" would be a truer word—to paint the unpaintable."[8] In one rather majestic piece, she included a *tiny* version of herself looking out, with her back to the viewer. When Ernst saw it he announced, "Now that is a self-portrait!"

Tanning and Ernst decided to build a little wooden shack out in the desert. To deal with the stifling heat, they hauled in ice from twenty miles away in Cottonwood. The closest bit of civilization was a convenience store with a beer vending machine and a shelf featuring found bones. With the jukebox always on in the background, Ernst took special poetic pleasure in placing his orders for carpentry materials, planks of wood. Tanning noticed the way he would say the names of the materials over and over to himself while building the shack: *sheetrock . . . shhhhheetrock.* Anytime a certain itchy complacency descended on their isolated coupledom, causing Ernst to watch Tanning through suspicious eyes, wondering if their love was getting a bit dried out, she'd do something to impress him, such as picking a snake up off the ground with a casual gesture (something he could not do!) or he'd study her paintings and nod to himself, *yes, she was a visionary, yes, he loved her.*

But his stifled nightmares, the post-trauma from serving in World War I, of getting shot, of watching his dada community unfurl into madness—had all followed him into the desert. He could feel those demons hiding behind the rocks, watching him, snickering. At night, when he and Tanning were both supine, staring at the unobstructed sky, he would remember them and tell her stories of that time. It was both liberating and daunting to vocalize details that had been smoldered by urban engagement. And once released, there they were, dropped in an expanse of nothingness, left to the coyotes, seeming worthy of nothing but perhaps being showcased, stripped of their life, on the dusty shelf of a gas station. It was a revelation that gnawed at him. Ernst himself, oft compared to a bird, became a vulture for flesh, some sign of life.

On October 24, 1946, Tanning and Ernst partook in a double wedding with fellow surrealist Man Ray and his dancer girlfriend, Juliet Browner (this was after her ménage à trois with de Kooning and a circus performer in New York). It was a very Hollywood wedding (in Beverly Hills), prompted with a great deal of excitement by Man Ray. "Painless, forgettable but fun," Tanning remembered the day in her memoir.[9] It was brushed off with temporary

Dorothea Tanning
Self-Portrait, 1944
Oil on canvas
24" x 30"

Painted from memory one year after her first
visit to Arizona, *Self-Portrait* reveals Tanning's
ambition to capture the sublime. The painting
was made the same year as her first solo
exhibition at the Julian Levy gallery. It is the
only straightforward landscape she ever
painted, lacking the usual surrealist flourishes
that defined her work.

delight, like a bit of theater. And it was dramatic due to its completely law
abiding status, signifying Ernst's further removal from his native Europe.

A few years later, Dorothea took an apartment in New York City. The
two resided in two homes, separated by the 2,500 miles that divided New
York and Sedona, a stretch they invariably became familiar with during their
long drives. And as they settled into the nomadic back and forth between
desert and city life, an even more distant place, one that sits several thousand
miles west of America's westernmost shore, invited them both to teach art in
their tropical setting. The University of Hawaii lured them to island life for
a time, an experience that ultimately sent them racing back to their familiar
mainland, and then further on to Paris, where Ernst remained in Tanning's
arms, surrounded by his old haunts, until his death in 1976.

PABLO
PICASSO
FRANÇOISE GILOT

ONCE A GODDESS, NEVER A DOORMAT

"Even at the age of twenty-one, Gilot knew she was being introduced to an unconquerable force. But she also knew she was just as interesting as he was."

IN 1943, PABLO PICASSO—ARGUABLY THE MOST BRILLIANT, UNDENIABLY the most well-known—painter in Europe met the precocious artist Françoise Gilot. Sometimes this story is viewed in the *Lolita* vein—an old man seducing a schoolgirl. But he was not *really* very much of an old man, especially not at sixty-one. The age gap was no more than a minor detail of their romance. He remained young through his "damnable curiosity that had to be satisfied by others."[1] When he found Gilot sitting across a small Parisian restaurant, he walked right up to her table as though she were there to be plucked. And she was. As was everything Mr. "I do not seek, I find" wanted. He wasn't greedy in his attraction; Picasso was too interesting and complex for that. So was Gilot. Even at the age of twenty-one, she knew she was being introduced to an unconquerable force. But she also knew she was just as interesting as he was.

When Gilot appeared at Picasso's home a few days later, it was at his invitation and with the *pure* intention to see his paintings. She, her friend/muse Genevieve, and the other worshippers waiting in the sitting room, were eager to be given a personal tour of Picasso's atelier. He offered a tour and an explanation of everything—except his paintings. When he came upon a faucet, he turned the knob and "after a while the water became steamy. 'Isn't it marvelous,' he said. 'In spite of the war, I have hot water. In fact, you could come here and have a hot bath any time you liked.'"[2] For Gilot, she was witnessing a sort of blasphemy (like art was God, and Picasso was its disrespectful messiah) and her face, with its elegant perma-frown, undoubtedly revealed disapproval. To this, Picasso shocked her and the rest of the

Françoise Gilot and Pablo Picasso in Golfe-Juan, France, 1948. Photograph by Robert Capa.

> *" His entire family—which consisted mainly of coddling, voluptuous women—always treated Picasso as though he was, well, Picasso. "*

chagrined crowd by suggesting they pay him a subsequent visit because they liked *him* and wanted to know *him*. If they wanted to see his paintings, they could go to a museum. Door slam. Gilot returned to his place on Rue des Grand Augustin within the week.

As Gilot spent more time with Picasso—mainly sitting in his studio listening to him talk, sometimes letting him comb her hair, and allowing an occasional kiss, nothing more—it became clear that her main issue as an artist was that she lacked life experience. Prior to meeting him, "love" was a lackluster process of going through the motions. Like when she lost her virginity at seventeen—it was just to get it over with. Her bookishness had pushed her up into a corner. Of course, Picasso spotted that, liked it, and wanted to be the one to pull her out. More importantly, he wanted it to be a struggle. Otherwise it would be futile for him. One day when she offered herself up to him willingly, he called her "disgusting."

Regarding experience, he was her opposite. As a stillborn, he had been brought to life by the puff of his uncle's cigar and placed in the arms of his protective, spitfire Spanish mother. He never had to face opposition to being an artist, for his father, who painted excellent portraits of pigeons in Spain, saw an artist in his son the minute he picked up his *lapiz* (pencil) with his tiny hand. His entire family—which consisted mainly of coddling, voluptuous women—always treated Picasso as though he were, well, Picasso.

When he moved to Paris at nineteen, not speaking a lick of French, and saw the Pierre-Auguste Renoir painting of men and women dancing, *Le Moulin de la Galette*, Picasso learned something new about women, something he did not find in his Spanish home nor in all the Barcelona brothels he frequented: "How these women dominate the men in this canvas! They are lovely, coquettish, confident, intimate with each other, and not at all un-sinister in their collectivity. . . . It is in the liberation of these sophisticated French women. Their grasp on how to manipulate men, their lust for action."[3] Perhaps around this time he realized women could be more than "doormats," as he so gracefully categorized them. There was another type of woman—a goddess.

Gilot divided her time between seeing Picasso and painting in her grand-mother's house. When she had made the firm decision to become a serious painter, her father lost all composition, beat her to a pulp, and disowned her. She had anticipated this would be the trade-off before she made her declaration.

Pablo Picasso and Françoise Gilot at his pottery studio in Vallauris with Picasso's sculpture *Head of Françoise*, 1953. Photograph by Edward Quinn.

From then on, every morning she woke up, she contemplated the fresh colors and then walked directly to her canvas to paint for hours. She created still lifes—teacups and wild green plants reaching up for the ceiling. Her relationship to the painting always contained a certain level of self-control—and then the overthrow of it: "A touch of red, how nice, why not a little more of the same, and then it is too much! All the more reason to go on adding more and more. It is good to exaggerate, to go beyond, to pursue the extreme limit of what is suggested by the pictorial imagination."[4]

When Gilot confessed to Picasso she felt at ease with him, he grabbed her arm and "burst out excitedly, 'But that is exactly the way I feel. When I was young, even before I was your age, I never found anybody that seemed like me. I felt I was living in complete solitude, and I never talked to anybody about what I really thought. I took refuge entirely in my painting.'"[5] From then on, everything "he did and everything she did was of the utmost importance: any word spoke, the slightest gesture, would take on a meaning and everything that happened between [them] would change them continually."[6] Several months later, he would warn her never to think he was permanently attached to her. Separation anxiety, desire for resistance, expectation of devout love, complete liberation—Picasso was, in short, impossible.

Pablo Picasso
Femme Fleur (Françoise Gilot), 1946
Oil on canvas
57 1/2" x 35"

Dora Maar was the mistress Picasso had abandoned for Gilot. During her muse-slot in his life, he typically painted Maar sitting in a chair, as he did with most of his portrait subjects. Upon close inspection of *Femme Fleur*, one can actually see traces of a realistic portrait of a seated Gilot beneath the final painting. Picasso ultimately chose to portray Gilot standing, because he didn't see her as the passive type. Giving Gilot green hair had originally been Matisse's suggestion when he told Picasso he wanted to paint her, which Picasso took as a threat.

There came the day when Picasso needed to paint the perfect portrait of his new lover. A visit to Matisse inspired a certain urgency to paint Gilot because Matisse was drawn to her "circumflex eyebrows" and enthusiastic about painting her with green hair. Picasso saw this as a challenge. Prior to Gilot, Dora Maar had dominated his canvases, always appearing as "the weeping woman" that she was. In fact, Maar wasn't completely out of the picture when Gilot arrived—but it was normal for Picasso to keep his lovers as overlapping as possible. He didn't approve when any of them were "over" him—and, as a consequence, a majority of them were not. For Gilot's portrait *La Femme Fleur* he struggled over how to present her. A seated portrait didn't work because he didn't see Gilot as "passive." As with all of his portraits of people, nothing in pairs—especially the breasts—were symmetrical. He obsessed over the colors and the shape of her face for a while until it made sense to him. He compared the process of placing the composition to juggling—nothing was fixed. When he knew he was done, he said, "About three-quarters of the human race look like animals. But you don't. You're like a growing plant; you belong to the vegetable kingdom rather than the animal kingdom. I've never felt compelled to portray anyone else this way."[7]

Because his aesthetic prevailed at the time and most amateur painters couldn't avoid his influence in their own work, Gilot's painting showed the mark of Picasso before she even met him. When she started paying him regular visits, sometimes she would bring her drawings to him for feedback. He would not tell her what she was doing right or wrong, but drop wisdom the way a monk instructs his Buddhist apprentice in meditation. What really helped her was listening to the way he described cubism—the movement he founded with the painter Braque (whom he chidingly referred to as "Madame Picasso"). With Gilot he spoke of the era in a nostalgic tone, for it had already come and gone for him. Despite cubism's departure, he thought Gilot needed to understand the style better—in a *spiritual* way—to improve her own work. Her eagerness to understand it endowed him with the sentimental opportunity to revisit the sites of cubism—the actual physical locations where it burgeoned. They drove to Bateau Lavoir, the bohemian seedbed of modern art, where Picasso had made *Les Demoiselles d'Avignon*, the painting that launched his name, where art history took one of its most significant turns.

When they arrived, it was dark and abandoned, just mice and spider webs. Holding her hand tightly, trying to maintain his emotions, Gilot recognized his cubist days as "the time before he conquered the world and then discovered that his conquest was a reciprocal action, and that sometimes it seemed that the world had conquered him. Whenever the irony of that paradox bore in on him strongly enough, he was ready to try anything, to suggest anything,

Françoise Gilot
Le Thé, 1952
Oil on board
21 1/4" x 25 5/8"

During Gilot's early years living in Picasso's atelier, he'd give her advice as she painted. He'd remind her not to over-think the placement of objects: "That's the pictorial idea. It makes no difference whether the principal element turns out to be glass or a bottle. That's only a detail. And there may be moments all along when reality comes close and then recedes. It is like a tide rising and falling, but the sea is always there."[8]

that might possibly return him to that golden age."[9] It was at that time when Picasso was starting to have little tantrums about needing Gilot, and insisting she move in with him.

Of course she moved in, she had his babies, she tried to make him happy and to reason with his games and daily mood swings. But she also laughed at him to a nearly hysterical degree when he would get hopping mad. Which was often. Sometimes it would push him to want to murder her, and then he'd study her inquisitively and realize she was as wild and rebellious as he was. It would stun him, throw off his power. Picasso was always dominant, but Gilot never allowed herself to be a "doormat." She had a tendency, from a young age, to swim upstream, which also allowed her to go with the flow. Like when she was pregnant with their son, Claude, Picasso insisted her only doctor be

"Once Gilot was out of his orbit, encountering all the people pointing out the influence Picasso had in her work, she'd correct them by saying it was actually Matisse who influenced her the most."

the psychoanalyst Jacques Lacan, up until a week before she gave birth. She never protested these sorts of things.

According to her memoir, she didn't leave Picasso for the reasons all the other women did—although, in fact, he had typically been the deserter. Of course it devastated her that he had affairs with other women, one even younger than *she*, while she stayed home and cared for the children. But that wasn't the deciding factor. Gilot left Picasso because he suddenly became an old man. He didn't keep her energized and he stopped influencing her work. She started to paint only when he was away on trips. When he returned her productivity froze. And when she told him so, ten years into their relationship, he threatened to kill himself. To which she basically replied, *might as well*. He protested, "You used to be a kind of somnambulist, walking on the edge of the roof without realizing it, living in a dream or spell!"[10] But Gilot eventually woke up and, with some dragging of her feet, walked away from him. And once she was out of his orbit, encountering all the people pointing out the influence Picasso had in her work, she'd correct them by saying it was actually Matisse who influenced her most.

Pablo Picasso
Nature morte au crâne (Still Life with Skull), 1945
Oil on canvas
28 5/8" x 36 1/8"

SAUL
STEINBERG
HEDDA STERNE

Saul Steinberg and Hedda Sterne (2 of 2), New York, 1947. Photograph by Irving Penn.

THE NON-PROFESSIONALS

IN ONE OF SAUL STEINBERG'S LESSER KNOWN MAPS, WAIKIKI EXISTS along a country highway west of Buffalo, which sits north of Juneau, across from Rome, along a pleasant winding river in what looks like Montana. The sole weeping willow—one of ten distinct trees in the landscape—is sandwiched between Niagara and Moab (the Dead Sea version). The ghostly tuft of a storm cloud drifts in the pink sky. There is something melancholy about the scene, but it is hard to tell precisely why. Maybe it's because it is not immediately funny, like most of Steinberg's other drawings. *Autogeography*, also referred to as the "Map of Saul" by the *New Yorker*,[1] reveals the personal side of an artist whose art was pretty much always about other people. It was meant to be a 1966 *New Yorker* cover, but didn't run. No hard feelings, surely, as Steinberg did publish eighty-nine covers during the fifty-seven years he drew, or rather, "wrote pictures" for them.[2] Steinberg's presence is alive in every drawing, kind of the way a comedian is alive in his punch lines: it is that type of creative offering that is there for the immediate taking. His art was something you could buy at the supermarket, along with milk, and then take into your kitchen to study while drinking coffee.

When fellow Romanian immigrant Hedda Sterne[3] first saw his drawings, she invited him over to have tea in her own kitchen on East 50th Street. Over half a century later, Sterne could still recall the meeting clearly: "I had a collection of children's art on the wall. He was very pleased." She felt a nearly instant kinship with Steinberg. "I grew up out of refusals—'I don't want this.' Saul had the same horrors and taboos. It took about a half-hour and we were old friends."[4]

The exhausting journey that Steinberg took—which eventually allowed him to settle comfortably in Sterne's kitchen as her husband in 1944—began with him leaving his native Romania, whose "virulently anti-Semitic nationalism boiled

Saul Steinberg
Autogeography, 1966
Ink, gouache, and watercolor
29 1/2″ × 20 3/4″

Steinberg drew a number of maps throughout his career. *Autogeography*, which was intended to be a *New Yorker* cover, presents Steinberg as a river, winding through places he knew in various capacities, such as Râmnicul Sărat, which he referred to as a "place invented for me to be born in."[5] This map is a particularly personal representation of Steinberg's imaginative depiction of the world as he knew it.

up in scattered pogroms in the 1920s,"[6] to enroll in the architecture program at Regio Politecnico in Milan in 1933, where the "cribbed Bauhaus curriculum" did not inspire him to design buildings.[7] When the twice-weekly humor newspaper *Bertoldo* set up shop in 1936, Steinberg began submitting cartoons of absurd characters such as Zia Elena (Aunt Helen), who wore a butcher's knife in her twine belt to one side and hid a lachrymose lamb in her skirts to the other; he later worked for *Settebello*, another humor paper.

When Italy's race laws barred Jews from professions in 1938, Steinberg was out of a job. In 1940 he desperately tried to get out of Italy, managing to make it all the way to Lisbon in hopes of boarding a ship to United States, only to be sent back to Milan. Through a confusing series of events, which included a six-week detention at an internment camp in a villa with a view to the sea, he was able to set sail for the Dominican Republic, where he mailed out a series of packages containing a total of 300 drawings, in hopes of getting enough work to earn a U.S. visa. "The breakthrough came with a cartoon portraying a student painter and her misassembled centaur, horse in front, man behind . . . printed at nearly a full-page scale in the October 25, 1941 issue of the *New Yorker*,"[8] hence establishing the beginning of his relationship with the magazine, which continued throughout his entire life and beyond.

The year Steinberg met Sterne, she was fresh off the boat herself. The two Romanians, unknown to one another, had both been received in the city graciously—the way an immigrant dreams of arriving in New York City. "Theoretically a challenging town for a stranger, [it] lay open to Steinberg on three fronts . . ."[9] and Sterne represented one of them—the New York School of painters. In 1943, she was being exhibited in the Wakefield Gallery, which was managed by Betty Parsons (who would become both Sterne and Steinberg's dealer). With the help of people like Peggy Guggenheim and Parsons, Sterne had become an odd force within the early development of the abstract expressionists, a label she did not identify with ever. She had been a surrealist (a label she wore) while living in Europe—and transitioned into the abstract realm as she absorbed the aesthetic of United States. "I was struck that this country was more surrealistic than anything anybody imagined. Already in '41, I'd seen California buildings in the shape of ice cream cones and oranges that you could walk into. That kind of freedom, that romanticism about the future, was utterly delightful to me. So I became a passive observer, for a while. I started looking at my American kitchen, and I painted my American kitchen. Then I went on the streets, and I did cars. Then I did all the highways and all the machinery. . . . If you look at my work from the beginning it's an absolute diary."[10]

Before settling down with Sterne in her fascination of American everyday-ness, Steinberg was commissioned as an ensign by U.S. Naval Intelligence and

was shipped to Happy Valley in China's western Yunnan province. Exactly what he did there remains uncertain, but during his off-time he drew wherever he could, including the walls of his bedroom, where his "roommate recalls going out for an hour and returning to find one wall turned into a life-size Manhattan annex, with 'a table, two chairs, a bottle of whiskey, and two glasses, near a window which looked down on Times Square.'"[11] He was reassigned to Morale Operations, which took him back to Italy by way of North Africa. Meanwhile his drawings continued to appear in the *New Yorker*, offering American readers a humorous perspective of military life. When he returned to the States in October, 1944, in his lieutenant's uniform, his future wife and a surge of artistic success awaited him.

In 1945 Steinberg's first book, *All in Line*, was published, becoming an instant bestseller around the country, and he was invited to take part in the 1946 MoMA exhibition *Fourteen Americans*. He was able to broaden his audience in such a way that it didn't disengage him from the avant-garde. What was it about his drawings that placed him in the same exhibition as the complex abstract expressionists Robert Motherwell and Arshile Gorky? Was his modernist identity established when "Romania gave him a sense both of the relativity of style and the thinness of civilization,"[12] or did it develop later, when he arrived in New York to witness the various platforms of creativity he could simultaneously exist on? And in the midst of all of this, when, for example, *New Yorker* editor Harold Ross one day "took him aside and told him he would now have to draw the noses on his characters a bit smaller; in America, Ross informed him, people did not have such big noses,"[13] he refused to acquiesce, only continuing to draw noses the way he wanted. Steinberg understood his role: "The nature of the modern artist is to search, is to be in a precarious position and to be nonprofessional."[14]

Sterne's experience in being nonprofessional fared differently. In 1951 she was the only woman included in *Life* magazine's photographic portrait of the abstract expressionists, nicknaming them "The Irascibles." In one of her last interviews, her disdain for that frozen moment was immediately addressed: "I am known more for that darn photo than eighty years of work."[15] The photograph was taken based on a letter of protest, initiated by New York painter Barnett Newman, claiming the Metropolitan Museum of Art did not encourage modernism. Every newspaper in town published the letter, which was signed by a group of painters, including Sterne. When the *Life* photo shoot was arranged, she arrived late and the photographer made her stand on a table behind all the male artists, making her the John Hancock of the portrait. This put her in an awkward position because not only did she not identify with being one of the abstract expressionists, she had to listen to them whine about her inclusion in the photo at all the dinner parties that followed. They felt that because she was a woman—

"*As Sterne described in an interview after their divorce, 'Saul would have liked to have a harem. He knew how to add, not subtract.'*"

Saul Steinberg
Self-Portrait with Hedda Sterne in Cadillac, 1947
Ink on paper
11 1/2" × 14 1/8"

Steinberg drew this portrait of them traveling through Vermont farmlands during the year he purchased this Cadillac in order to explore the country. In Vermont, where she studied farmland machinery, Sterne was inspired to paint her "anthrographs" such as *Machine*.

and the only woman in the photo—she diminished the intellectual and historical value of the event.

Steinberg, in his natural proclivity to poke fun at situations, celebrated her stereotypical womanhood by creating two signed and stamped diplomas—first, one for cooking and, a few years later, one for dishwashing. Sterne was an indefatigable hostess, making their apartment on East 71st Street a sybaritic hub for New York's finest intellectuals: "The house schedule included two dinnertimes, a social one and a 'new dinner' after midnight, with extra time for drawing in between."[16]

Steinberg and Sterne traveled extensively throughout their marriage, which fed Sterne's enchantment with America's machine-scape, and led to her anthropomorphic paintings, referred to as her "anthrographs." "I had a feeling that machines are unconscious self-portraits of people's psyches: the grasping, the wanting, the aggression that's in a machine."[17] Interesting that Sterne's fascination with these characteristics of agricultural machinery would be the same ones that would make Steinberg too challenging to hang on to as a husband. As she described in an interview after their divorce, "Saul would have liked to have a harem. He knew how to add, not subtract."[18] They separated in that distinct New York style—by becoming even better friends for it.

In the years leading up to her death in 2011, various writers interviewed Sterne about her life, not without a question or two about Steinberg. She always remembered Steinberg as the diploma-making, funny Saul as well as the sitting-under-the-weeping-willow-of-his-autogeographical-map Saul. He, above all, represented drawing. For Sterne, life began and ended with that form. "Drawing," she said, "is continuity. Everything else is interruption, even the night and sleep.... I can die at any moment. But I still learn. Every drawing teaches me something."[19]

LEON
GOLUB
NANCY SPERO

DELICATE GIRL-ART VS. GROWN BOY-ART

In the intersection of art-world rejection and political awareness, Spero and Golub embarked on creating a parallel series of works exploring the struggle of humanity—specifically in times of war.

IT TOOK A WHILE FOR THE WORLD TO CATCH UP TO NANCY SPERO and Leon Golub. In interviews given later in life, they openly remembered being very angry about this. In the late 1940s and early 1950s, the American abstract-oriented art scene initially spurned the couple for their use of the figurative: they could conform or be outsiders, which was quite an irony, since the art community has often been considered a haven for outsiders. Not in their case. This reality fired them up to remain true to their portrayal of the human figure. Beyond their disdain for the dominant art scene, they were also politically radical. World War II had just ended, and despite the country's general enthusiasm for brighter horizons ahead, Spero and Golub were suspicious. They were passionate about human rights and watched the way their native country, high on its glory, developed a stronger appetite for military domination. They spent hours in Chicago's Field Museum of Natural History, studying the fossilized remains that outlined the rise and fall of ancient empires (Spero was drawn to the Etruscans, Golub to the Hittites). In this intersection of art world rejection and political awareness, the two embarked on creating a parallel series of works exploring the struggle of humanity—specifically in times of war.

But by 1959, Golub and Spero had two young children and teaching jobs, and were becoming embittered. In their inaugural joint exhibition they were presented as Leon Golub and Mrs. Leon Golub; Spero could've burned the gallery down she was so livid. So off they all went, the whole Golub-Spero clan, leaving snowy Chicago and abstraction behind. And Paris was the perfect destination for American expatriate artists. They lived in France and Italy for five years, and, in a sense, it's where they really both got started; it

Nancy Spero and Leon Golub in New York City, 1985. Photograph by Christopher Felver.

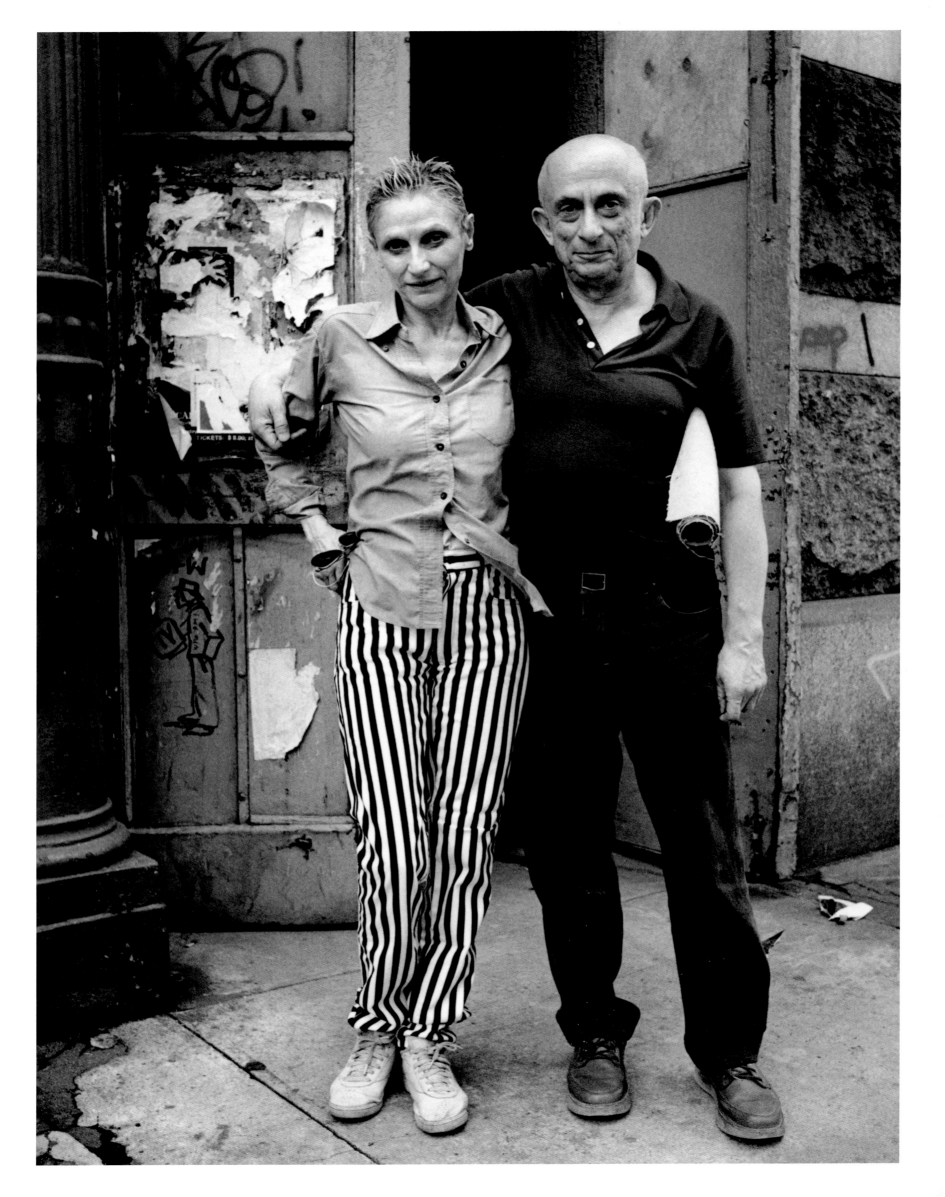

Leon Golub
Gigantomachy II, 1966
Acrylic on linen
9′11″ × 24′9″

To create the figures in his *Gigantomachy* series, which portrays the history of meaningless conflict among men, Golub studied images of the male body in motion, which he collected from various sources such as periodicals and films (including sports magazines and pornography).

was the place where they were able to purge toxicity out of their systems and experiment with new ideas before facing the American art scene again.

Paris still resonated with the impact of World War II, the former Nazi tyranny, the Holocaust, the overwhelming numbers of lost lives. Furthermore, the Algerian drive for independence could be heard through the streets; blood was pumping. Golub began to paint images of men, specifically heroes, in classic moments of extreme glory and demise. It stemmed from his acknowledgement of the fact that men ruled the world. "Ok, we all know that," Golub would often say. He had no interest in tiptoeing around the subject. He brought it all forward, to the very front of the canvas, in gruesome, brutal detail with his *Gigantomachy* series. Within a few years, Spero made the

> "Golub began to paint images of men in moments of extreme glory and demise. It stemmed from his acknowledgement that men ruled the world. 'Ok, we all know that,' Golub would often say."

decision to only paint women ("Let the male artist respond to us!"). It became a faceoff—except, of course, Spero and Golub were on the same side. They both knew male domination was ugly and that war was evil. Their individual artistic investigations only strengthened their political bond.

Before Spero made the absolute decision to edit men out of her work, she developed her pivotal *War Series* in response to Vietnam. It was 1966. The family (which had added one more member in Paris) had moved into a New York loft in the heat of student war protests, where televisions revealed scenes from behind shop windows, and draft-card bonfires burned in city parks. Spero's anger returned, and in the span of four years she created a hundred drawings of "sperm bombs," crashing phallic helicopters, phallic eagles—lots of airborne phallic destruction! But at the same time, despite their obscene nature, they were sort of . . . pretty. Unlike Golub, she gave the negative space within the composition a lot of presence and suspended the images in the paper's white background. It bestowed her drawings with an airy quality, similar to the way hovering stinging insects appear like magical, innocuous creatures at first sight. Decades later in their dual career retrospective, *War and Memory*, Golub joked that it was the pairing of "delicate girl-art versus grown boy-art."[1]

Through his paintings *Napalm* and *Vietnam*, Golub also addressed the war. This work took a slightly abstract turn, and was less obviously derived from ancient art and more concerned with the real and present texture of carnage and fatality. His violent contact with the actual surface of large rolls of un-stretched canvas—which involved scraping and the heavy reapplication of oil paint—divulged his sentiment towards the inexhaustible fall-of-man narrative. The figures in the painting literally embodied his concept of napalm's destruction, and made the televised broadcasts of war atrocities appear completely two-dimensional by comparison. They were the largest, most physically involved paintings of his career. They also marked a "decisive shift . . . a crisis of self-doubt over the future direction of his work."[2] In his depiction of warriors, he considered the fact that he was not one of them. He started to feel a clash between the past, present, and future forms of himself—what he had done versus what he would do next. After being steadily confrontational with his subject, on the front lines so to speak, he fell back. Golub's output came to a pause around the same time Spero omitted men from her work to focus on painting the *Torture of Women*.

Unlike Golub's men, Spero's women do not end in despair. Working on scrolls, she began by depicting tragic scenes of women forced against

Nancy Spero
Panels from *The Goddess Nut II*, 1990
Handprinting and collage on paper
Panel: 84″ x 21 3/5″; Overall: 84″ × 108″

Goddess Nut is comprised of a series of vertical panels with the goddess figures (inspired by the Egyptian goddess of the sky) denoted by their extremely long arms and legs, interspersed throughout the panels, weaving through and around characters like wisps of wind.

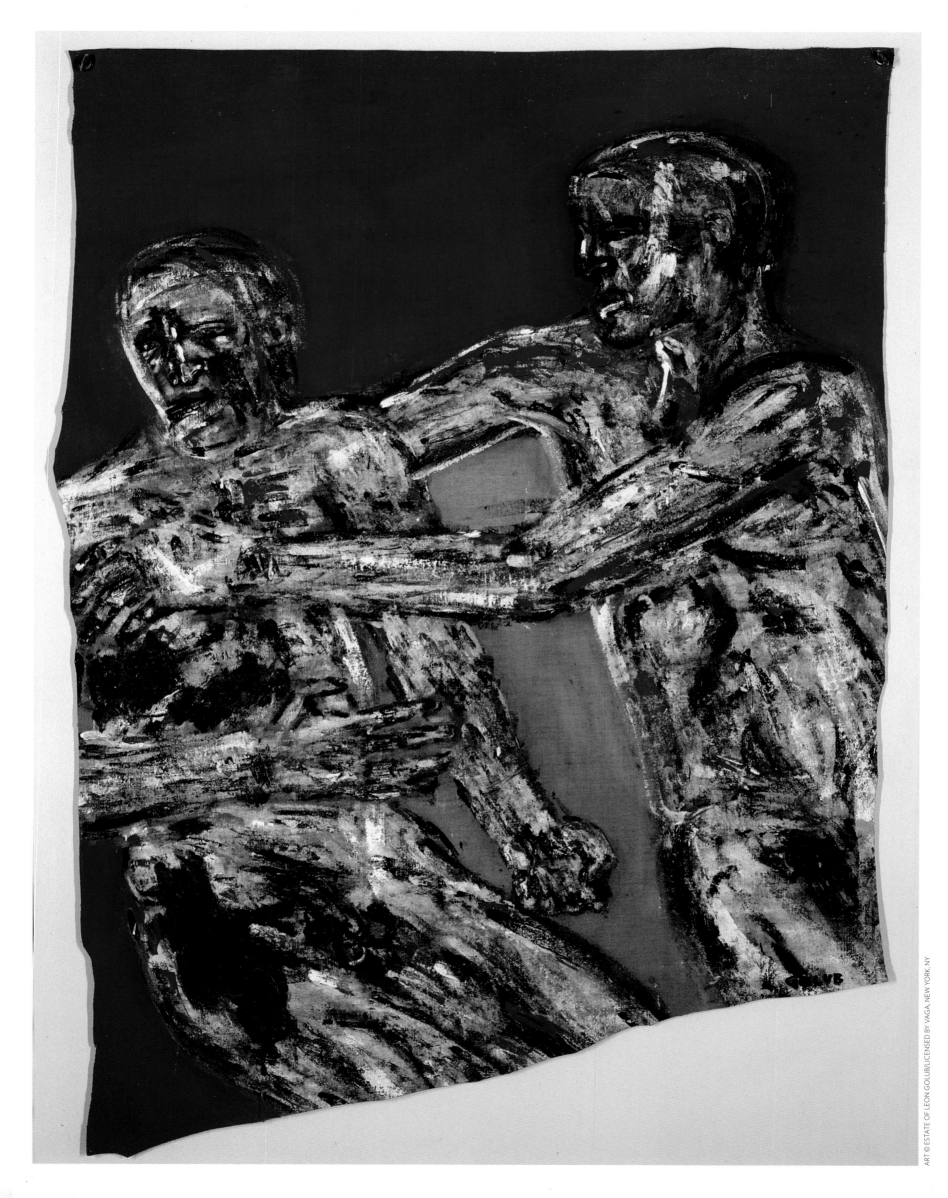

Nancy Spero
Detail from *Torture of Women*, Panel III, 1976
Gouache, typewritten texts, collage, and
hand-printing on laid paper
Panel: 24″ x 115″

This 125-foot-long series of panels was
largely inspired by *Beatus Apocalypse*, the
medieval illustrations that depicted the
horrors described in the *Book of Revelation*.
With *Torture of Women*, Spero wanted
to make the gruesome visible, specifically
torture, which was and remains a veiled
reality in the world, an act conducted in
secrecy. "The history of women I envision
is neither linear nor sequential," said Spero
about the dominant theme in her work. "I try,
in everything I do—from using the ancient
texts, to the mythological goddesses, to
H.D.'s poem on *Helen of Egypt*—to show that
it all has reverberations for us today."[3]

Leon Golub
Napalm V, 1969
Acrylic on canvas
59 5/8″ x 43″

With regards to his *Napalm* series, Golub
stated, "The question is: who am I painting?
Well, I have this way of putting it: I'm painting
citizens of our society, but I'm painting them
through certain kinds of experiences which
have affected them. I can describe some of
them—Dachau, Vietnam, automatized war,
I would even say such a phrase as Imperial
America, in a way."[4]

their will, victims of barbaric power, alone and persecuted. But as the work
advanced and continued into its pictorial anthology of real and mythical
females—including Greek goddesses and feeble Vietnamese peasants
alike—it evolved into more of a celebration of women. This body of work did
not present women as triumphant, per se, but certainly as more than mere
survivors. After depicting all the negative impact revealed through the
history of women, Spero wanted to liberate them. She wanted to conclude on
the possibility of what *could* happen rather than what *had* happened. About
the choice to focus on their respective genders, Golub would say years later:
"We didn't just sit in the studio and push paint and so on, there was directed
intention, intentionality, in what we were about. . . . Nancy hooked into the
issues that women face. Not just women artists, but women subjected to the
pressures of subordination in the modern world. And I hooked into all phases
of how men act out aggression and violence, power moves. We have always
tried to fight the good fight! To be relevant to ourselves and the world!"[5]

In 1996, towards the end of their lives, more than four decades into
marriage, the *New York Times* took a tour around the Metropolitan Museum
of Art with Golub and Spero. By this point they had both reached an age
where they could reflect on their struggles and successes as artists with a
glimmer in their eyes. The journalist accompanying them through the
galleries of ancient art described their rapport of "Leon's right! No, Nancy is
right!" as an "Alphonse and Gaston routine."[6] It was like they were at the very
beginning again, when they were art school students in the 1940s, flirting
with one another in the midst of tomb artifacts. Except on this occasion,
the art world had finally caught up to them.

JASPER
JOHNS &
ROBERT
RAUSCHENBERG

> *"The two Southern gentlemen, warm with whiskey, found their way into an intimate dialogue that didn't end until seven years later."*

MY QUIETNESS HAS A MAN IN IT

BEFORE ROBERT RAUSCHENBERG MET JASPER JOHNS ON A NEW YORK street corner in 1953, he had gained the reputation as an enfant terrible based on exhibiting "ugly sculptures" in the prestigious Stable Gallery. The aftermath included sharp criticism from the seasoned abstract expressionist crowd, the dealer taking a dive in her career, and Rauschenberg feeling completely rejected as an artist. Johns had no reputation to speak of when they met, except that he was working as a bookseller and fresh out of serving in the army. When they saw one another again in a dingy artist haunt, the Cedar Bar, the two Southern gentlemen, warm with whiskey, found their way into an intimate dialogue that didn't end until seven years later. "Jasper was soft, beautiful, lean, and poetic. He looked almost ill—I guess that is what I mean by poetic," Rauschenberg recalled.[1] As for Johns, who was the far less verbally descriptive of the two about their ensconced relationship, "Bob was the first real artist I knew. Everything else was arranged to accommodate that fact."[2] By 1954 Johns was living in the studio below Rauschenberg, where they developed a two-man painting movement that served as the powerful antithesis to abstract expressionism, and the definitive inspiration for pop art.

Poverty was a dominant component of their early years together and perhaps one of the most vital forces of their shared creativity. They lived

Robert Rauschenberg in conversation with Jasper Johns, New York City, 1954. Photograph by Rachel Rosenthal.

on Fulton Street, near the southern tip of Manhattan, in a building with no running water. By the time Johns arrived, Rauschenberg was deeply attached to the area because of its port culture and easy access to Staten Island. The trash that washed up on its beaches would end up in his paintings the following day. When they ran out of money, they traveled uptown under the alias Matson Jones to decorate Tiffany's windows with swamplands or winter fields for their jewels to rest upon. After they were paid, the two would swiftly return to the studios and paint as long as they could before they were penniless again.

"The daily stimulus of seeing each other's work almost certainly saved them both a great deal of self-doubt."[3] More than that, though, both of their practices fiercely traveled into new territory based on the nonstop trading of influences and ideas. Both grew into distinct artists—but two sides of the same coin. They were a gay couple amongst masculine, "tortured" abstract expressionists (famous for brazenly overshadowing their artist wives). In their circumstance, there were no models to relate to besides the unconcealed homosexuality explored in the beat poet scene. As Jonathan Katz—a true

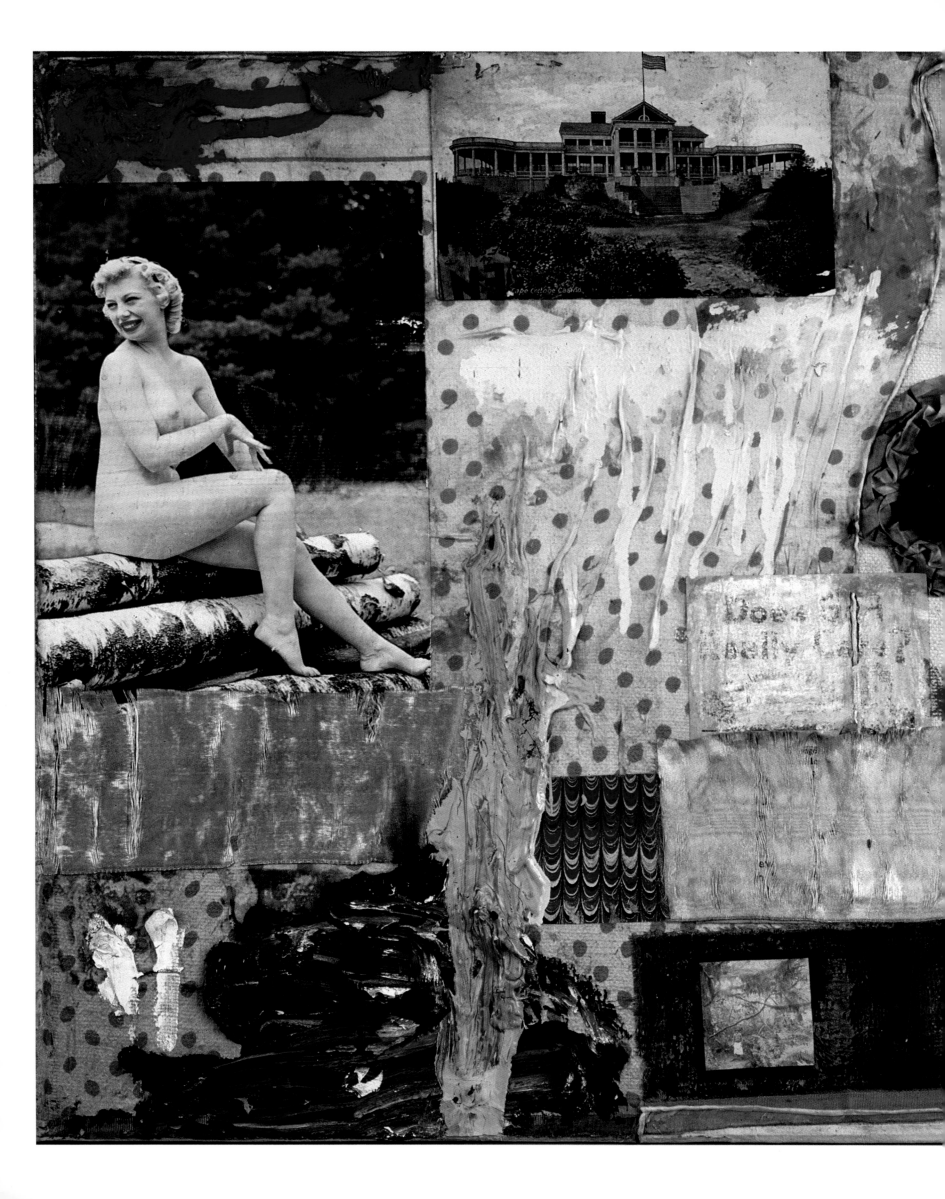

Here is a picture I drew about playing away from traffic.

"*Not in interviews, correspondence, letters, or witness accounts did their genuine bond come through; it was only truly exposed in the messages contained in their works.*"

Robert Rauschenberg
Untitled, 1955
Oil paint, crayon, pastel, paper, fabric, print reproductions, photographs, and cardboard on wood
15 1/2" x 20 3/4"

A precursor to pop art, Rauschenberg's work was in response to the abstract expressionism that surrounded him at the beginning of his career. The most famous example of this was his *Erased de Kooning* where he literally erased a de Kooning drawing, chosen by the artist himself. Another subject he addressed, in a subtler manner, was his sexual orientation. To be a gay man in the midst of heterosexual, male-driven abstract expressionism certainly influenced the coded nature of his "combines."

Jasper Johns
In Memory of My Feelings – Frank O'Hara, 1961
40¹/₄" x 60" x 2⁷/₈"

Johns painted his first American flag after the idea came to him in a dream, seven years prior to *In Memory of My Feelings – Frank O'Hara*. Beneath each of John's *Flag* paintings are buried pieces of collage collected from newspapers, books, and magazines. In this work, the layers are notably reversed, and the flag is buried under a wash of moody tones.

expert on their coded relationship—explained, "After meeting Johns, Rauschenberg turned away from painting as an abstract expressionist drama of selfhood and started to bring culture—history, politics, Judy Garland, and Abraham Lincoln—back into art."[4] Hence leading to Rauschenberg's *Untitled* 1955, in which he "explicitly addressed his relationship with Johns and its place in his emotional life. On to the surface of the piece, he collaged drawings by his former lover Cy Twombly, a photo of his young son, clippings about his family from a hometown newspaper, a naive oil painting by a relative, a drawing of an American flag (the same year Johns painted his first one), a photo of Johns that Rauschenberg once termed 'gorgeous,' as well as letters from Johns, judiciously torn up." This piece reveals an incredible insight into a relationship that was otherwise cloaked from the rest of the world. Not in interviews, correspondence, letters, or witness accounts did their true bond come through; it was only truly exposed in the messages contained in their works.

> "At first glance, the painting just looks like colliding shades of grey paint. Upon closer inspection, the ghost of an American flag appears beneath the surface."

In 1957, dealer Leo Castelli paid Rauschenberg a studio visit to discuss a potential exhibition. Of all the versions of this important story, one of the most visually enticing accounts involves Rauschenberg casually taking Castelli downstairs to "get more ice" for their drinks. It was as though the dealer had walked through the looking glass of Rauschenberg's work. Upon sight of the younger, practically unknown artist's paintings of American flags and targets, Castelli offered Johns a solo exhibition. Johns' version of nationally recognizable symbols represented a distinct move away from macho abstract expressionism and into a new frontier in art. Well-acquainted with poetry and philosophy, he later explained his process in terms of advice: "If one would make any rule, it might be a good rule to avoid anything one knows, and still act. If one can do that, then one has something that one did not have before."[5] In terms of American painting, solely he and Rauschenberg exist on the island that sits in the gap between the two major art movements of abstraction and pop.

When they split in 1961, they both left New York and headed south, but in separate directions. It is hard to trace the reason for their silent departure from one another, but in one interview in 1990, Rauschenberg disclosed that they split "for embarrassment of being known—socially. What had been tender and sensitive became gossip. It was sort of new to the art world that the two most well-known, up-and-coming studs were affectionately involved."[6] The artwork they made afterwards reveals suffering—namely that of Johns with his piece *In Memory of My Feelings - Frank O'Hara*. The title refers to a poem by the inspirational gay poet Frank O'Hara that begins, "My quietness has a man it in it, he is transparent." At first glance, the painting just looks like colliding shades of grey paint. Upon closer inspection, the ghost of an American flag appears beneath the surface. A spoon bound to a fork—a metaphor for "spooning" and coupledom—is tied to the canvas.[7] At the right corner, hidden in the busy brush strokes, is a skull and crossbones, echoing the repeated drawings titled *DEAD MAN* from Johns' sketchbooks. And under all the paint are real hinges, which allow for the painting to fold up into itself, as if it was intended to be packed up and stored away.

HELEN FRANKENTHALER & ROBERT MOTHERWELL

A HONEYMOON IN SPAIN

EVERY DAY OF THEIR NEW YORK LIVES, THOSE HAUNTED PAINTERS of the 1940s considered how to transform a raw canvas into a masterpiece. They drew energy from pasts left behind—abandoned countries, poverty, lost loves, the memory of overbearing mothers. Hardship was a common thread amongst them—except with Robert Motherwell. He showed up in polished shoes, cash in pocket, and academic nods from Stanford, Harvard, and Columbia. Motherwell entered into art cerebrally whereas artists like Pollock and de Kooning arrived by virtue of their hands. Perhaps because he was more of a thinker than a feeler, painting offered him a worthier method of emoting. Once he established painting as a fluid extension of his being, he was able to determine when a painting was finished—"I think, when your feeling is completed."[1]

Motherwell met Frankenthaler in 1957, five years after she had hit the scene running with the painting *Mountains and Sea*. One could say she became so instantly successful because she introduced the novelty of "soak-staining" into abstract painting. But it's also possible it was because her lover at the time, the critic Clement Greenberg, played a big part in determining what made art Art.

Robert Motherwell and Helen Frankenthaler
at their Provincetown studio, circa 1960.

He had navigated the young Frankenthaler's movement in painting—and she could execute the ideas very successfully. Daughter of a supreme court judge, she was scholarly, well-spoken, and sure of her abilities. When Motherwell met her in Long Island, she was cordially separated from Greenberg and free to become the other half of a power couple. They married the following year and deserted New York for an extended honeymoon in Spain.

Though he had not been there before, Spain was one of the keys that opened Motherwell's heart. It is where Picasso, whom he so greatly revered, came from. It was the place that André Malraux spoke of during a 1937 rally in San Francisco. When Motherwell listened to that speech as a young college student, an eager philosopher, he was able to visualize the "conflict in individual will and collective restraints."[2] Going to Spain with his artist wife for a honeymoon wasn't a way to escape everything in order to focus on her;

> '*What concerns me when I work,*' Frankenthaler once explained, '*is not whether the picture is a landscape, or whether it's pastoral, or whether somebody will see a sunset in it. What concerns me is—did I make a beautiful picture?*'

Helen Frankenthaler
Basque Beach, 1958
Oil and charcoal on canvas
58 5/8" x 69 5/8"

The colorful abstract landscapes Frankenthaler produced on her honeymoon with Motherwell stand in stark contrast to the elegiac tones of her husband's monochromatic canvases. Known as the inventor of the short-lived, but pivotal, American Color Field movement, Frankenthaler was, in a sense, her own island. She painted with a sense of purpose and direction that, despite her early detractors, would eventually earn her a highly respected place in the pantheon of twentieth century artists. Painter Morris Lewis, whose work was largely inspired by Frankenthaler, once called her "a bridge between Jackson Pollock and what was possible."

it carried the emotional intensity of meeting a long-lost father for the first time. He went there to essentially see where he came from.

For Frankenthaler, the Spanish honeymoon did not intrigue her interest in the country's political history, but more so in its countryside. She was inspired by landscape, yet she would not refer to her paintings as such. "What concerns me when I work," she once explained, "is not whether the picture is a landscape, or whether it's pastoral, or whether somebody will see a sunset in it. What concerns me is—did I make a beautiful picture?"[4]

> " *Where his wife saw color, Motherwell saw the complete absence of it.* "

While the newlyweds were potentially of two different minds when they went to Spain, their ever growing elucidations overlapped like Venn diagrams. Perhaps this intersection allowed them to feel, i.e., paint, together. Or maybe it was because new love encourages lovers to connect whatever dots they wish to.

They shared an almost fetishistic love for the raw canvas and saw painting as the result of an "intense and irrational desire to dirty" them.[5] In Europe, Frankenthaler was compelled to stain-paint her unprimed canvases with the blues, yellows, and reds that reminded her of the Basque beach, the ochre of bull rings, and the blood tones in prehistoric cave paintings. Where his wife saw color, Motherwell saw the complete absence of it. His *Iberia* series was an "elegy [funeral lament] for the former Republic [of Spain] . . . a former mourning, not a call to action, but a lyrical sense of outpouring."[6] Large canvases swathed in black revealed alarming flashes of white in the far left bottom corners. The white, obviously symbolic for life, punctuated each piece—marking the moment he, the complex thinker, *felt* they were complete.

To describe what happened after the honeymoon ended would be like summarizing a muffled conversation heard through a thick wall. Theirs was a very dry, discrete relationship. Summers were spent in Provincetown while New York maintained its pulse. As painters of the 1940s entering into the 1960s, they became exceedingly distant from their pasts—and starved less. Frankenthaler remained loyal to the staining, Motherwell to the relationship of black and white. But it ended, as all relationships do in one way or another. And no one really knows the details of this ending because they never spoke of it. Divorce was what people did when certain feelings ended. Just like painting.

Robert Motherwell
Iberia, 1958
Oil on canvas
70 3/8" x 89 3/16"

In 1948 Motherwell began a series of 150 paintings which were originally inspired by his experience witnessing Andre Malraux's speech on the Spanish Civil War. Subsequently, through painting, he realized that the "thing he cared deepest about was the defeat of the Spanish Republic."[3] He had never actually been to Spain until his honeymoon with Frankenthaler, a generation after the Spanish Civil War. It was then that he claimed a certain ownership of the color black, much in the way Matisse had done with blue.

CHRISTO & JEANNE-CLAUDE

Christo and Jeanne-Claude in their room at the Chelsea Hotel in New York City, 1964. Photograph by Ugo Mulas.

AN EAGLE WITH TWO HEADS

CHRISTO AND JEANNE-CLAUDE WERE BOTH BORN ON JUNE 13, 1935—the year Amelia Earhart became the first person to fly solo from Hawaii to California and airplanes were banned from flying over the White House, when Persia was renamed Iran and an earthquake hit Pakistan killing 40,000 people, when the Nuremberg Laws went into effect in Germany. The planet, gaining velocity, released whispers that foreshadowed the plangent reality to come. One in Bulgaria, the other in Morocco, the two newborns delivered on the same day—dare I mention, in a month that is astrologically associated with twins—seemed to have their ears to the ground, already mentally stripping away a membrane of convention that would separate them from the societal automaton behavior they would defy as an artist couple.

As a child of the World War II era, Christo had been torn away from his Macedonian heritage and, for a short time, found a sense of "home" while huddled with his family in a basement in Gabrovo, Bulgaria. Possessing an obvious talent for art as a teenager qualified him to study at the art academy in Sofia. Witnessing the ruin and abandon of a country that erased and rewrote its borders and laws became the infrastructure of Christo's artist mentality. It also pushed him to migrate westward and join the postwar tribe of displaced people.

The morning Christo met Jeanne-Claude in 1958 she had dark circles under her big blue eyes from her late night partying. He was painting a

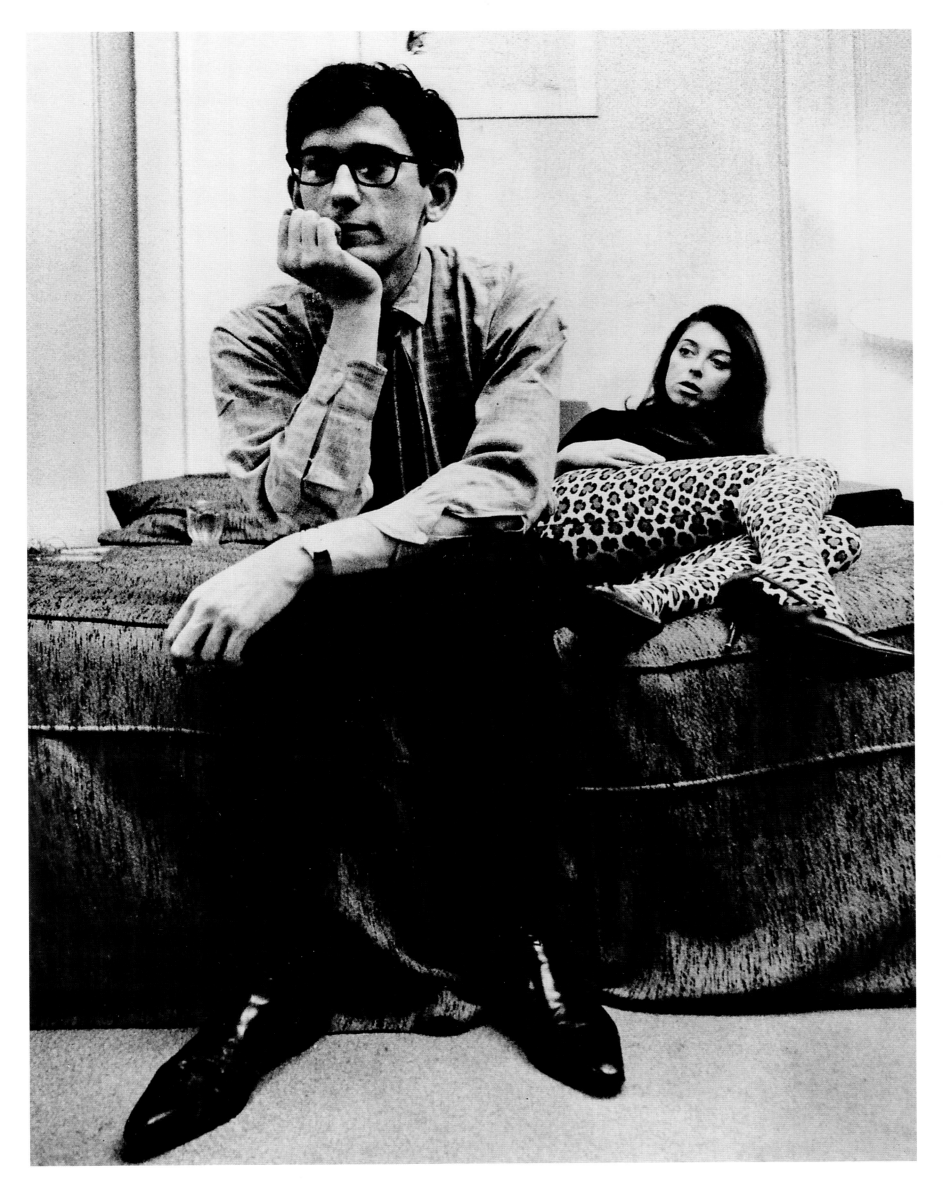

portrait of her high society mother, Précilda, in their Parisian flat. In this first interaction, Jeanne-Claude wore her vanity on her sleeve and dismissed Christo with a polite snort. Her childhood spent as a neglected girl in North Africa had been well disguised by her teenage years galloping through the desert on her magnificent horse and the daily line of suitors—a few of the

luxuries that came with a new wealthy and generous stepfather. The cloud of adoration that attached itself to her twist of fate made it hard for her to see she was meeting the love of her life that day. In later years, after living and working as an internationally recognized duo—held together by indestructible admiration and affection for one another—she'd be quoted as saying that her life started the day she met Christo.

> " *Christo seemed to be guided by the will to alter or destroy everyday appearances . . . The simple gesture of wrapping brought the identity of an object into question.* "

Their early life as a couple in Paris met several distinct challenges. While Jeanne-Claude's family—the Guillebons—were charmed by Christo's presence as the family portrait painter, they did not want him to bear their next of kin. But while she was on a lackluster honeymoon with a family-approved husband, Jeanne-Claude discovered she was pregnant with Christo's son. Naturally, once the scandal came out in the open, the family exiled Christo and Jeanne-Claude from their lives. Another travail was the fact that the couple had no money. Jeanne-Claude had been accustomed to a very comfortable way of life, while Christo knew how to find inspiration in poverty. He was fiercely dedicated to his art. Painting portraits allowed for him to survive, but made him feel like he was wasting his ambition (a realization that came to him long before he started painting for Jeanne-Claude's family).

Christo's real work—which he called *Inventory*—initially rose out of collecting discarded materials from painting and, eventually, extended to a wide assortment of everyday objects (including Jeanne-Claude's clothes). These phenomena had been inaugurated decades earlier by Marcel Duchamp and continued by artists like Robert Rauschenberg—but Christo put his distinct signature on found objects by wrapping them in plastic or fabric. "Christo seemed to be guided by the will to alter or destroy everyday appearances. Rather than adhering to the uninspiring nature of an object, he overcame its predictability. The simple gesture of wrapping brought the identity of an object into question."[1]

Jeanne-Claude's reaction to this was the real test of their relationship—because to love the man involved understanding how he worked. It was clearly a challenge to live with an artist who would spend an entire night lugging empty oil barrels up five flights of stairs to store in their tiny apartment. But not only did she understand him, she started offering an aspect

Christo
Wrapped Portrait of Jeanne-Claude, 1963
Oil on canvas portrait by Christo, wrapped with polyethylene and rope, mounted on black wooden board
30⅞" x 20⅛" x 2"

This wrapped portrait of Jeanne-Claude was made in two stages—at the time of the painting, and at the time it was wrapped. The portrait was likely made shortly after Christo met Jeanne-Claude in her family's Parisian home in the late 1950s, when he was the family portrait artist. He had fallen in love with her while painting her likeness despite his distaste for painting as an artist profession. The piece is dated 1963, the year Christo wrapped the portrait (hence designating its official status as a work of art).

"It was clearly a challenge to live with an artist who would spend an entire night lugging empty oil barrels up five flights of stairs to store in their tiny apartment."

to the equation that eventually allowed for found cans to be replaced by medieval castle towers and miles of Australian cliff tops. She became the final layer that sealed each work for its temporary albeit unforgettable existence. Without Jeanne-Claude, Christo would never have become Christo.

One of their first real public interventions, *The Iron Curtain*, occurred in 1962.[2] On an early summer day, Christo and Jeanne-Claude orchestrated the stacking of eighty-nine multicolored oil barrels in a narrow street, which blocked Parisian traffic. When the police arrived, Jeanne-Claude unhesitatingly went into action. She delayed them by looking for a fictional permit, thrusting wads of papers at them to keep them distracted. When a crowd gathered, she became more invigorated. She managed to convince the officers to allow the installation to remain until midnight. When they walked away she posed for photographs in front of the barrels in her green Christian Dior dress, salvaging every minute of the installation until the stroke of twelve, upon which they all disappeared like magic.

From 1961 through 1994, the couple signed off on every art piece under the single name "Christo." Jeanne-Claude never tried to be an artist the way Christo was trained to be one. She never drew any of the illustrations that served as project proposals—and were consequently sold to fund their projects. Yet, she was a masterful organizer, a negotiator, and a spokesperson. For example, it was her idea that they always flew in separate planes when traveling to a new installation location. It was a strict rule to insure the continuation of the work should one of their planes crash. On many occasions all eyes were on Jeanne-Claude because she was the one publicly challenging questions and accusations with humor and confidence. They were a fused entity, "an eagle with two heads."[3]

The first bit of coverage of Christo's 1968 Australian installation *Wrapped Coast* silenced the world for a minute. What followed was a barrage of voices, many of which expressed lashing disapproval. Some assumed the artwork subtracted funds from serious issues like health and environmental safety (an assumption that goes against the grain of their practice) while others merely disliked the description of the work, finding it pretentious. The choir of uninformed objection contributed an important element to their projects—the power of collective ignorance. A month later when it was complete and the one million square feet of erosion control fabric ballooned off the rocky

Christo and Jeanne-Claude
Wall of Oil Barrels – The Iron Curtain,
1961–62
Rue Visconti, Paris
13^7/10' x 13^1/5' x 2^7/10'

Christo and Jeanne-Claude collected 89 oil barrels to barricade a narrow one-way street on Paris' Left Bank, for eight hours in September of 1961, the same year that the Berlin Wall was constructed and demonstrations and barricades protesting the Algerian War were occurring throughout the city. This project marked the beginning of Christo and Jeanne-Claude's unique balance as a collaborative artist couple. While Christo was the quiet engineer of their many installations, Jeanne-Claude was the fearless spokesperson who never doubted or allowed their work to be compromised.

[pages 150–151]

Christo and Jeanne-Claude
Wrapped Coast, 1968–69
Little Bay, Sydney, Australia
One million square feet

In 1968, Australia granted Christo and
Jeanne-Claude thirty-five miles of a
jagged coastline south of Sydney to wrap
in white fabric. For the artist duo who
started their career building walls with
discarded oil barrels, this was a game
changer in terms of a "canvas" to work with.
Financing the entire project with sales of
Christo's numerous illustrated proposals
for *Wrapped Coast,* they assembled a
team that included fifteen professional
mountain climbers led by a retired army
corps engineer. In 17,000 man-hours they
fastened a million square feet of eco-
friendly fabric to the rocks with Ramset
guns. When they completed it, shimmering
white material ballooned off the bay,
altering the landscape every second, for
ten weeks straight.

Australian bay, silence returned. This time, the audible human reaction
was driven more by awe and less by concern about potential art-inspired
corruption.

In the decades that followed *Wrapped Coast,* Christo and Jeanne-Claude
(in 1995 they retroactively changed the attribution of all their artwork from
"Christo" to "Christo and Jeanne-Claude") have maintained their manifesto
for existence. There is no visible evidence of their fundamental values chang-
ing—although they have always opened their practice up for discussion. The
audience engagement has always had a platform for them—and they, namely
Jeanne-Claude, have always had answers. They have vocally debunked
people for incessantly reducing their art to the action of wrapping. As stated
on the section of their website titled *Errors*: "It is totally idiotic to call Christo
and Jeanne-Claude the 'wrapping artists.' . . . The 'wrapping' is NOT at all the
common denominator of the works. What is really the common denominator
is the use of fabric, cloth, textile. Fragile, sensual, and temporary materials
which translate the temporary character of the works of art."[4]

> " *They promised one another the work would
> not stop being made when one of them left the
> world. A challenge, yes, but one that Christo
> has unhesitatingly met.* "

Where there is complete lack of inhibition to propose projects, explore
foreign places, and take dangerous risks, there has been just as much
protectiveness of the unique environment they've created within the larger,
ever changing world. In the literal sense, they have lived in the same house
since moving to New York City in 1964, where Christo still works from his
studio on the fifth floor (there is no elevator). They have never once accepted
outside capital or donations to subsidize their extremely costly work, claiming
that to do so would be to sacrifice some bit of freedom. "It is expensive to be
free," Jeanne-Claude has said of their commitment to self-finance. They have
relentlessly pursued their visions, receiving permission to work with territory
and monuments that were seemingly untouchable. When they constructed
the concept for *The Gates*—the saffron arches that flapped in the wind above
all the pedestrian paths in Central Park—they never gave up on making it
a reality during the twenty-two years it took to be approved. For Christo
and Jeanne-Claude, it was a uniquely personal piece that emerged from the
process of tying their nomadic identities to New York, the place where people
are always going *somewhere*. Their fascination with the nonstop peripatetic

Jeanne-Claude and Christo at *The Gates* in New York City's Central Park, 2005. Photograph by Wolfgang Volz.

In 2005, New York City's most cherished plot of land—Central Park—became Christo and Jeanne-Claude's terrain to temporarily transform with a vision they had been developing for twenty-six years. Since the first blueprint proposal, the municipal government of New York had refused permission to create *The Gates*—until Mayor Bloomberg was elected in 2001. For the installation, 7,503 saffron fabric panels were installed on poles to hang over twenty-three miles of pedestrian walkway. From a distance, the park looked appeared as though it were threaded with an ever-shifting ribbon, sometimes described as a "golden river" or an "orange serpent." *The Gates*, kept up for sixteen days, drew thousands of foreigners to New York and boosted the city's economy by over $250 million.

nature of the city lead them to *The Gates*—which was the last project Jeanne-Claude witnessed before she passed away in 2009.

Jeanne-Claude thrived on answering the barrage of questions and arguments that swarmed around their artworks. She relished in the way Christo shyly smiled whenever she quieted the room with her boldness (what else could be expected from a woman with flaming orange hair?). When asked which of their projects was her favorite, she'd answer, "The next one."[5] They promised one another the work would not stop being made when one of them left the world. A challenge, yes, but one that Christo has unhesitatingly met. On one of the few occasions that he's publicly spoken about Jeanne-Claude in the past tense, as an absence, he said, "I lived with Jeanne-Claude for over fifty years. One of the most important parts was that she was a very critical person, argumentative and extremely critical of everything, and this is one of the greatest things I miss. She was very critical, and that is something artists need all the time."[6]

BERND & HILLA
BECHER

THE NOMADS

> *The notion of settling down in one place seemed baffling to Bernd and Hilla Becher, like accepting an early death.*

BERND AND HILLA BECHER RECOGNIZED THE SAME GHOSTS. THEY perceived this in the diffused sunlight of the afternoon, through the single lens of a metal-folding Linhof camera in 1958. They were both art students at Düsseldorf Academy, where Hilla was the head of the darkroom and the only student to be admitted into the program solely based on her photographic portfolio. Bernd had been the one to encourage her to apply, when he had observed her straightforward and masterful technique at the Troost advertising agency where they both worked in 1957. In turn, he impressed her with his familiarity of the Düsseldorf region when the two started dipping into local adventures to explore the source of their shared fascination—the monuments of heavy industry.

They never referred to the buildings as ghosts—although Bernd was especially concerned that they were "doomed to disappear."[1] Blatantly attaching themselves to a phantasmagoric analogy would have been too abstract for the two very precise, methodical Germans. The Bechers did not obscure reality just because they had the artist's license to do so. They documented the birth of western modernism in a scientific manner, one that removed their subjectivity from the images. Even so, their work often sends chills down their viewers' spines. According to Bernd, they conducted their work with future generations in mind and "wish[ed] to send as much as possible in a package to the future."[2] Captured from numerous carefully plotted angles, the black and white photographs preserve the ephemeral stillness and, despite the calculated exclusion of personal touch, mournful quality of now extinct industrial architecture. In "Notes from her Travels" Hilla Becher wrote in 1980: "Everything is lying around as if people have just left—coffee cups, a pile of thrillers, clothing, tools—but it's all covered

Hilla annd Bernd Becher
Self Portrait, 1985

in a thick layer of dust. This room has a number of windows, and from one of them we can get a wonderful shot of the blast furnace."[3]

The Bechers adopted "objective" photography to remember where they came from. In doing so, they provided an opposition to the "gooey and sentimental subjectivist photographic aesthetics that arose in the early post-war period."[4] Bernd had grown up in the mining town of Siegen, next to a massive blast furnace, during World War II. While Germany fell to pieces in his periphery, he would wake up in the morning to draw numerous illustrations of the furnace. The day it started to be demolished, in his urgency to capture it, he turned to photography. When reflecting on his attraction to the furnace, as opposed to sacred or cultural structures like churches and museums, he explained that the war robbed him of the "European opportunity to delve into the past."[5] He didn't connect to the Europe all the tourists wanted to see, with its cobblestones and stained glass windows. His Europe was the steel mills, the mines, the furnaces. For Hilla, who had fled the Pomeranian region in Poland with her photographer mother, the camera offered a new way of *looking* within an unstable existence. Exhibiting an early talent, she "became the apprentice of Walter Eichgrun, whose family had been, for three generations, photographers to the Prussian court at Sans Souci. Deeply traditional, Eichgrun taught her the fundamental techniques of his conservative approach to photography."[6] When she ventured off on her own to explore the country, "the strange and manifold creatures slipping past her train window" engaged her to create an active correspondence with them.[7]

"They found happiness in forgotten rooms deep inside old deserted factories, where they waited for the rain to pass."

Bernd and Hilla Becher
Blast Furnace, Hainer Hütte, Siegen, Germany, 1961
Gelatin silver print
11³/₄" x 15³/₄"

The Bechers took photographs of this blast furnace that Bernd had grown up next to in Siegen, Germany. Bernd was raised by coal miners; his artistic subject matter was ingrained at a young age. *Hainer Hütte* is certainly the most personal of their "anonymous sculptures."

Bernd and Hilla Becher
Water Towers, 1994–1995, 2003
9 black and white photographs
68¹/₄" x 56¹/₄"

The Bechers created hundreds of these "typologies," grids of images depicting variations of a singular kind of industrial structure.

The Bechers became a happy, *unsettled* couple. Their standard of living revolved around constant travel to find all the first-generation industrial sites in the world before they were potentially destroyed. They could see the way an abandoned plant in America's fly-over country resembled a "thousand year old temple tucked into a jungle."[8] They found happiness in forgotten rooms deep inside old deserted factories, where they waited for the rain to pass. They comforted one another when local police pestered them to leave sites, embraced when they were bestowed with perfect natural light, argued when one wanted to shift the tripod a little to the left, and fell asleep wrapped up in old motel blankets. The notion of settling down in one place seemed baffling, like accepting an early death. The "anonymous sculptures"—many of which were rendered useless, no more than "corpses"—gave them a shared mission in life.

 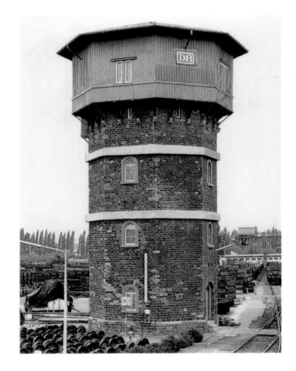

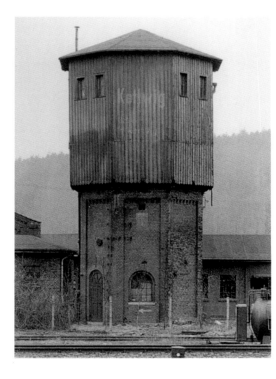 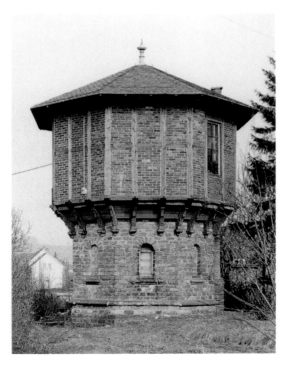 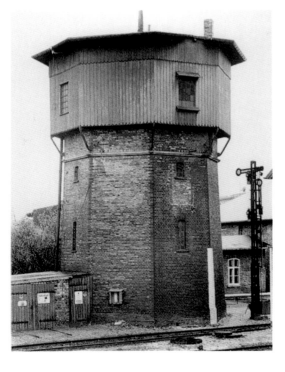

TOM
DOYLE
EVA HESSE

THE STURDY AND THE ABSURD

IN 1964 THE GERMAN INDUSTRIALIST FRIEDRICH ARNHARD SCHEIDT invited the married artists Eva Hesse and Tom Doyle to take a break from New York City and develop their individual artistic practices in his abandoned factory in Kettwig-am-Ruhr, Germany. Doyle, an all-American college football player type from Jerry City, Ohio, saw it as an opportunity to make his masculine sculptures alongside his wife in a massive space. For Hesse, it was the first return to the country she was forced to flee at the age of three during World War II, while her extended Jewish family stayed behind, to be killed in concentration camps. She was full of anxiety but traveled with Doyle to her birth land to see what it would set off in her art practice.

When the two arrived in Kettwig, the floor below theirs revealed a machinery slaughterhouse where giant spools were being dismantled. Doyle started dragging discarded bits up to their studio space and incorporating them into his sculptures. Hesse thought the parts resembled human organs spilling out of their shells. She instantly began creating drawings that synthesized human anatomy and machine. During their fifteen-month residency Hesse and Doyle created two separate bodies of work that shared a similar source of inspiration, a visual dialogue, materials, and colors. In this exchange, Hesse discovered herself simultaneously as an artist and a person—the fusion of which would become a slightly schizophrenic subject matter. This included recognizing

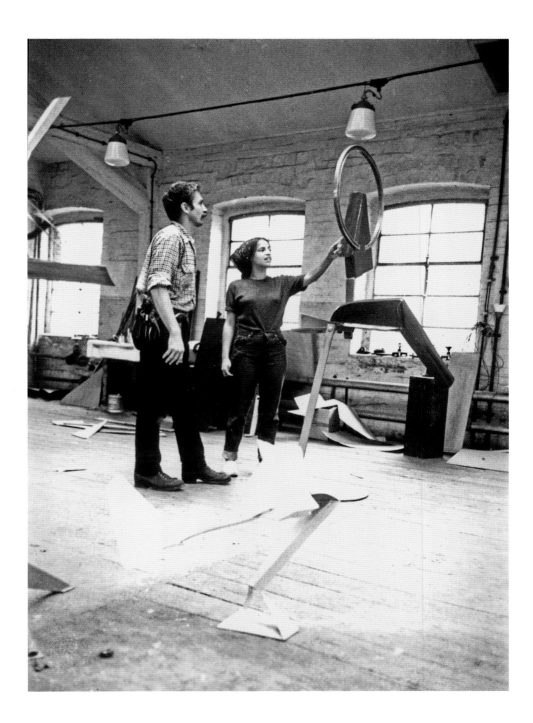

Tom Doyle and Eva Hesse in their studio in Kettwig-am-Ruhr, Germany, circa 1965. Photograph by Manfred Tischer.

their marital demise. As Doyle described, "We always got along in the studio. Outside the studio was chaos."[1]

Hesse traveled there as a painter, only to promptly discover she disliked painting. It didn't allow her to reach "the absurd," which was her self-proclaimed intention based on her life being filled with extremities. Years later she'd argue that her sculptures could be considered paintings, asserting that paintings and sculptures were interchangeable *in a way.* She had a tendency to argue herself into a circle, revealing a way of describing things almost paradoxically (everything was what it was not, and vice-versa). The "circle" was a major component in her work—but never as a symbol for the circle of life or anything similarly obvious.

She was self-conscious about her concern with the soul, the inner self. She didn't want to be seen as a romantic. This way of thinking also infected her marriage. The question "What does it mean to be a wife?" clashed with "What does it mean to be an artist?" At the end of a long day of working well together in the studio, she'd hang her artist cap up and return to the wife crisis. Her love of Simone de Beauvoir's book *The Second Sex* added fuel to her fire regarding the polemical challenge of being a female artist in the 1960s.

Doyle was known for his cowboy-ish appearance—mustache, pipe in hand, hardcore boots. He worked hard, steadily. His wood sculptures had initiated Scheidt's invitation to Germany. When visitors stopped by the factory studio to see *his* work, he made it a point to show them Hesse's work as well. He celebrated daily rituals and felt comfort in his Midwestern habits, like always eating a big breakfast. Hesse started resenting him for being inexhaustibly sweet and affectionate every morning. Maybe he whistled too much when she was feeling introspective about where she was—reflecting on what Germany had been during her first three years of life.

> *The floor below theirs revealed a machinery slaughterhouse, and Doyle started dragging discarded bits up to their studio and incorporating them into his sculptures.*

But then in the studio, the tension would evaporate to make room for her to concentrate on her work. Doyle would ask her to mix colors—something she had specialized in at Yale under Josef Albers's instruction—and she'd apply the perfect shade of blue or yellow enamel to his sculptures. They would both become consumed with the mechanical parts. She created a series of drawings that would evolve into the "German reliefs" that established the basis for her sculptor identity. Doyle would study her drawings and wet Masonite in hot water to mold into a resemblance of one of her drawings. She'd take the debris—"fall offs" as he called them—from his sculpture to make her own. *Legs of a Walking Ball* is a significant example of the way Hesse teased her drawings out into sculptural forms. They would think of titles together, some of which were inside jokes between them. "Hesse's reliefs are, in a sense, documents of their marriage and artistic exchange; they are embroidered with references to Doyle, grafted with fragments to his culture and history through their titles and their quotations of his sculpture."[2]

For Hesse, because the definitive was interminably questionable, she was in denial about the separation when she and Doyle returned to New York and

Tom Doyle
B.C. BEFORE 3C, 1965
Polychrome steel
5' x 3'

Doyle studied art under the pop artist Roy Lichtenstein at Ohio State University. While renting a room in his house, he watched Lichtenstein paint. Like many of the young sculptors in New York at the time, who were influenced by abstract expressionist painters, Doyle was drawn to the idea of working with free space, and molding a work within it. He particularly wanted to create large sculptures that appeared as if they were floating, without emphasis on physical support.

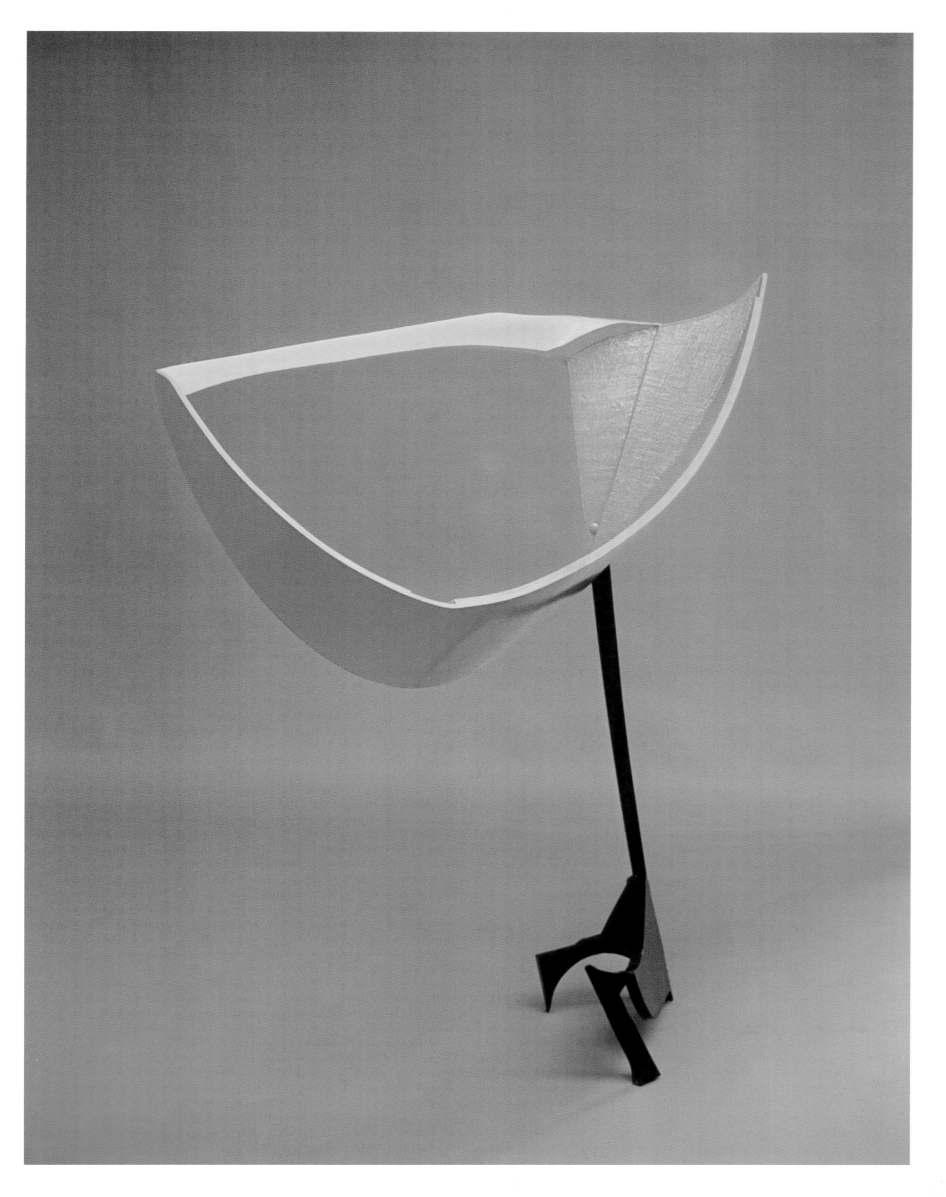

Eva Hesse
Study for or after *Legs of a Walking Ball*, 1965
Colored ink and gouache on paper
11 1/5″ x 16″

"*Hesse thought the parts resembled human organs spilling out of their shells. She instantly began creating drawings that synthesized human anatomy and machine.*"

divorced in 1966. He took a step out of the city's art scene and decided to work in the expanded field of the outdoors, where he could increase the scale of his sculptures, forcing the viewer's experience to involve walking around, onto, and into them. He probably didn't want to share the platform with Hesse anymore either, as some major critics had started throwing tomatoes at him for being a misogynist as she escalated in the realm of feminist sculpture. Journal entries revealed her coping with it—sometimes admitting to it as a failure on her part. Dolye shrugged off his distance from the gallery world in an interview: "I felt like a girl who quit the whorehouse when she found out the others were getting paid. . . . I mean, I only did it for love."[3]

Eva Hesse
Legs of a Walking Ball, 1965
Varnish, tempera, enamel, cord, metal,
papier-mâché, unknown modeling
compound, particle board, wood
17³/₄" x 26³/₈" x 5¹/₂"

Hesse shifted from painting to sculpture
during her artist residency with Doyle
in Germany. He was making work that
would eventually be intended for outdoor
exhibition, as a part of the land, whereas her
works were about the internalization of the
body and the mind. "My works are much
closer to the soul or introspection, to inner
feelings. They are not for architecture or sun,
water or for the trees, and they have nothing
to do with color or nature or making a nice
sculpture garden. They are indoor things."[4]

In the three years that followed, life only tumbled for Hesse with the
death of her father and the diagnosis of her brain tumor. Despite the series of
paralyzing news, she continued to forge ahead with her sculptures. Within five
years of her German reliefs she created a powerful body of her own version
of minimalist and geometric art mastered by the likes of Carl Andre and
Sol LeWitt. Unlike anything done before with that kind of form, her pieces
appeared to have the gravity partially knocked out of them as they drooped
and cascaded across rooms. When exhibited in galleries, visitors have not
been able to resist the urge to touch them as though they'd melt in the first
second of contact or release an electric shock. Despite her dislike of the word,
this came to define "feminist" sculpture because it added a specific life form to
work that had been considered cold and masculine-dominated. When Cindy
Nemser interviewed Hesse right before she died at the age of thirty-four,
Hesse described art's unique placement in her tumultuous life as "the only
thing I never had to do."[5]

ROBERT SMITHSON & NANCY HOLT

THE DIGGERS

THE FOLLOWING IS A CLIP OF DIALOG FROM *SWAMP*, AN EXPERIMENTAL film made in 1971 by husband-and-wife environmental artists Robert Smithson and Nancy Holt. In this film, Holt wanders into a reed-filled swamp in New Jersey, allowing the clunky film camera to be her eyes, her sole vision, while Smithson walks behind her, navigating her movement.

SMITHSON: Walk straight. Walk straight into that clump. Straight in. Just go right in. It is ok. Go ahead.

HOLT: So much of it is out of focus.

SMITHSON: Well, just go right in. Don't worry about the focus. Just keep advancing in as much as you can. . . . Oh. Wait. Head over that way.

HOLT: Which way? I can't see anything.

SMITHSON [*slightly impatient*]: To your right.

HOLT: My legs are stuck.

SMITHSON: That's ok.

HOLT [*exasperated*]: I think that there's too much. I really . . .

SMITHSON: Well then, hold it for a while. Try to pick up that body of water back there.

HOLT: Where is it?

SMITHSON: Directly in front of you.

HOLT: Oh . . .

SMITHSON: Make an about-face.

HOLT: An about-face?

SMITHSON: Go back the way you came. And shoot into the density of it.

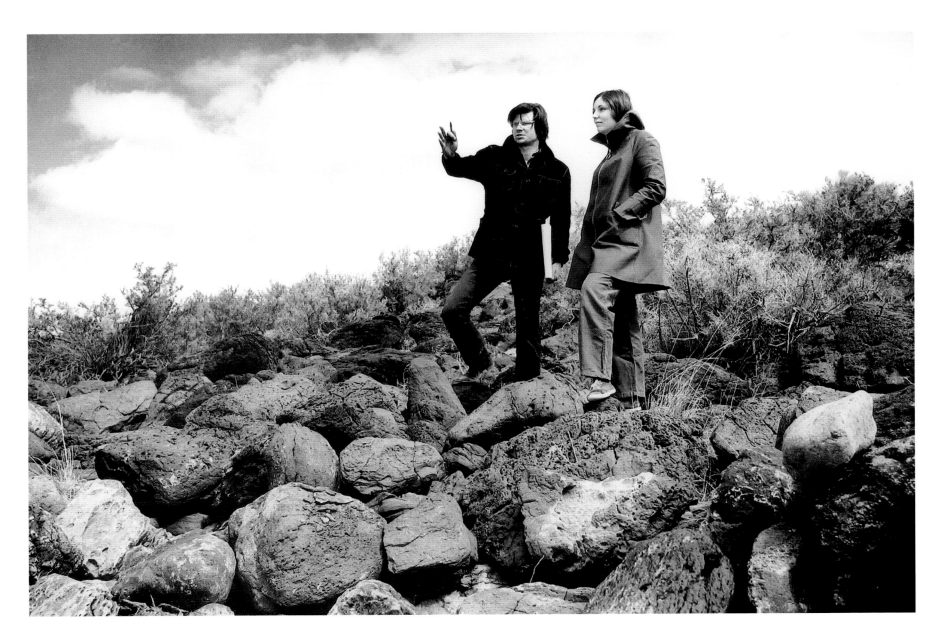

Robert Smithson and Nancy Holt at the
Spiral Jetty site in Utah, 1970.
Photograph by Gianfranco Gorgoni.

The "density of it" was a thicket of reeds, a bit of land that was never explored, probably forgotten, until Smithson and Holt ventured in to film it. Prior to *Swamp*, they had been making art in similarly desolate areas of the country for some time. They were two of the pioneers in a conceptual art movement that prided itself on making art outside the walled confines of a studio—art that wasn't meant to be created or exhibited in an enclosed space. They did not need to make art that lasted *forever*, either—the fight for artistic immortality died on some level in the 1960s, when the whole world was reconsidering its framework and boundaries. A group of artists veered off the predetermined paths that would have taken their work from a classroom to a studio to a gallery, and, ultimately, to a museum wall, or, worse, a dark storage space. Out of this static environment, Robert Smithson and Nancy Holt deserted the waiting-room atmosphere of the art world—for the desert.

Catching wind of the movement, the director and producer Gary Schum followed Smithson and other artists into the wilderness to film their work for a "television exhibition" called *Land Art*. The hour-long documentary, which aired on a Sunday night, bored the hell out of seasoned television viewers.

Robert Smithson and Nancy Holt
Still from *Swamp*, 1971
6-minute, color/sound 16mm film on video

In reference to the experience of filming *Swamp*, Holt explained, "It deals with limitations of perception through the camera eye as Bob and I struggled through a muddy New Jersey swamp. Verbal direction cannot easily be followed as the reeds crash against the camera lens, blocking vision and forming continuously shifting patterns; confusion ensues."[1]

When asked for a response, one particular nonplussed art critic commented, "They go out into the deserts and onto the oceans. There, where it is loneliest, they engage in their games with the elements. Generally, a camera observes their activities. Their transient works are quickly scattered by the wind, washed over by the water."[2] And it was true. That was exactly what happened with the largest artworks made in the twentieth century. Centered on a direct relationship to the land, the work was a journey for the artists. People did not need to follow them if they didn't want to. The lines of "land art" were dictated by the artist's need to travel, to move.

Holt instantly realized the Southwest was her canvas when she and Smithson drove out to the Colorado Rockies with their friend, fellow artist Michael Heizer. As a photographer who often thought about how the Earth looked from the stars, being in the Southwest made her feel "like I was colliding with the universe. Everything we said and did seemed to reverberate into the great outer space and we were establishing a whole new paradigm."[3] They set out to do their own research. Smithson focused on the compacted layers of rock that they scrambled around on, while Holt studied the way sunlight traveled across it. When they returned to New York in 1968, Smithson brought some of the rocky land back with him, referring to it as "fragments experienced in the physical abyss."[4] It was exhibited in a group show called *Earth Works* with other (only male) land artists at the Dwan gallery in New York the same year. Why wasn't Holt included in the exhibition? Aside from the fact that the art community still tiptoed around presenting women on the same stage as their male counterparts (and the

"land art" scene was *very* macho), Holt was still figuring out how to capture the sun (something she couldn't scoop up and take with her). While Smithson indulged in determining his work as *non-sites* and *sites*, she needed to be site-specific.

Two years later, Smithson completed the construction of *Spiral Jetty*, the most well-known "earth work" ever made, in the muddy, red, dehydrated Great Salt Lake of Utah. Shaped like a coiled circle with a tail, it was 1,500 feet long, made of 6,738 tons of black basalt rock, earth, salt crystals, algae, and water. It resembled the ancient Nazca lines etched into the Peruvian desert in AD 400—specifically the monkey's tail—made for the gods to see from the sky. Whereas the pre-Incan Nazcas had created their markings—which are presently best viewed from airplanes—digging in the earth with handheld rocks, Smithson directed a team of bulldozers to create his spiral, making it strong enough to sustain the fluctuating water levels in the lake which would, at times, rise so high the sculpture would be entirely submerged.

> " *In his investigation of the center, Smithson always remained on the periphery, with a predisposition to drill southwards—like an archeologist, along a circular downward slope.* "

While her husband worked quickly, with big teams and machines, Holt visually meditated on the landscape, in awe of the way it mirrored her inner sentiment. She roamed the terrain with a constant regard for what it looked like from an aerial view, the way it reduced her to a fleck on a map. Her first project in the land was a very quiet one—Holt buried five poems dedicated to five different artists (Michael Heizer, Philip Leider, Carl Andre, John Perrault, and Robert Smithson), in various locations that best reminded her of their personalities. She took a photograph of each location, typed detailed directions to the site, described in writing the habitat of the surrounding area, and sent this in a package—along with a map, and various nearby rocks and leaves—to each of the artists. They were not meant to be, nor have they been, dug up—but her decision to bury the poems in vacuum-sealed containers suggests that Holt expects, one day, they may surface—and be read.

Four years after Holt's *Buried Poems*, Smithson died in a plane crash while surveying a site for the sculpture *Amarillo Ramp*. He was thirty-five, planning the construction of a minimalist slant on the Tower of Babel—a rock ramp that formed a semicircle, dropping off once it reached fifteen feet above the ground. In imagining the last conversation of his life, most likely one that

[pages 168–169]

Robert Smithson
Spiral Jetty, 1970
Mud, precipitated salt crystals, rocks, water coil
Rozel Point, Great Salt Lake, Utah
1500' x 15'

Two years before his most famous and final work, *Spiral Jetty*, was completed, Smithson, who wrote quite extensively, released his well-known essay "A Sedimentation of the Mind: Earth Projects." In it he described his artistic philosophy, one that Holt shared: "One's mind and the earth are in a constant state of erosion, mental rivers wear away abstract banks, brainwaves undermine cliffs of thought, ideas decompose into stones of unknowing, and conceptual crystallizations break apart into deposits of gritty reason."[5]

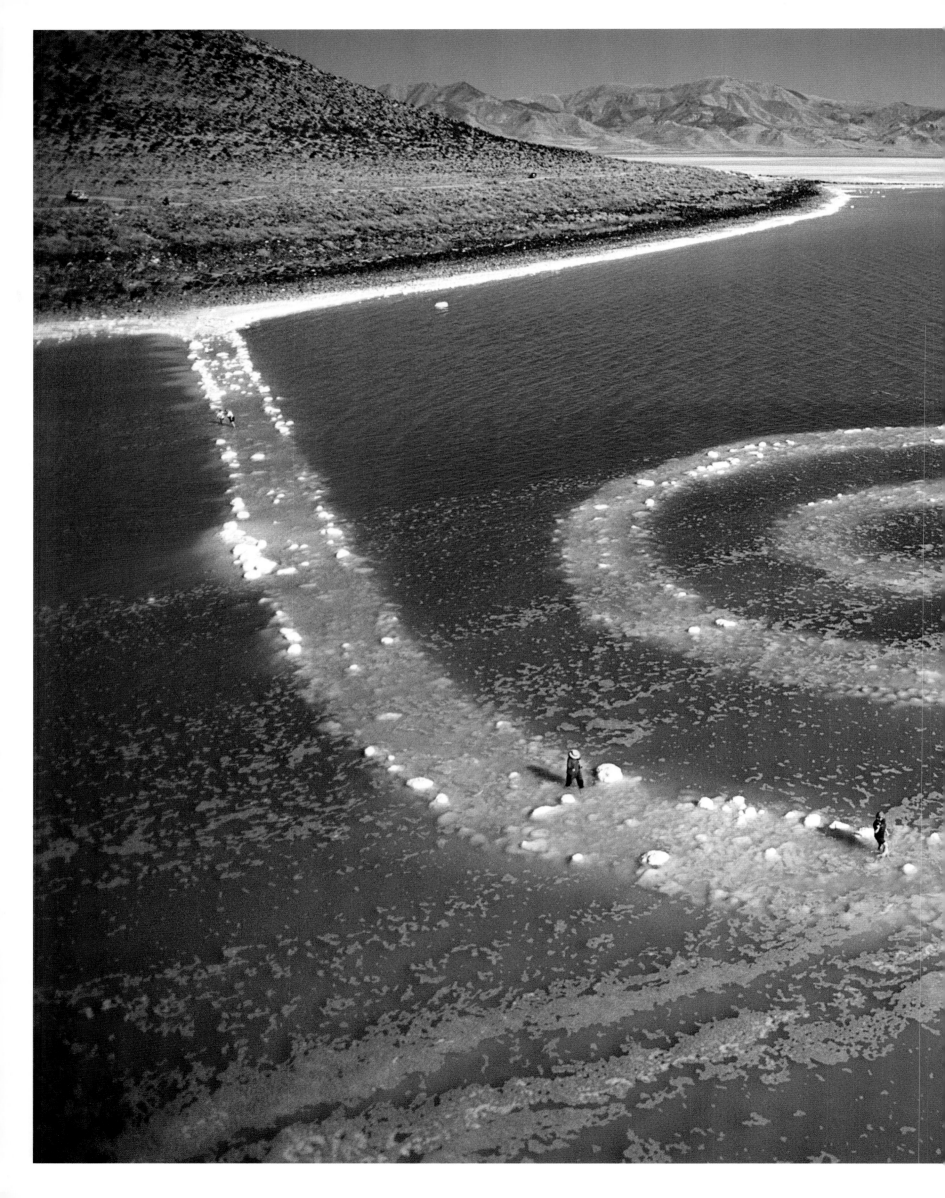

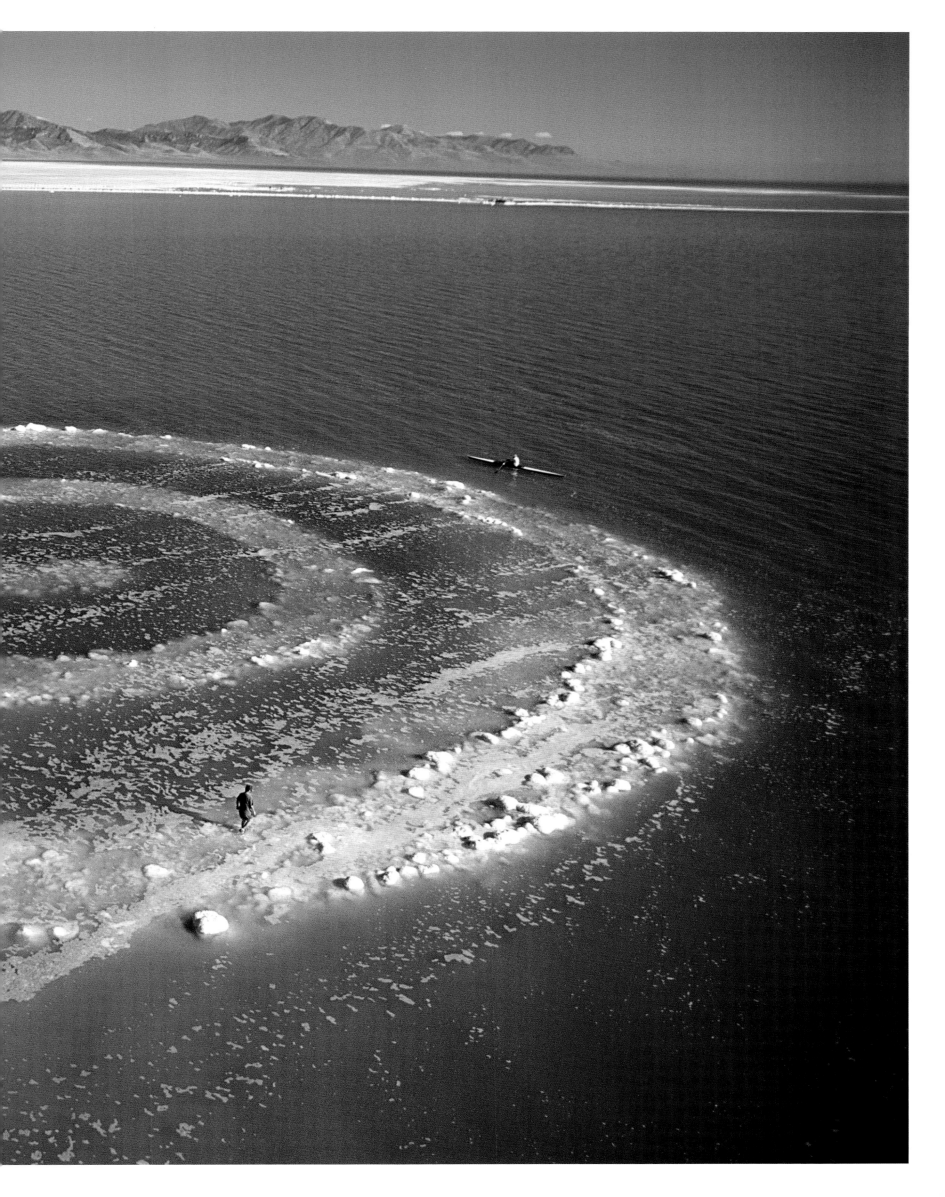

Nancy Holt
Sun Tunnels, 1976
4 concrete tubes with drilled holes
Great Basin Desert, Utah

During the four years Holt spent working on the *Sun Tunnels*, she collaborated with an astrophysicist and several astronomers to align the tubes in such a way as to allow them to flood with light during the winter and summer solstices. Like Smithson's *Spiral Jetty*, the installation involved a major undertaking, requiring delivery trucks, cranes, and a helicopter, and introducing a high volume of activity to this isolated corner of the desert during the time of its creation.

"Holt's gaze tended to travel upwards, imagining the view from above, a place she could not reach, that could only reach her."

involved him giving his pilot instructions—it is hard *not* to think of Smithson's voice during the filming of *Swamp*, the way he assertively directed Holt to "Walk straight into that clump. Straight in." In his investigation of the center, Smithson always remained on the periphery, with a predisposition to drill southwards—like an archeologist, along a circular downward slope. Holt's gaze tended to travel upwards, imagining the view from above, a place she could not reach, that could only reach her. It was in Amarillo, where she completed Smithson's sculpture, that she conceived of the idea for *Sun Tunnels*. Not too far from Smithson's sinking *Spiral Jetty*, it consists of four large concrete tunnels placed at an axis in the desert that floods with sunlight twice a year, during summer and winter solstices. They are keyholes to the universe, a place where "stars are cast down to earth, spots of warmth in cool tunnels."[6]

NIKI
DE SAINT PHALLE
JEAN TINGUELY

BONNIE AND CLYDE

NIKI DE SAINT PHALLE, THE PATRON SAINT OF SHOOTING AT ART, the coquette of *nouveau réalisme*, offered the world something very enticing in 1966. At the Moderna Museet in Stockholm, visitors walked through the museum doors into a spacious room partially filled with the spread legs of a supine woman and were invited to wander into her "cathedral" entrance. Through the brightly tiled tunnel, inside her palatial uterus, there was a well-stocked bar, an aquarium—and an "orgasm machine" that resembled a Rube Goldberg contraption. *She: A Cathedral* was one of the early collaborations between Saint Phalle and her kinetic-sculptor husband Jean Tinguely, which exhibited their shared proviso that "art should be fun." She created the Gaudí-inspired sculpture of the woman's climbable mosaic-tile legs, while he supplied the mechanized orgasm. In order to experience their work, people had to physically move through it and be open to machine-operated malfunction. Needless to say, their hypersexual interactive sculpture became very popular with children.

Prior to their coming together as the "Bonnie and Clyde of Art" (the title of a 2010 film about their work), Saint Phalle and Tinguely were both undergoing delightfully destructive phases in their art practices. Saint Phalle had discovered painting as a form of therapy while in a Massachusetts asylum recovering from a nervous breakdown. "At other times in history, I would have been locked up for good,"[1] she once said. After being discharged, the former fashion model fled to Paris and discovered how to paint with a

Jean Tinguely and Niki de Saint Phalle, 1963. Photograph by Harry Shunk.

Niki de Saint Phalle, Jean Tinguely, and Per Olof in front of *Hon [She] – a Cathedral,* at the Moderna Museet, Sweden, 1966.

According to Saint Phalle's illustrative blueprints for the collaborative installation, *Hon* was the "biggest and the best woman in the world." The original design made it so museum visitors could sit in a "lover's nest" in her calf and ride a slide that traveled the inside of her thighs. For a time Greta Garbo films were projected inside her cavernous stomach. The bar was situated in her breast. She was a headless woman, with her neck positioned as the cul-de-sac of the experience.

.22 rifle. Each time she stretched her canvas, she sewed in satchels of paint. Being able to "shoot Daddy" over and over again released a lot of aggression, giving her a sense of calm each time the paint exploded and dripped from its wounds. She took advantage of the most evident way to attack the universal male expectation of her by publicly undermining patriarchy. This didn't ruffle too many feathers in Paris—the city had seen it all, especially this Freudian workbook activity. In fact, Paris applauded her. She was quickly invited into the inner artist circle, the New Realists. Although her art wasn't deeply investigative, it offered clever commentary to the more serious trajectory of art because "action paintings" were dominating the art scene. Her frisky mockery of this also functioned as an homage to artists like Jasper Johns (specifically regarding her use of the gun target that had made him so famous). After she got the shooting out of her system, she settled into papier-mâché sculptures of maternal, Venus-inspired women, which she called *Nanas*.

Around the time Saint Phalle was exploding paint bombs, Tinguely was blowing his art up. After seeing the skyscrapers of New York City from an airplane window, he executed *Homage to New York*, a public sculpture that self-destructed into a smoke cloud in MoMA's sculpture garden. The museum supplied him with a Buckminster Fuller geodesic dome workshop to assemble

a "machine that served no purpose," which ran on bicycle and baby stroller wheels. Tinguely convinced the head curator that it was the perfect tribute to the city that continuously rebuilt itself. The day he completed it, he brought it to life with fireworks for the sole purpose of watching it overwork itself into a staggered death in just half an hour. Witnessing one of his sculptures in action was like watching a slapstick, cartoony anti-hero who never learned from his mistakes. Tinguely would double over with laughter, slapping himself on the forehead, revealing a clear resemblance between the artist and his art.

When Tinguely returned to Paris, he joined the bombshell Saint Phalle in shooting paintings in the New Realist's Dionysian courtyards. They were both married to others, but that didn't stop them from moving into a sprawling, storybook, upside down–ish house south of Paris. Saint Phalle was progressing from papier-mâché to mosaic tile sculptures of female dolls. Once she got her patriarchy-directed wrath out of her system, she settled into making work about matriarchal stereotypes, such as her childhood nanny (whom she had called "Nana"). As her sculptures of women grew to become house-sized, they brought a more figurative element, and occasionally, an outer membrane to Tinguely's minimalist black iron kinetic sculptures. Some people, much to Tinguely's amusement, declared his "meta-matics" (his title for the machine-operated abstract movement he created) to be *anti*-art. As Marcel Duchamp, his hero, claimed, in a way that rapidly reduced this criticism, "to be what people call anti-art is really to affirm art, in the same way that an atheist affirms God."[2]

The trigger-happy, pyromaniac duo never outwardly exhibited much concern for elitist criticism. Judgment didn't torture them the way it did some other artists (e.g., abstract expressionists). Besides, Tinguely's "meta-matics"

Niki de Saint Phalle
Study for *Le Paradis Fantastique*, 1967
Ink and crayon on paper
14" x 21⅞"

All of Saint Phalle's ideas started with childlike scribbles. Based on her own claims, she didn't know how to draw three-dimensionally. Regardless, she took great pleasure in the initial phase of drawing and describing the works.

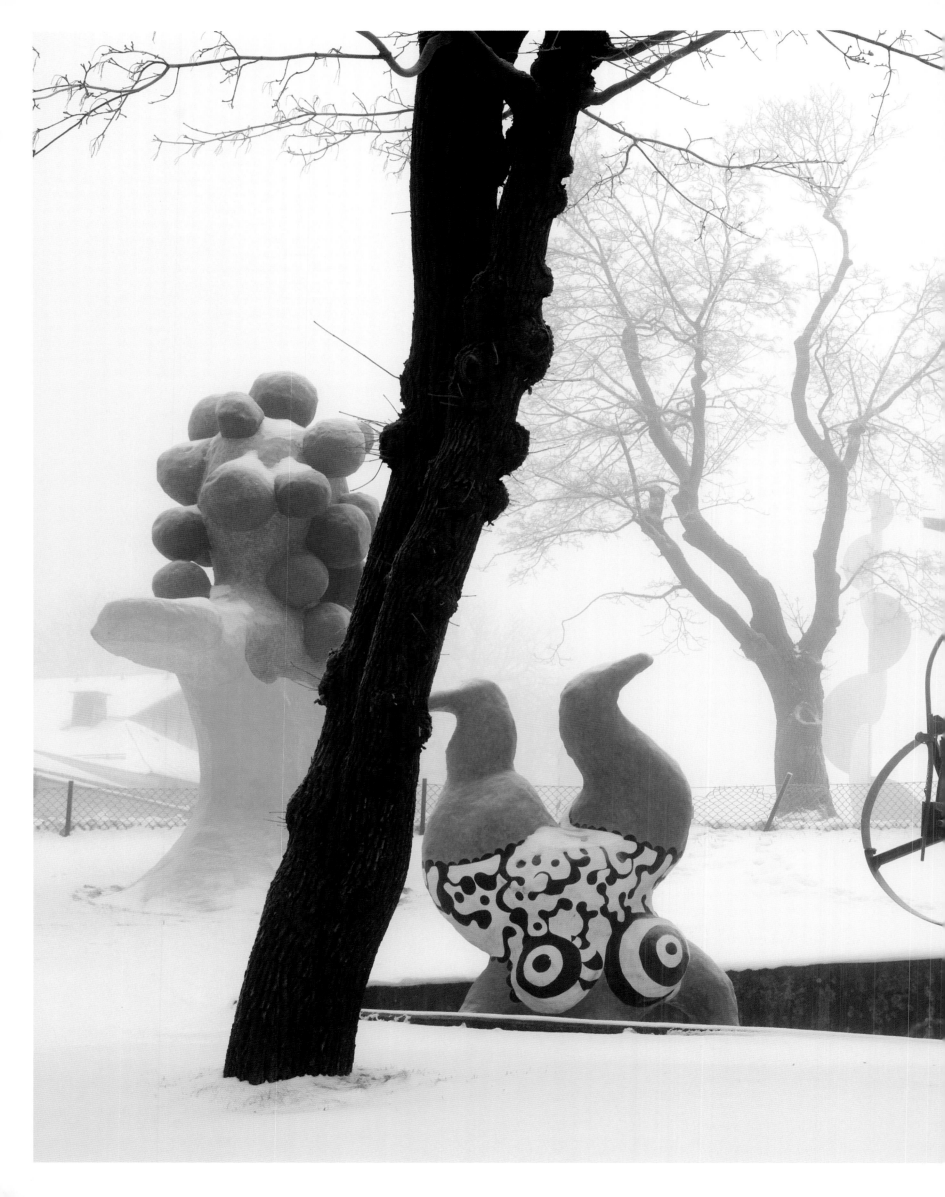

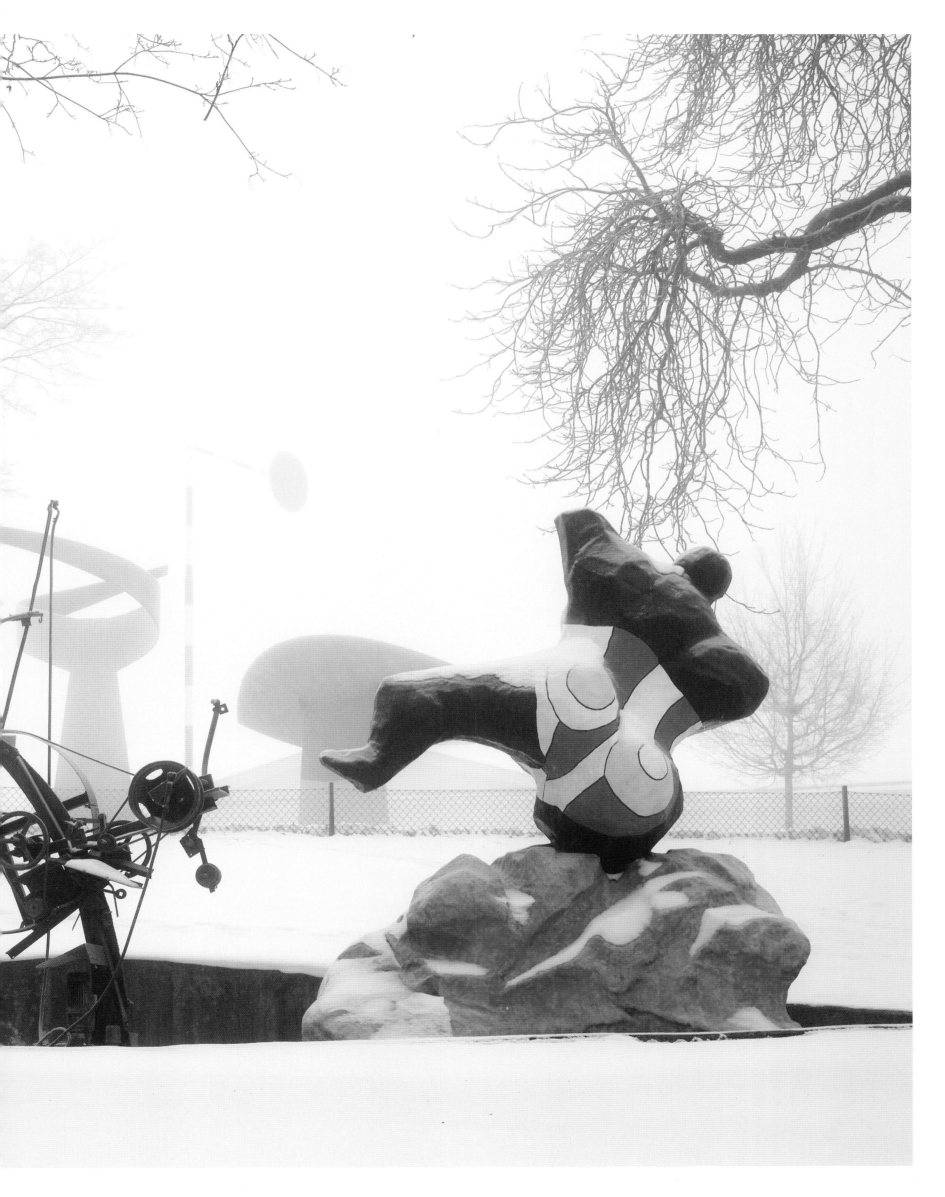

[pages 176–177]

Niki de Saint Phalle and Jean Tinguely
Le Paradis Fantastique, circa 1970
Sculpture Garden
Moderna Museet, Stockholm, Sweden

Le Paradis Fantastique was originally designed only to exist at the World Fair in Montreal in 1967, but based on popular demand, traveled to Albright Knox in Buffalo, then New York City's Central Park, and finally to Stockholm, the site of Saint Phalle and Tinguely's first major collaboration, where it has remained ever since.

Niki de Saint Phalle and Jean Tinguely
Detail from *La Fontaine Stravinsky*, 1982
Painted polyester, with metal sculptures
Square in front of Centre Georges Pompidou,
Paris, France
118'2" × 54'2"

In an interview that took place when the *Stravinsky Fountain* was unveiled, Tinguely explained the importance of Saint-Phalle's contribution: "I wanted [the fountain] to have charm, with the colors of Niki, the movement of the water, and a certain attachment of the heart that I gave to my sculptures. I didn't want artifices of color in the California style, with jets of water that were electronically controlled, things mysterious and bizarre. I wanted sculptures like street performers, a little bit like a circus, which was at the heart of Stravinsky's style itself when in 1914 he had his first encounter with jazz."[3]

came out of the same art history cradle that prompted the dada movement. The major issue the couple faced was the same that had fueled their bond— they just couldn't stand for things to remain still. In this sense, they struggled with the dust-settling of monogamy. Both had agreed to welcome other lovers into their junkyard love nest, but that eventually imploded in on itself like one of Tinguely's sculptures.

Their joint installations gained momentum in global conversations surrounding public art. The two embraced this evolution even as their relationship lost its footing. Though they continued to steadily collaborate on chimerical installations with names like *Le Paradis Fantastique*, it wasn't always harmonious. As Saint-Phalle's granddaughter recalled, "Jean was like a hurricane. If he arrived to find one of Niki's boyfriends, he'd make it clear that he was the man in Niki's life, that this was his territory, that she was his wife. And if they didn't approve of each other's lovers, the relationships wouldn't last."[4] While it might have made their personal lives difficult, their shared territorial dominance flourished in the realm of public spaces. *Le Paradis Fantastique*, which they first created a year into their relationship, was originally commissioned by the French government to be exhibited at an art expo in Montreal. The layout of the fifteen sculptures (nine by her, six by him) eventually traveled to Central Park in New York City and, ultimately, across the Atlantic to Sweden.

> "Both had agreed to welcome other lovers into their junkyard love nest, but that eventually imploded in on itself like one of Tinguely's sculptures."

In 1982 when the city of Paris commissioned Tinguely to design the *Stravinsky Fountain* in front of Centre Pompidou, they expected it to be pure black lines, in constant chaotic movement to match the city's rhythm. It seemed to be the most appropriate testimony to the experimental modernist composer behind *The Rite of Spring*. When Tinguely realized Niki wasn't included in the plan, he refused to take part until they included her. Several commissioners shuddered at this. Again, from a snobby intellectual perspective, Saint Phalle wasn't up to snuff: there were too many smiling faces and cheery tones in her work. But Tinguely did not budge until they factored in her large symbolic sculptures, which involved a pair of lips that produced a waterfall, a firebird, and a mermaid. To this day, the fountain is a much-loved monument, representing a city that takes as much pride in its museums as it does in its playgrounds.

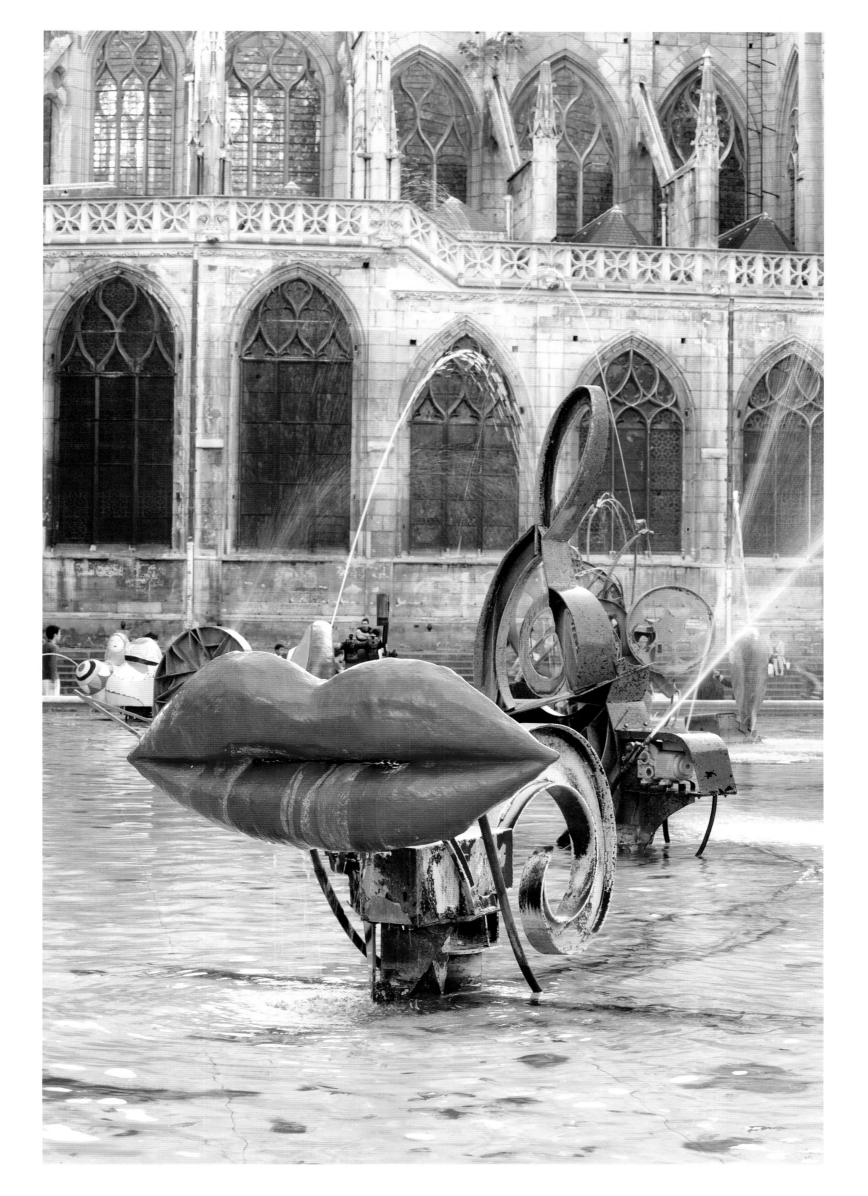

MARINA
ABRAMOVIĆ
& ULAY

FULL CIRCLE

WHEN MARINA ABRAMOVIĆ WAS A CHILD IN BELGRADE, HER MOTHER would beat her every time her temperamental baby brother wailed. In contemplating ways to stop the abuse, she figured out that if he died, there would be no more crying, thus no more beating. So she tried to drown him in the bathtub—unsuccessfully. When she was in art school in Zagreb, a fellow student ceaselessly advertised the desire to kill herself. When Abramović got sick of hearing it, she snapped, "Fine, do it then!"—and the girl hung herself that night. Throughout her young life, Abramović noticed that the extreme weaknesses in others spurred her to see vulnerabilites in herself. Her contemplation of this was a linchpin in her evolution as a performance artist.

Ulay was born in 1943, exactly three years to the day before Abramović, in Solingen, Germany—"the city of blades"—where his mother, the only family he knew, was raped by Russian soldiers when he was fifteen. When she fled the town in trauma, he started drifting north into the Scandinavian region to find out where he belonged. Attempts at a "normal life" were met with hasty decisions that would overwhelm him—like marriage and fatherhood and, consequently, abandonment. In the early 1970s, Ulay resurfaced in Amsterdam, appearing half man, half woman. One side of his body featured long flowing hair, smooth skin, rouge, and feminine clothing, while the other

Marina Abramović and Ulay
Imponderabilia, 1977
Performance, 90 minutes
Galleria Communale d'Arte Moderna,
Bologna, Italy

At the opening of an exhibition at the Galleria Communale d'Arte Moderna, Ulay and Abramović stood facing each other in the nude, on either side of a narrow entryway, forcing spectators to squeeze between them to gain access to the galleries beyond. As with many of their early works together, *Imponderabilia* created an environment of total vulnerability designed to test the limits of trust and human endurance—both of the performers and of the audience.

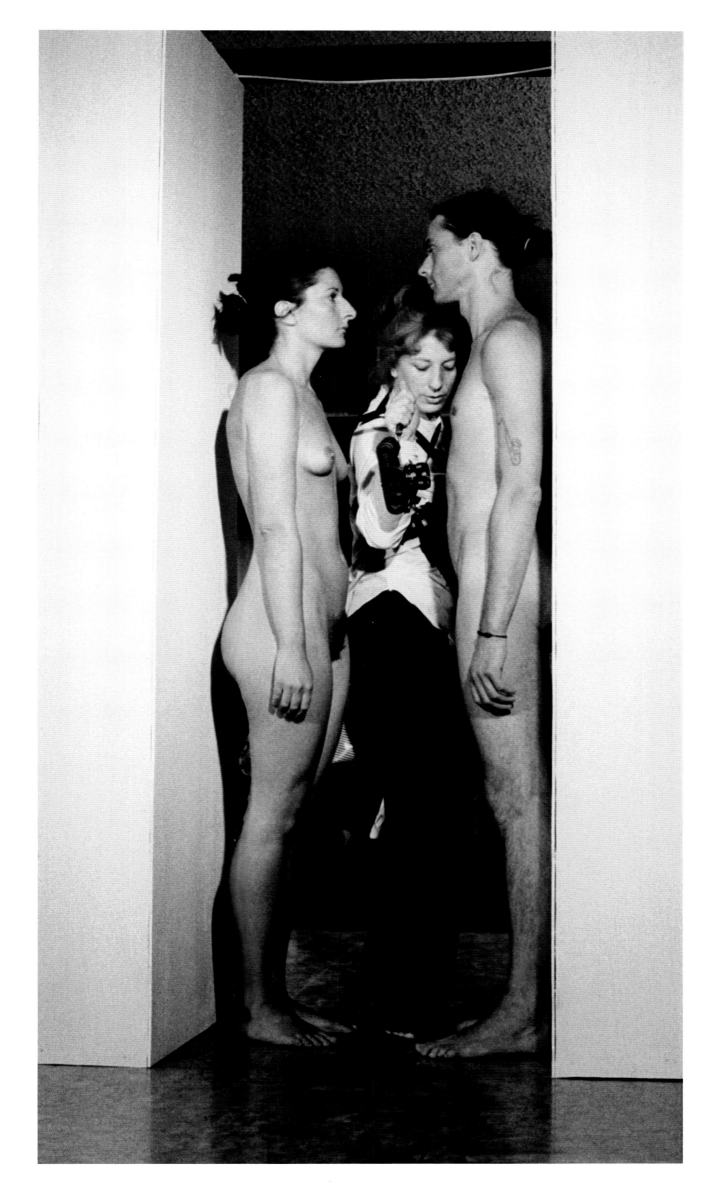

half revealed stubble along the jawline, short hair, and a pant leg. He was immediately embraced by the Dutch art community.

Abramović and Ulay's story begins in 1975 on their shared birthday, November 30, in Amsterdam, when they met at the Dutch television station VARA. They had both been invited to perform one of their art pieces, and each arrived with their hair held back by chopsticks. Their synergetic connection was almost instantaneous. Within a few days they had recognized everything they had in common, starting with the fact that they had both ripped out the date November 30th from their respective pocket calendars. When Abramović returned to Belgrade, she ran up the phone bill at her mother's house talking to Ulay daily for three months.

> " *They developed a manifesto containing the first two rules of their art: no fixed living place, permanent movement.* "

In forming a bond with him, Abramović became less individualistic about her performances, which were all oriented around self-inflicted pain and humiliation. In 1974's *Rhythm O*, she passively stood next to a table filled with instruments (including a loaded gun) used to induce pleasure and pain, offering the audience full rein over her body for six hours. By the end, her clothes had been ripped off, someone was sucking blood from her slashed throat, the gun had nearly been blown into her brain with her limp hand (but had been frantically prevented from doing so by a terrified viewer at the last second.) "If I hadn't met Ulay, [those performances] would have destroyed my body,"[1] Abramović said in an interview in 1978.

In 1976, Abramović and Ulay moved into an awkwardly tall black van equipped with a mattress and a stove, which became their home for the following five years. They developed a manifesto containing the first two rules of their art: *no fixed living place, permanent movement*. They took their *Relation Work* series across the continent of Europe, where they would be given palatial rooms at times, to conduct their lengthy performances—which consisted of driving their van in perfect circles for sixteen hours straight, or standing naked in a narrow doorway facing one another while their audience had to pass in between them. They maintained perfect tension with one another even when it seemed they should've been in a lot of pain. Together, like two molecules bouncing off one another or fusing into a perfect stillness, they could emotionally detach from the rest of the world. This followed in the footsteps of Buddhism, a spiritual practice that kept their collaborations

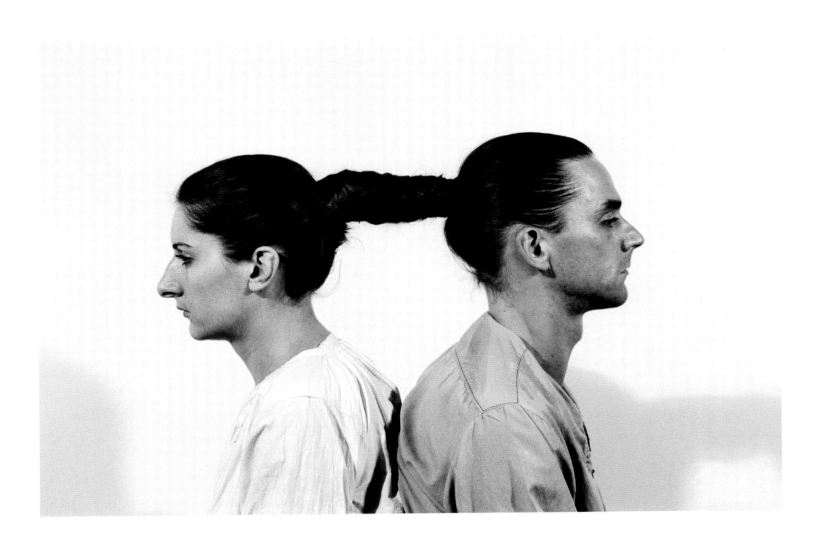

Marina Abramović and Ulay
Relation in Time, 1977
Performance, 17 hours
Bologna, Italy

In *Relation in Time* the artists sat in this position, held together by their hair, without speaking, for seventeen uninterrupted hours. During Abramović's 2010 MoMA retrospective, *The Artist Is Present*, this piece was performed anew by dancers in rotating shifts for a total of 700 hours.

centered and unplanned, giving them the opportunity to make numerous rounds of the same action until they *felt* it was over.

When they finally separated, it was atop the Great Wall of China in 1988, in their final joint performance. It wasn't supposed to end that way, initially. In the beginning, the plan was for Abramović to start walking from the Yellow Sea in the east, and Ulay from the Gobi Desert in the west, until they'd each traversed nearly 2,000 miles to meet in the middle and have a traditional Chinese wedding. As Abramović explained, "Ulay, as a fire, as a male, starts from the desert. And I start, as a female, as water, from the sea."[2] They referred to the piece as *The Lovers*, and were drawn to the Great Wall because it was said to be the only manmade structure visible from space. In plotting the performance, while China and the Netherlands hammered out international relations details with increasing enthusiasm, the couple lost speed. It was as though planning a monumental performance that ended in a traditional union ceremony turned them into a trite couple, with China and the Netherlands playing the parts of their in-laws, arranging all the wedding details.

The Walk (replacing the title *The Lovers*) was a fragmented battle on both ends. The account *Art, Love, Friendship* by critic and close friend Thomas

Marina Abramović and Ulay
Breathing In/Breathing Out, 1977
Performance, approximately 20 minutes
Belgrade, Serbia

In *Breathing In/Breathing Out*, connected
by their open mouths, Ulay and Abramović
exchanged their breath for twenty minutes
until they both collapsed.

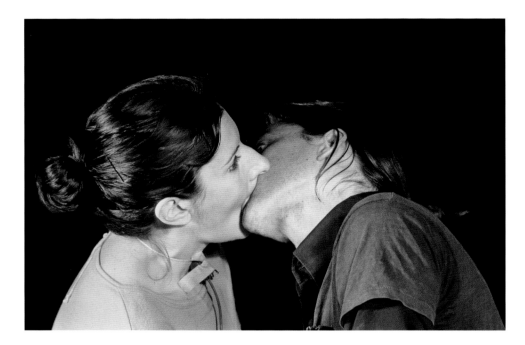

Marina Abramović and Ulay
AAA-AAA, 1977
Performance, approximately 15 minutes
RTB Studios, Liege, Belgium

The performance *AAA-AAA* involved Ulay
and Abramović yelling face to face for fifteen
minutes, moving closer together with each
passing minute until they were yelling directly
into one another's mouths. While in some of
their performance pieces they became a single
unit working together towards the same goal,
AAA-AAA was competitive, with each trying
to out-yell the other. In the end, Abramović
was the last one yelling.

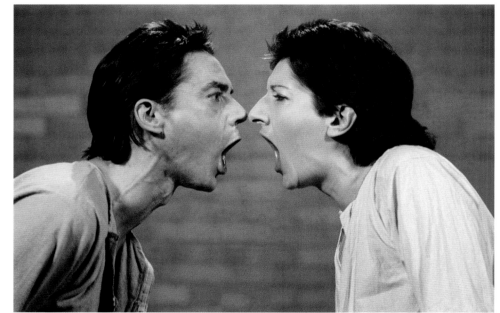

[opposite]

Marina Abramović and Ulay
The Great Wall Walk, 1988
Performance, 90 days
. The Great Wall of China

In their final performance together, Abramović
and Ulay walked towards one another from
opposite ends of the Great Wall of China,
meeting in the middle after 90 days, where
they embraced and said goodbye to one
another, as collaborators and lovers.

McEvilley illustrates details that the satellite photographs do not.[3] When he
found Ulay midway through his journey, he watched him light a candle at night
and keep his tent unzipped to create an openness with the Chinese peasants;
teenagers smashed their bodies against the tent that night, trying to pile up on
him. This resulted in veering off path to sleep in hotels. Despite the fact that
Ulay had, in the past with Abramović, voluntarily accepted physical pain—
and hours of running and colliding against her repeatedly in one particular
performance—violent adolescents crushing his tent did not feel like love.

On her end of the Wall, Abramović was fiercely determined not to stray
from the path. Powering through, she looked forward to climbing to the highest
peaks, where the eagles flew close by. She forged ahead in anticipation of

[pages 186–187]

Marina Abramović
The Artist Is Present, 2010
Performance, 3 months
The Museum of Modern Art, New York

For her retrospective at MoMA, Abramović conceived of a new solo piece to be performed daily during the museum's hours of operation for the entire three-month span of the exhibition. In *The Artist Is Present*, Abramović sat silently in MoMA's light-filled atrium, clothed in a crimson gown, facing an empty chair, which any visitor could occupy. Spectators lined up for hours on end for the chance to engage Abramović's gaze. On the opening night of the retrospective, more than twenty years after their dramatic parting atop the Great Wall of China, Abramovic and her former lover and collaborator shared performance space once again when Ulay slipped unexpectedly into the unoccupied seat opposite Abramović, and leaned in to clasp her hands.

> " *When they finally separated, it was atop the Great Wall of China in 1988, in their final joint performance.* "

ending the trek and finding a certain beauty that she felt a communist country, like the one she had been raised in, did not offer. Her disdain for communism separated her from Ulay—a division that silently grew as they both separately absorbed and rejected differing elements of China during their walks.

When they met one another at last on June 27, 1988, at Shenmu in the Shaanxi province, amongst a group of Buddhist, Taoist, and Confucian temples, in the middle of a stone bridge—"over the abyss," as Abromović described it—they embraced before parting ways forever.[4] Surrounded by a curious local audience, a photograph taken of Ulay and Abramović on the Wall depicts two unrestrained smiles, a genuine embrace, a final non-performance that marked a break in their obsession with self-control. Their ninety-day journey concluded their thirteen-year collaboration, a relationship that ended with the two standing side-by-side one final time, fire and water together, specks visible from outer space.

CLAES
OLDENBURG
COOSJE
VAN BRUGGEN

> *It's a logical story. Artist becomes famous. Artist meets young, beautiful curator. Curator falls for him, marries artist, and takes over his career. What did he lose in this equation? Perhaps some pride. But otherwise, he had a ball.*

THE IMPERIALISTS

CLAES OLDENBURG'S GARGANTUAN SCULPTURES HAD HUMBLE, albeit highly adrenalized, two-dimensional beginnings. His first drawings portrayed the mundane objects he had collected in his studio in New York City in 1959. Initially the attraction to the subject offered a way to combat loneliness and boredom. While such characteristics have threatened to destroy all famous artists, they toyed with Oldenburg during a monumental shift in American art. Random found objects were a crucial part of the lexicon that determined pop art. When he walked the streets, kicking cans and stepping over the homeless, he observed the way all forgotten things contained their own life force in the city. Within the same stride, he saw the way human beings could appear completely inanimate. He studied clothespins and razors through the lens of science fiction, eroticism—and as the debris of fierce capitalism. Most notable of his beginning is his drawing *The Ray Gun*, which presented his perfect "fusion of mass culture with private sexual or aggressive impulses."[1] In 1960 he created *The Store*, where he transformed his studio into a "general store" in which each commodity possessed a twist (what was supposed to be hard was soft and vice-versa) and where the customers engaged in the interactive "Happenings."[2] His ideas grew in their hungry investigation of the impossible within the framework of the pop art movement.

Oldenburg met van Bruggen in 1970 at Stedelijk Museum in Amsterdam, where she oversaw the installation of his *Trowel I*, a garden shovel built forty-one feet tall and stuck into the ground as though its owner temporarily stepped inside to have a glass of ice tea. The color he chose—silver—didn't agree with her. She thought blue, the shade of the workingman's overalls,

Claes Oldenburg and Coosje van Bruggen
Trowel I, 1971–76
Kröller-Müller Museum, Otterlo, Netherlands
Steel painted with polyurethane enamel
41′9″ × 11′3″ × 14′7″

Trowel I was the first collaboration between Oldenburg and van Bruggen. Oldenburg designed it initially to be installed in Sonsbeek Park in Arnhelm in the Netherlands. When van Bruggen shared her criticism of the piece, telling Oldenburg it should have been blue, he later recreated it under both of their names during its installation at the Kröller-Müller Museum in Otterlo. Oldenburg gave van Bruggen equal rein in designing his subsequent public sculptures. As with *Trowel* she felt very strongly about the color of select pieces. For example, she changed the color of the *Batcolumn* (in Chicago) from its original red to metallic grey.

would have been better. Furthermore, she didn't like him, referring to Oldenburg as a "typical imperialist American artist."[3] A year later they met at the opening of *Sonsbeek '71*, the historically renowned, site-specific exhibition he was included in, where *Trowel I* reappeared (still silver). She shared her criticism of Oldenburg's tool sculpture and, as he was besotted with her, he suggested they collaborate as artists on a new version of the trowel according to her preferences. In 1976 he unveiled *Trowel I* in the shade of workman's (albeit brand new) overalls. Van Bruggen, freshly divorced, became quite drawn to the real possibilities of joining forces with the "imperialist artist." As soon as she took hold of the reins, his enlarged sculptures of everyday objects colonized major city centers and gardens all over the world—under both their names.

But Oldenburg hadn't really been an "imperialist" artist. In fact, the year before he erected *Trowel* in the Netherlands, Yale University had commissioned one of his "feasible sculptures," which, up till that point, had only existed as drawings. The giant inflatable lipstick container was mounted on "a base of suggestive tank treads . . . to be inflated on occasions of student protests and other public gatherings" on campus.[4] His *Large-Scale Sculptures*—as van Bruggen aptly titled them—were on their first legs when she got involved. From 1977 through 1985 they created pool balls, a pickaxe, a bat column, an umbrella, a toothbrush, a garden house, a stake hitch, a series of balancing tools, a screw arch, several hats and—a "knife ship." Another twenty-five flamboyant public sculptures follow this list, but the *Knife Ship* marked the moment when van Bruggen truly inhabited her role as curator-cum-artist.

The *Knife Ship* was a massive Swiss Army knife that floated in water. It was the key prop in *Il Corso del Coltello*, the *commedia dell'arte*[5] play that van Bruggen wrote to add more of a fleshed out storyline to their collaboration. It included the "disorganized order"[6] of architect Frank Gehry, whom they invited to take part as a way to combine the architectural and the theatrical. It was created to be performed at the Venice Bienniale in 1984 in honor of its theme, "Art and Theater 1800–1984," but was postponed by the Bienniale's curator due to its extravagant cost.

Claes Oldenburg and Coosje van Bruggen
The Coltello (Knife) Building with Sailboats and Gondolas, 1984
Crayon, pencil, watercolor
13″ × 20⅛″

Before Oldenburg had become a frequently commissioned artist, his proposals for public sculptures were viewed as provocations. For example, he once suggested the Statue of Liberty be replaced with a colossal table fan. He referred to his interpretation of objects as "rips out of reality." In the case of *Knife Ship*, it was fabricated twice—once for the Venice Biennale (as proposed in this study) and again to be showcased at the Guggenheim Museum in New York, after which it travelled to the Museum of Contemporary Art in Los Angeles, where it now resides.

Claes Oldenburg and Coosje van Bruggen
Knife Ship II, 1986
Steel, aluminum, wood; painted with polyurethane enamel
Museum of Contemporary Art,
Los Angeles, CA
Closed, without oars: 7′8″ × 10′6″ × 40′5″;
extended, with oars: 26′4″ × 31′6″ × 82′11″;
height with large blade raised: 31′8″; width with blades extended: 82′10″

The Swiss Army knife was originally selected by van Bruggen as an object for architecture students to focus on during a seminar she ran with Frank Gehry at the Faculty of Architecture in Milan in 1984. It developed into the key prop in the performance *Il Corso del Coltello* to be featured at the Venice Biennale the following year. In that context it was meant to reference a double-sided identity: one that echoed both the legendary ceremonial ship the *Bucintoro* and the mass-produced tourist souvenir that it was modeled after.

Milan hosted the play in their city a year later. The result looked like the work of a precocious little girl who presented a lengthy, tangential play to her family during the holidays—the kind where every aunt and uncle takes long sips of wine, counts the seconds until it is over, and rises in over-enthusiastic applause at the end. She wrote the main characters—versions of Oldenburg, Gehry, and herself—in a style that saluted all the postmodern, intermixed with Marcel Proust. Although it was obviously influenced by a grand pastiche of intellectual greats, it fell short of holding a candle to their genius. In her published journal entries written during its creation, she repeatedly compared herself to Oldenburg's pre–van Bruggen work: "In the Happenings of the 1960s spoken texts were typically used only for their sound, but in *Il Corso del Coltello* much of the text is being used to present meaningful statements."[7]

If one were trying to pinpoint something completely amiss in the Oldenburg–van Bruggen dynamic, the *Knife Ship* does a good job revealing the reason why "critics often looked askance at Ms. van Bruggen's participation in what was often perceived as Mr. Oldenburg's work."[8] Or maybe not? It is logical story. Artist becomes famous. Artist meets young, beautiful curator. Curator dislikes him (i.e., she was married at the time, or was playing hard to get—or both). Artist falls head over heels and wants to charm curator. He recreates one of his sculptures to her liking, under the same title, adding her name to it. Curator falls for him, marries artist, and takes over his career. What did he lose in this equation? Perhaps some pride. But otherwise, he had a ball. They bought a magical castle in the Loire valley where they drank wine and decided what object they would next recreate to the scale of a building within various high-traffic settings all over the globe.

DAVID
McDERMOTT
PETER McGOUGH

McDermott & McGough
Portrait of the Artists (with Top Hats), 1865, 1991
Platinum print
14″ x 11″

REST IN PEACE, TWENTY-FIRST CENTURY

IN 1980 THE BOYISH PETER McGOUGH WALKED UP TO DAVID McDERMOTT, the "master of ceremonies" of the New Wave Vaudeville, poised in his 1930s coattails and white tie, and told him, "There's a photograph of you in my apartment." This would be the apartment on Thompson Street that McDermott had been thrown out of before McGough had moved in. Eviction would later become a recurring event in the couple's time-machine-existence. Standing by his side, Walter Flemming, McDermott's 1920s-style china doll of a boyfriend, regarded McGough with a bored, catty glance. They snubbed him and the whole interaction disintegrated rapidly.

During the second meeting—at another party, where McDermott and Flemming were dressed like Gertrude Stein–ish frumpy 1920s women—their conversation took a different turn. McDermott took an interest in the young McGough and asked him what he did with his time. When he told him he was an artist, McDermott responded, "Oh, well, then maybe you could help me finish this abstract expressionist–style painting for my mother. She likes that *sort of thing* and she's tired of outright giving me money." This marked the beginning of their thirty-two-year artistic collaboration, which was rooted, for the most part, in the nineteenth century.

In elementary school, McDermott had found it daunting the way teachers roared, "In the world, you have to *keep up, keep up, keep up!*" As a child, he decided he did not want to compete with the modern world, he would not "keep up" or work towards the future—but go backwards instead. Reading by candlelight, he burrowed into the past until he hit upon a particular comfort

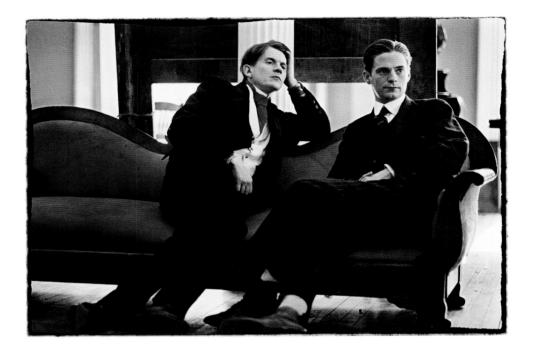

David McDermott and Peter McGough in their studio in Williamsburg, Brooklyn, NY, circa 1980s. Photograph by Wouter Deruytter.

" *McGough naturally created a passage from McDermott's mind into his own, editing it, adding to it—bringing it to life. They became perfect bookends to one another. "*

McDermott & McGough
Chart 5, 1904, 1990
Oil on linen
76" x 66"

McDermott and McGough's *Chart* series lampoons the nineteenth-century obsession for the pseudoscience of phrenology, the study of how the conformation of the brain relates to a person's mental faculties and character. Their body of work positions itself in that era and they use the phrenological chart to map the trajectory of their thought processes—aptly overwriting the historical dates represented in their work with the names of men, the subjects of erotic memory.

with the Civil War era. From there, he blocked out the contemporary world in an obsessive-compulsive way—covering up electric wall sockets and shutting off hot water wherever he lived. Any mundane detail of the "present" sent his perspective off-kilter. He would not be able to work in a room that didn't have the right period wallpaper. "It wasn't about sitting around in old clothes and drinking sherry. He really believed that all time consists of the same time, so why not relish in its finest moment? There were offshoots in economy, ecology, metaphysics . . . and he was adamant to live in a permanent time experiment."[1]

The proliferation of television screens did not tempt him. Nor did the quickening tempo in music that surged a new life force into the gay male community. He remained early to bed, early to rise. McGough, on the other hand, worked through that night at Danceteria, where his shift ended at 6 A.M. When he'd walk out into the painful glare of morning, he'd find McDermott sitting on the steps in his dapper suit, waiting to eat breakfast with him. It was always a welcome sight for McGough, who, after a night of throbbing music and sweaty dancing, genuinely enjoyed listening to McDermott extrapolate on his theories of time. Although McGough was not of the same mind (yet), all of his responses sounded like "manna from heaven"[2] to McDermott. In a gentlemanly way, he courted McGough, who never expected the odd man to eventually become his mentor. Or life partner, for that matter.

McDermott and McGough moved into an echo-filled twenty-five-room house two hours north of the city, in the river town of Hudson, where they reveled in bibliophilia and projected films in the basement of an old church. Up there, in their cloistered world, McGough nestled into the raw material of McDermott's mind. He grew to realize that McDermott was an "original

CHART 5.

He loved boys, artists and aristocrats.

> **"** *With works like* Advertising Portrait—*which they would backdate to 1908—they experimented with the early American campaign-style brainwashing aesthetic that was used to sell values.* **"**

thinker" with ideas that were too brilliant not to share with the rest of the world.[3] His life was an entire evolving artwork held back by the fact that he didn't work well with people: his communication with others had a tendency to grow volatile. McGough was nothing like him in that regard. He was, one could say, a people person. He naturally created a passage from McDermott's mind into his own, editing it, adding to it—bringing it to life. They became perfect bookends to one another.

When they returned to the city after, yes, getting evicted from their house upstate, impoverished artists they had known from the streets, like Keith Haring, had become famous overnight. Up until that point they hadn't ever really considered selling their art. They had always made paintings for the specific purpose of filling their own domestic world, complementing them to window curtains and household fixtures. When they returned, they moved into a Victorian space across from a homeless shelter in the East Village where they painted "fabulously bad genre paintings" of dainty flower vases and young boys. On weekends, they packaged them up and took them to their rich friends' apartments yelling, "Paintings for sale! Fifty dollars. One hundred dollars. A boy on ice-skates on a pond . . ."[4] When the painter Julian Schnabel caught sight of the "liberal fairies" in their nineteenth-century Republican garb, he heralded them in the contemporary art world, where no paintings sell for a measly fifty dollars.[5] To welcome their entrance—and encourage their backdated existence—he bought them a turn-of-the-century camera from a flea market so they could keep a record of their archaic lifestyle.

As rewarding as celebrity can be, its glitter always attracts bad attention. Shortly after McDermott and McGough earned enough money to buy their apartment and indulge in their antiquated lifestyles, a devilishly handsome man who worked in the business of horses and classic old automobiles wandered into their gas-lit parlor and seduced them both in one fell swoop. He was a crooked intellectual with dangerously mirthful eyes, a hound for new money in the domain of old things. In the honeymoon phase, this was cloaked in the novelty of fresh romance. Once McGough caught on to the fact that he wanted to exploit them, McDermott refused to believe it. A nasty mixture of business and pleasure pulled their entire existence into question. It all

McDermott & McGough
Advertising Portrait, 1908, 1989
Oil on canvas
61" x 60 1/5"

During the 1980s McDermott and McGough lived and worked as men who lived circa 1900 to 1928. They categorize the paintings made during this time as their Early Work, with *Advertising Portrait* positioned as the last painting they created together before McDermott moved to Ireland, marking a hiatus in their collaboration that lasted through the mid-1990s. McDermott only communicates with McGough via telephone and postal service, refusing to use the Internet. As he has explained—ironically, on their *website*, which has a biography page—"I've seen the future and I'm not going."

happened during the severe economic crash of 1988–89, one that impacted art sales dramatically. Once the IRS caught wind of McDermott and McGough, they, too, entered their parlor. They popped in and out with distressful regularity, making it a point to prove that McDermott and McGough made taxable products that were government approved. The agents tortured them by sitting on the Victorian sofa, stuffing their faces with McDonald's cheeseburgers. In response, the duo allowed their practice to tiptoe into the twentieth century. With works like *Advertising Portrait*—which they would backdate to 1908 (a quasi-scrambling of 1989)—they experimented with the early American campaign-style brainwashing aesthetic that was used to sell values. This did not go down well with the IRS who, ultimately took away their home, sold off their furniture, and severed their ties to their galleries. Upon which McDermott proclaimed, "This country does not support artists, I am moving to Ireland, where they do." He renounced his citizenship and traveled by ship to Dublin, where he has remained since.

> *As long as they have one another, with McDermott looking over his shoulder and McGough staring straight ahead, they can live in any moment of time that they want. After all, they have for this long.*

As they settled into their transatlantic partnership of the 1990s, they resurfaced on the art map, with two major differences in their work—an entire century had gone by in their oeuvre, and the female had become their leading subject. There was no better place to study this than in the male-controlled world of 1960s Hollywood, where starlets appeared perfectly framed on the screen, almost always on the verge of a suicide or hysteria. Their work, such as the series *Because of Him*, titled after a gay 1960s porn movie, took on the vivid tones of red lipstick and blond hair. It fit them like a silk glove. In the realm of art history, one writer, Wayne Koestenbaum, observed that they filled Andy Warhol's shoes—"Warhol, dying just at the moment that M&M came into their first fame, ceded the terrain of Pop: now, retroactively."[6]

Where will we find McDermott and McGough in the future? Will they punctuate their collaboration in the year they met? Or will it remain frozen and fixed on a teary Hitchcock beauty? Whatever happens, they will always be in the past. And the past is now. As long as they have one another, with McDermott looking over his shoulder and McGough staring straight ahead, they can live in any moment of time that they want. After all, they have for this long.

McDermott & McGough
I Want You So, 1966, 2008
Oil on linen
60″ x 48″

In the first decade of their collaboration, McDermott and McGough rejected electricity and, thus, refrained from anything television-related. After McDermott moved to Ireland, a few changes were made—one being that they leapt forward in time to the 1960s, when tragic, beautiful women graced both the big and small screens. Soon the aesthetics of television, and its physical properties, became celebrated in their work.

> *When Nauman, the rancher, met Rothenberg, painter of horses, it was nearly impossible not to fall in love.*

BRUCE NAUMAN
SUSAN ROTHENBERG

THE ART OF HORSEMANSHIP

IN 1966 BRUCE NAUMAN MOVED INTO A FORMER MEXICAN GROCERY store in the Mission district of San Francisco. In the emptied space that used to be lined with aisles, he paced, and delved into a self-critical spiral (not a downward one, but definitely fraught). "I was working very little, teaching a class one night a week . . . and I didn't know what to do with all that time. There was nothing in the studio because I didn't have much money for materials. So I was forced to examine myself, and what I was doing there. I was drinking a lot of coffee, that's what I was doing."[1] He had a Masters in Art from the University of California, Davis, and that made him a "certifiable artist." This fact only perpetuated the spiral.

The store windows at the front of his home were papered over, but that didn't conceal that fact that something was going on inside the space. His thoughts were loud. He probably overheard several conversations drift into his studio from the outside world along the lines of: "Oh, there used to be a store here! What's in there now? An artist, I think." Except it was likely spoken in Spanish, as the neighborhood was primarily Latin. Perhaps the former energy of the place—the constant exchange of money for goods, simple needs and desires met—influenced his daily examination of what it meant to be an artist. What exactly did an artist provide? What function did an artist serve in the

Susan Rothenberg and Bruce Nauman, 2006.
Photograph by Patrick McMullan.

world? These questions supplied the impetus for what became Nauman's post-minimalist sculpture and performance. The work itself was the answer. The daily investigation of purpose led to a breakdown in language, a consideration of the objects that made up the everyday—and resulted in a sardonic, yet profound body of work that started with a neon sign he placed in the shop window. The text, forming a red and blue spiral to be read from the inside out, stated: "The true artist helps the world by revealing mystic truths."

On the opposite coast, in New York City, Susan Rothenberg was painting. She had a natural relationship to the canvas, the creation of layers and contemplation of surface, but she was not in sync with her subject. Each piece grew out of a central dividing vertical line she drew down the middle of the empty canvas. "One dull afternoon," in early 1974, as she describes,

Bruce Nauman
The True Artist Helps the World by Revealing Mystic Truths, 1967
Window or wall sign, neon tubing with clear glass tubing suspension frame
59" x 55" x 2"

Among the variety of materials Nauman worked with, neon and fluorescent light installations have been very present throughout. Light-based works, especially neon, grab the viewer's attention in an aggressive manner. This was appealing to Nauman when he began working with the material which, up until that point, had appeared to him on a daily basis as beer advertisements in store windows.

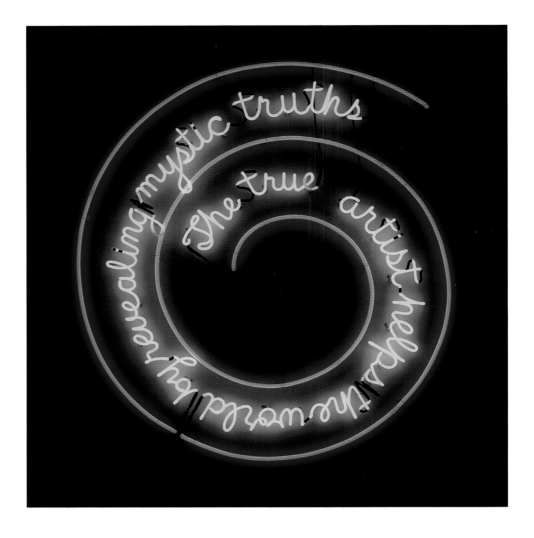

"I doodled the image of the horse. It was divided perfectly. Maybe there was some unconscious reason, but horses really don't mean anything to me. I rode them at camp, but that's about it. The horse was just something that happened on both sides of my line. The image held the space and the line kept the picture flat."[2] From the first horse grew a series, all of them aesthetically reminiscent of a cave drawing's planeness. They were two-legged, tailless, and eyeless. Rothenberg's horses were not homages to the animal itself. But when looking at them, it is hard not to think of the moment when a human creates a relationship of trust with a wild horse by approaching it slowly, the animal frozen with panic, and the way when the hand is placed on the neck, both become still for an endless second before the suspension of fear occurs. Or as one of Rothenberg's most adoring critics, Peter Schjeldahl, puts it, they appear "as if hysteria could be fine-tuned."[3]

When Nauman met Rothenberg at a dinner party in New York in 1988, he was a ranch owner in New Mexico with a stable full of horses. They were both represented by the same gallery, Sperone and Westwater. The dinner was hosted by their dealer, who purposely sat them next to one another, sensing they would get along. By then Nauman was known for his disturbing audio

Susan Rothenberg
Blue U-Turn, 1989
Oil on canvas
91" x 112"

Blue U-Turn began as a portrait of Nauman shortly after Rothenberg moved to New Mexico to live with him. Whether it is still meant to be Nauman is up for debate, for as she once described with regards to her process of painting a particular subject, "I don't know exactly what they are, or how, or if they relate to any of my other work. I'm not sure how I ended up here."

[pages 206–207]

Susan Rothenberg
Triphammer Bridge, 1974
Synthetic polymer paint and tempera on canvas
5'7 1/8" × 9'7 3/8"

Made in 1974, this is likely the first in Rothenberg's famous horse series, about which the *New York Times* once wrote, "The nerve and conviction of these paintings became signposts for a generation." Similar to Nauman, Rothenberg's interest in the body (animal, human) influenced her deeply as an artist. In contrast to Nauman, however, she had no special interest in horses beyond the boundaries of the canvas.

recordings directly ordering the viewer to do something, occasionally politely asking them—*Please Pay Attention Please*. The work was about language, what he called "utterances," and the viewer's response to the "anti-visual" pieces was a crucial component of the art itself.

He had come a long way from the grocery store studio and had followed a woman—his child's kindergarten teacher—into the desert. Out there, peripatetic and tranquil, he had settled. He had reached a high enough point of success as an artist to own a Ferrari (to use that particular American measuring stick), and had earned his right to disappear. But even from the middle of nowhere, he still had to take calls and deal with the demands of people who expected things of him. He was an important artist and that didn't allow him to fall off the grid completely.

One day a phone conversation made him so angry that he plunged his fist into the wall and broke a finger. Although he was the man who created an installation that consisted of nothing but his voice in a room, pouring out through imbedded wall speakers, creepily ordering everyone to "get out of this room, to get out my mind," he was not a wall puncher. This indicated a problem. The solution: horses. Working with horses—breaking and training them—allowed him to understand his own fear. It became as important as spending time in the art studio. "To him, there was no difference."[4] So when he met Rothenberg, painter of horses, it was nearly impossible not to fall in love. They married three months later and she eventually moved to be with him in Galisteo.

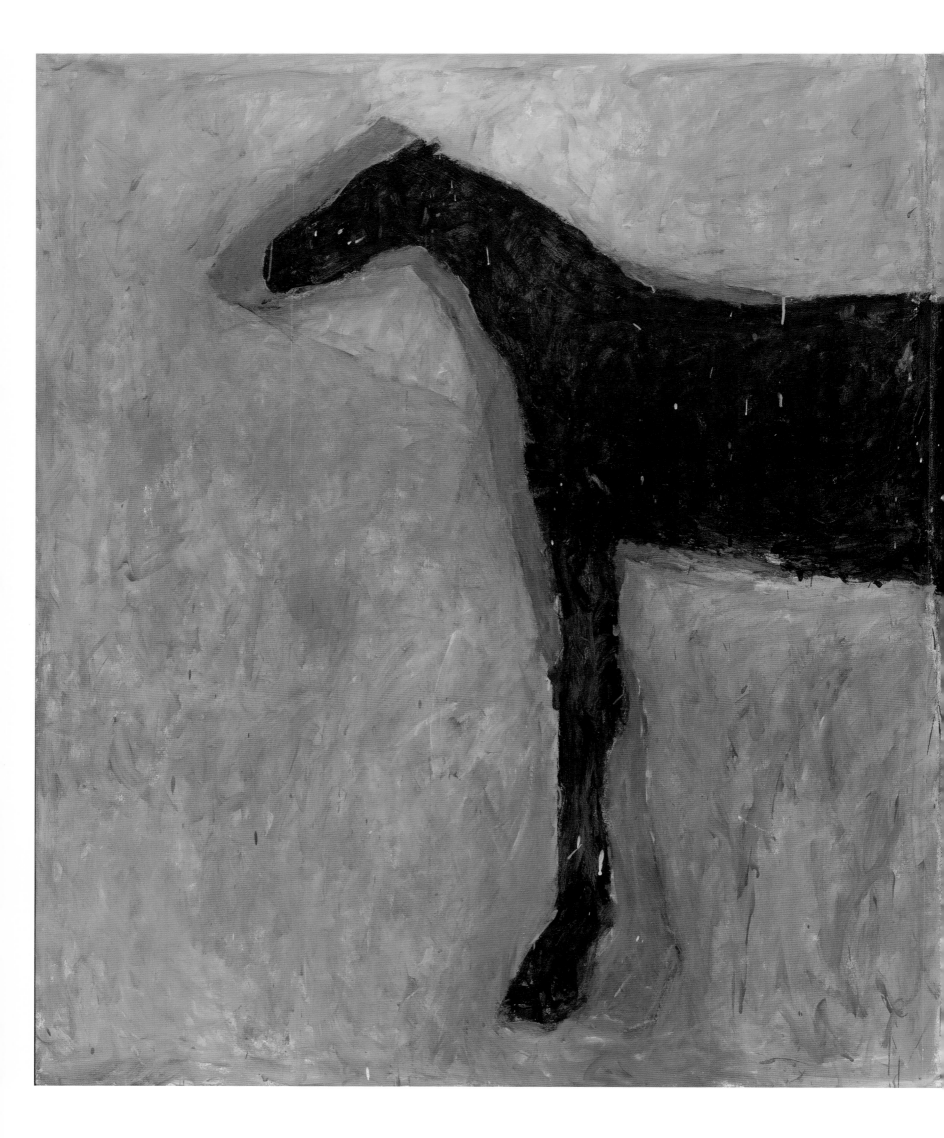

Bruce Nauman
Model for Animal Pyramid II, 1989
Cut-and-taped gelatin silver prints
90¹/₂" × 60¹/₈" (irregular)

Bruce Nauman
Animal Pyramid, 1989
Sculpture, polyurethane foam
143³/₄" × 95³/₄"

When Nauman first saw the taxidermy molds he used in *Animal Pyramid* in a New Mexico shop, he was drawn to their "beautiful generic abstract" quality. His first artworks using them were arranged into carousels. Prior to this, animals had never been an element of his work.

> *"'I don't think I'll ever know Bruce,' Rothenberg once disclosed, 'but he's mine and he's a beauty.'"*

"There's a pattern here," Rothenberg described in a documentary made over a decade later. "Bruce makes the coffee, we read in bed for twenty-five, thirty minutes, shower (sometimes). He does the horses. I feed the chickens and the dogs. He throws the hay and gets the newspaper."[5] She narrated their daily rituals as the PBS cameraman panned across her desk filled with yellow notepads, a pack of American Spirits, several opened matchbooks, a desert-dust-covered phone. Her steady voice revealed a casual pride behind the simple life of animals and ritual and open land. But it wasn't always that simple. Several years into their marriage, Nauman encountered a block. This was on the heels of the *Animal Pyramids* he'd started making the same year he met her. "Rather than casting abstract spaces or human forms . . . he turned to readymade molds—taxidermy forms used in molding stuffed animals. He found these strangely unnatural, fearless polyurethane foam models—including deer, wolf, bear, fox, and others—in a taxidermy shop in New Mexico."[6] He was consumed by them—stacking them, suspending them, dismembering and reconstructing them. And then, unexpectedly, he stopped making work for three years.

By the time Rothenberg moved to New Mexico, she had incorporated new figures into her life-sized paintings—humans that appeared to lack skeletal frames. Her portrait of Nauman, *Blue U-Turn*, appeared like an aerial view of a bizarre cerulean body of water. Since her purpose with art was "to never take life for granted," there was less threat of Nauman's block contaminating her own studio practice. That said, it was hard to ignore it. Her individual efforts to pull him out of his creative paralysis were futile, so Rothenberg brought a third party into the equation—a shrink—who hung onto Nauman's occasional "utterances" during their couple's therapy. Attempts to pry Nauman open were met with cowboy shrugs. When they returned to their ranch, he would walk off for hours, sometimes days. Rothenberg realized she had to let him be. Once she did, the dust eventually settled and he returned to creating art—which was aptly inspired by what happened in his studio when he wasn't in it. Just as in the beginning, he was motivated by the philosopher Ludwig Wittgenstein's quest to "pursue an argument to the point where I give up on it." In a 2009 *New Yorker* profile that explored their desert existence, the laid-back Rothenberg disclosed a sentiment that also followed those lines, "I don't think I'll ever know Bruce, but he's mine and he's a beauty."[7]

ILYA & EMILIA

KABAKOV

A THAWED MEMORY

"Born twelve years apart in the same town—they did not truly meet until the 'West' started celebrating Ilya as one of the most important artists to emerge from Russia."

THE MOTIVATION TO BECOME AN ARTIST BEHIND THE IRON CURTAIN was very different than that of becoming an artist in, say, France. There was no Pablo Picasso in Soviet Russia. The path of the individual artist had to exist and evolve in the realm of an underground collective. The other option was to become an "official artist" by making government-approved art, which translated, essentially, to giving up one's identity. So one either became a lap dog or an alley cat. In 1957, the year Russia put Laika the dog in outer space, Ilya Kabakov, en route to becoming the "leader" of the Moscow conceptualists, was granted legal artist status by the communist government, with the expectation that he'd become a fine children's book illustrator. Once his officialdom was established, Kabakov unintentionally (at first) started to create a wormhole through the system: "In the Soviet Union there existed little islands amid all that dirt and darkness, islands of light and enlightenment: libraries, museums, conservatories, theaters, also art museums and the systems of self-education. Young intellectuals found themselves confined in this dark space but they believed they could find a tunnel of enlightenment, a connection to universal culture. There were a lot of groups of self-education, especially in Moscow."[1]

Fast-forward to the twenty-first century: Kabakov lives in a charming cottage in Long Island with his wife, Emilia. Despite their similar histories—they were born in the same town, Dnepropetrovsk, twelve years apart—they did not truly meet until the "West" started celebrating Kabakov as one of the most important artists to emerge from Russia. The museum and auction environments staged his albums of paintings and collages as though he were the sole survivor of a vanished civilization, the only one left to tell the story.

Emilia and Ilya Kabakov in Palermo, 1988.
Photograph by Shobha.

In a way, that is what he was—a storyteller from what he referred to as "the first modern society to disappear." When Emilia, a New York–based curator, reconnected with Ilya in the 1980s, they fell in love and jointly contributed to his ongoing "museum of memories." They made larger works, which they called "total installations."

For the thirty-two years prior to this partnership, he had just been "Ilya." In 1989, the year the Berlin Wall fell, the shift to becoming "Ilya and Emilia" was immediate and official. All of his past work suddenly fit under their two-name umbrella. The moment the Soviet Union fell apart, they synced up under a joint memory. It was as though their individual pasts were sucked into the cosmic vacuum that swallowed Russia's long-reigning, failed government. From then on, they created small worlds within museums that revealed a shared memory bank and evoked the Soviet communal apartment setting, the doors that led nowhere, the enclaves for secret societies.

Ilya and Emilia Kabakov
The Red Wagon, 2011
The State Hermitage Museum,
Saint Petersburg
55 3/4' x 11 1/2' x 23'

The idea of creating *The Red Wagon* occurred
to Ilya in 1989, when he was living in West
Berlin. It was conceived as an attempt to
collate the previous seventy years of Soviet
history into one installation. Explained Ilya
about the piece, "*The Red Wagon* reverts the
symbols to their opposite: the stairs, originally
intended to lead to heaven, eventually lead
nowhere. The wagon, designed to rush
forward at high speed, lacks even wheels and
is eternally static. The propaganda inside
the wagon arouses nostalgia and longing for
reversing time, instead of calling the spectator
to the luminous horizons of the glorious future."

On the other end of the spectrum, in the vanished Soviet memory,
Kabakov was the artist-child who betrayed his country. Metaphorically, if the
country had been Kabakov's adopted father, it was the type that had murdered
the young artist's birth parents and then fostered his talents so that he would
represent his new family in a flattering light. There is nothing more prideful
than a child's adulation of his parent figure. When Kabakov was in Moscow's
finest art school, being pushed along by his mentors, he became entrenched
in his lost childhood, his hushed Jewish heritage, and—in exploring all this—
created an vast series of collages and paintings as an "unofficial" artist. Into
the 1970s he maintained his illustrative painting style to humorously serialize
the daily existence of his several Soviet alter egos. His *10 Characters* series
focused on men taking showers, which in Russian are called *dushis* (the same
word for "souls"). One portrayed a man standing under a spout, the water
pouring in a solid little stream that perfectly outlined one side of his body
without touching it. Russia's response to this image was utter outrage.

> *"The Kabakovs have always viewed Russia and the United States as two sides of the same coin."*

How can my boy represent me like this? It was seen as a statement on Soviet living conditions, piercing the image of a powerful country. This flurry of art drama behind the Iron Curtain signaled the attention of the Western art world. In 1988, the Sotheby's auction house hosted their first contemporary art auction in the Soviet Union. Kabakov and the Moscow conceptualists were for sale. This reality descended onto them like a dark cloud. "The artists' struggles for accurate consciousness seemed overblown and trite when encountered in a commercial context."[3]

Today in the Kabakov cottage, which sidles right up to the ocean that separates the couple from the frigid banks of their homeland, Ilya and Emilia are American citizens who identify as international artists. They do not like pinning their artistic practice to a single nation, seeing that as a form of self-colonization. That said, their "total installations," most notably *The Red Wagon*, transport their audience into an experience that embodies Soviet Russia. The *Wagon* was modeled after the snow-clearing machines that paraded around Moscow. The front entrance into its interior revealed a narrow stairway that led up to a locked door. Through another entrance into the wagon, romantic 1930s music played in a small room lined with Kabakov's childlike wonderscapes. The back entrance was heaped with garbage. Hence, every impressive entrance led to an ugly, dirty rear exit, or vice-versa.

The Kabakovs remember Russia as such, but that doesn't mean they see the United States as the ideal. They have always viewed both countries as two sides of the same coin.

Although they are embraced by it, they think the current international art market is full of hot air, making artists "look like prophets." They can see the black-and-white version of everything, especially regarding the hand that feeds them. The world, according to the Kabakovs, has the problem of consisting of "two parallel worlds: that of culture and that of reality. It is not possible to combine the two: money is for survival, culture is for the spiritual being."[4] The solution, they both say, is to never take either too seriously. This is a concept they've best interpreted through their drifting, candlelit *Ship of Tolerance*. With a patchwork sail quilted together from the drawings of school children from all over the world, it is a total installation, unbound to any country, a bridging of coasts and borders, a nod to Kabakov's early life as a children's book illustrator—a life he rejected when faced with the choice to tolerate government control of his creativity, or set himself free.

[pages 214–215]

Ilya and Emilia Kabakov
Ship of Tolerance, 2011
Miami, Florida
66' x 23' x 43'

In 2005 the original *Ship of Tolerance* set sail on a salt lake in Siwa in the Saharan desert. Watching from the shores to celebrate the completion of the work were the Berber schoolchildren who had painted the square patches of the sail, standing alongside wealthy Western art collectors who had traveled to the location via private jets in support of the artists. Since then, versions of the *Ship of Tolerance* have been erected in five countries around the globe, including the U.S., Switzerland, Italy, United Arab Emirates, and Cuba. Emilia described the power of a piece like this when she stated: "Installation is the oldest art form in the world. A church is an installation in a way, an atmosphere, a total created environment. Now we have art instead of religion."[2]

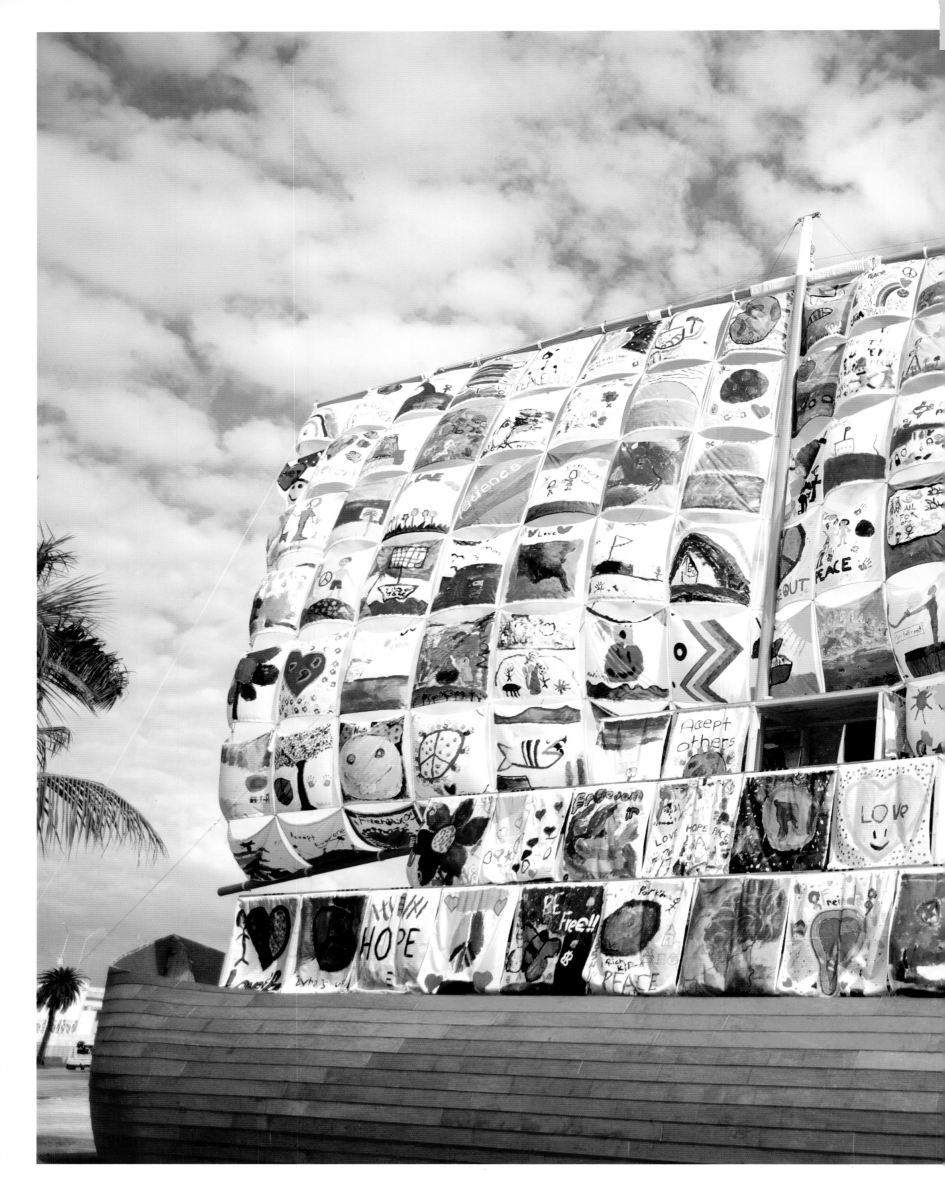

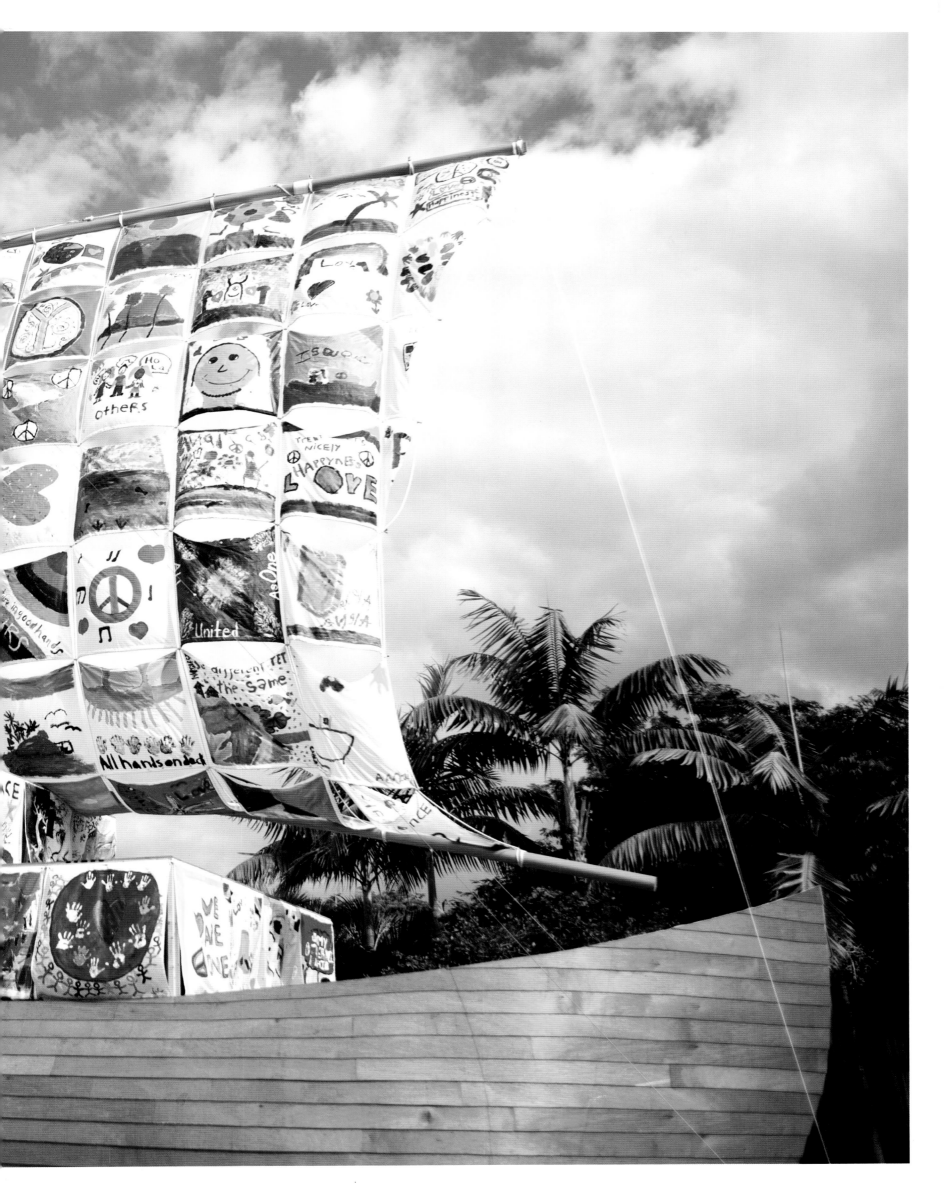

NOTES

WASSILY KANDINSKY & GABRIELE MÜNTER

1 Wassily Kandinsky, "Concerning the Spiritual in Art" (1911) in *Art in Theory 1900–2000: An Anthology of Changing Ideas* (Hoboken, NJ: Blackwell Publishing, 2003), 84.

2 Annegret Hoberg, ed., *Wassily Kandinsky and Gabriele Münter* (Munich: Prestel, 1994; repr. 2005). 34.

3 Ibid., 37.

4 Ibid, 43.

5 Ibid, 48.

6 Ibid, 134.

SONIA & ROBERT DELAUNAY

1 Robert Hughes, *The Shock of the New* (London: Thames & Hudson, 1991).

2 Cubism was created by Picasso and Braque to introduce a proper retaliation against traditional painting by presenting rich multiple perspectives through flat, geometric painting, an early example of abstract painting.

3 Whitney Chadwick, "Living Simultaneously: Robert and Sonia Delaunay" in *Significant Others* (London: Thames & Hudson, 1993), 39.

4 Cindy Nemser, *Art Talk: Conversations with 12 Women Artists* (New York: Charles Scribner's Sons, 1975), 42.

5 Robert Delaunay, letter to August Macke, 1912, quoted in Herschel B. Chipp, *Theories of Modern Art: A Source Book by Artists and Critics* (Berkeley, CA: University of California Press, 1984).

6 *Art Talk*, 42.

7 "Living Simultaneously," 43.

8 *Art Talk*, 42.

9 Ibid.

HANS (JEAN) ARP & SOPHIE TAEUBER-ARP

1 When Arp spoke in German he referred to himself as "Hans;" in French, "Jean" (pronounced "zhaw").

2 Carolyn Lanchner, *Sophie Taeuber-Arp* (New York: Museum of Modern Art, 1981), 17.

3 Hans Arp, *On My Way: Poetry and Essays 1912–1947*, included in Robert Motherwell's series *Documents of Art* (New York: Wittenborn, Schulz, 1948), 40.

4 *Sophie Taeuber-Arp*, introduction, 9.

5 Ibid., 10.

6 Ibid., 17.

7 *On My Way*, 28.

ALFRED STIEGLITZ & GEORGIA O'KEEFFE

1 Richard Whelan, *Alfred Stieglitz: A Biography* (Boston, MA: Little, Brown, 1995), 372.

2 Anne Middleton Wagner, "O'Keeffe's Femininity," *Three Artists (Three Women)* (Berkeley, CA: University of California Press, 1996), 54.

3 Doug Stewart, "Stieglitz in Focus," *Smithsonian* (June 2002).

4 John Szarkowski, *Alfred Stieglitz at Lake George* (New York: The Museum of Modern Art, 1995), 23.

5 Ibid.

JOSEF & ANNI ALBERS

1 Roderick Conway Morris, "Making of a Bauhaus Master," *New York Times* (October 21, 2011).

2 Nicholas Fox Weber, *The Bauhaus Group: Six Masters of Modernism* (New York: Alfred A. Knopf, 2009).

3 Roderick Conway Morris, "Making of a Bauhaus Master," *New York Times* (October 21, 2011).

4 Martin B. Duberman, *Black Mountain: An Exploration in Community* (New York: Norton: 1993), 42.

5 Nicholas Fox Weber, *Josef and Anni Albers: Designs for Living* (London: Merrell and New York: Cooper-Hewitt National Design Museum, 2004), 18.

FRIDA KAHLO & DIEGO RIVERA

1 *Porquería*: crap, trash, filth; cochinada: disgusting behavior, dirty trick.

2 Salvador A. Oropesa, *The Contemporáneos Group: Rewriting Mexico in the Thirties and Forties* (Austin: University of Texas Press, 2003), 153.

3 *Compañero*: companion, mate, partner, equal.

BARBARA HEPWORTH & BEN NICHOLSON

1 Barbara Hepworth, *Barbara Hepworth: A Pictorial Autobiography* (New York: Praeger, 1970), 20.

2 Extract from Hepworth's statement in *Unit 1: The Modern Movement in English Architecture, Painting and Sculpture*, Herbert Read, ed. (London: Cassell & Co., 1934), 19.

3 Norbert Lynton, ed., *Ben Nicholson* (London: Phaidon: 1993), 76.

4 Ibid., 82–3.

5 Ibid., 81.

6 Ibid., 61.

7 *The Studio* 104 (December 1932), 332.

8 Ibid., 31.

9 *Ben Nicholson*, 79.

10 *Pictorial Autobiography*, 33.

JACOB LAWRENCE & GWENDOLYN KNIGHT

1 Elizabeth Hutton Turner, *Jacob Lawrence: The Migration Series* (Urbanna, VA: The Rappahannock Press, in association with Washington, DC: The Phillips Collection, 1993), 18.

2 Langston Hughes, *Harlem: A Community in Transition* (New York: Citadel Press, 1964), 62.

3 Barbara Earl Thomas and Sheryl Conkelton, in *Never Late for Heaven: The Art of Gwen Knight* (Seattle, WA: University of Washington Press, 2003), 13.

4 Ibid., 24.

YVES TANGUY & KAY SAGE

1 Judith D. Suther, "Kay Sage and Yves Tanguy: Separate Studios," *Significant Others: Creativity and Intimate Partnership*, Whitney Chadwick and Isabelle de Courtivron, eds. (Thames and Hudson, 1993),152.

2 André Breton, "The First Manifesto of Surrealism," *Art in Theory: 1900–2000, An Anthology of Changing Ideas* (Blackwell Publishing: 1992, 2003), 452.

3 "Kay Sage and Yves Tanguy," 145.

4 Karen Rosenberg, "Surrealist Partners in Painting, but Don't Call Them a Team," *New York Times* (June 9, 2011).

5 Ibid.

6 Ibid.

7 Reference to his 1948 painting *Le malheur adoucit les pierres* (Suffering Softens Stones), 1948.

WILLEM & ELAINE DE KOONING

1 Mark Stevens and Annalyn Swan, *de Kooning: An American Master* (New York: Knopf, 2004), 153.

2 Ann Eden Gibson, *Abstract Expressionism: Other Politics* (New Haven and London: Yale University Press, 1997), 135.

3 Willem de Kooning, "A Desperate View," *The Collected Writings of Willem de Kooning* (Madras, India: Hanuman Books, 1988), 9–14.

4 Craig Owens, "Honor, Power, and the Love of Women," *Beyond Recognition: Representation, Power, and Culture* (Berkeley, CA: University of California Press, 1992), 143.

5 *de Kooning*, 165.

6 John Gruen, *The Party's Over Now: Reminiscences of the Fifties—New York's Artists, Writers, Musicians and Their Friends* (New York: Viking Press, 1972), 209.

7 *de Kooning*, 193.

8 Ibid., 339.

CHARLES & RAY EAMES

1 Eames Demetrios, *An Eames Primer* (New York: Universe Publications, 2001).

2 Jason Cohn and Bill Jersey, narration performed by James Franco in *Charles and Ray Eames: The Architect and the Painter*, broadcast on the American Masters series, PBS (December 19, 2011).

3 Donald Albrecht, "Design Is a Method of Action" in *The Work of Charles and Ray Eames: A Legacy of Invention* (New York: Harry N. Abrams,1997), 41.

4 *An Eames Primer*, 139.

5 Pat Kirkham, *Charles and Ray Eames: Designers of the Twentieth Century* (Cambridge, MA: MIT Press, 1998), 65.

6 Charles Eames, quoted in *An Eames Primer*.

7 *An Eames Primer*, 245.

8 *The Architect and the Painter*.

LEE KRASNER & JACKSON POLLOCK

1 Vivien Rayner, "John Graham, A Brilliant Scoundrel," *New York Times* (July 3, 1987).

2 Gail Levin, *Lee Krasner: A Biography* (New York: Harper Collins, 2011), 199.

3 Ibid., 167.

4 Ibid., 242.

5 Steven Naifeh and Gregory Smith, *Jackson Pollock: An American Saga* (New York: Clarkson Potter, 1989).

6 Berton Roueche, "Unframed Space," *The New Yorker* (August 5, 1950).

7 Quoting Audrey Flack, *Lee Krasner*, 307.

8 Amei Wallach, "Art and Architecture; The Lee Krasner Who Was Herself and Only Herself," *New York Times* (October 3, 1999).

9 Ruth Kligman, *Love Affair: A Memoir of Jackson Pollock* (New York: William Morrow, 1974).

10 M. G. Lord. "Lee Krasner: Before and After the Ball Was Over," *New York Times* (August 27, 1995).

11 Arthur Rimbaud, *A Season in Hell*, trans. Delmore Scwartz (New York: New Directions, 1939), 27.

MAX ERNST & DOROTHEA TANNING

1 Dorothea Tanning, *Between Lives: An Artist and Her World* (New York: W. W. Norton, 2001).

2 Interview with John Glassie, "Oldest Living Surrealist Tells All," Salon.com (February 11, 2002).

3 Grace Glueck, "Dorothea Tanning, Surrealist Painter, Dies at 101," *New York Times* (February 1, 2012).

4 *Between Lives*, 108.

5 Ibid., 72.

6 Werner Spies, "Aesthetics of Detachment," *Max Ernst: Dream and Revolution* (Ostfildern, Germany: Hatje Cantz, 2008), 9.

7 Werner Spies, "Max Ernst in America: Vox Angelica," *Max Ernst: A Retrospective* (New York: Metropolitan Museum of Art, 2005), 71.

8 Exhibition brochure, *Dorothea Tanning: Birthday and Beyond* (Philadelphia: Philadelphia Museum of Art, 2000).

9 *Between Lives*, 139.

PABLO PICASSO & FRANÇOISE GILOT

1 Françoise Gilot, *Life with Picasso* (New York: McGraw Hill, 1964), 123.

2 Ibid., 18.

3 Norman Mailer, *Portrait of Picasso as a Young Man* (New York: The Atlantic Monthly Press, 1995), 41.

4 Françoise Gilot, *Françoise Gilot Monograph: 1940–2000* (Lausanne, Switzerland: Editions Acatos, 2000), 26.

5 *Life with Picasso*, 32.

6 Ibid., 52.

7 Ibid., 119.

8 Ibid., 58.

9 Ibid., 82.

10 Ibid., 348.

SAUL STEINBERG & HEDDA STERNE

1 Roger Angell, "Map of Saul," *The New Yorker* (February 28, 2005), 56.

2 Jane Kramer, "Portfolio by Saul Steinberg: Mission to China," *The New Yorker* (July 10, 2000), 59.

3 The Publisher had hoped to include Hedda Sterne's work in this chapter. Unfortunately The Hedda Sterne Foundation Board of Trustees did not approve of the reproduction of any of her works in this publication.

4 Sarah Boxer, "The Last Irascible," *New York Review of Books* (December 23, 2010).

5 Saul Steinberg quoted by Joel Smith in *Steinberg at the New Yorker* (Henry A. Abrams: 2005), 220.

6 Joel Smith, *Illuminations* (Yale University Press: 2006), 24.

7 Ibid., 26.

8 Ibid., 29.

9 Ibid., 30.

10 Anney Bonney, "Hedda Sterne," *Bomb Magazine* 39 (Spring, 1992).

11 *Illuminations*, 31.

12 Adam Gopnik, "What Steinberg Saw," *The New Yorker* (November 13, 2000), 142.

13 Ian Frazier, Introduction to *Steinberg at the New Yorker* (New York: Harry N. Abrams, 2005), 10.

14 Steinberg, quoted in *Steinberg at the New Yorker*, 29.

15 "The Last Irascible"

16 *Steinberg at the New Yorker*, 22.

17 Joan Simon, "Interview with Hedda Sterne," *Art in America*, February 1, 2007. [online]

18 "The Last Irascible"

19 Ibid.

LEON GOLUB & NANCY SPERO

1 Katie Kline and Helaine Posner, "A Conversation with Leon Golub and Nancy Spero," *Nancy Spero and Leon Golub: War and Memory* (Cambridge, MA: MIT List Visual Arts Center, 1995), 11.

2 Jon Bird, *Leon Golub: Echoes of the Real* (London: Reaktion Books, 2000), 69.

3 Joanna S.Walker, *Nancy Spero: Encounters* (Farnham, Surrey, U.K.: Ashgate, 2011), 95.

4 *Echoes of the Real*, 45.

5 "A Conversation with Leon Golub and Nancy Spero," 21.

6 Michael Kimmelman, "AT THE MET WITH: Leon Golub and Nancy Spero: 2 Artists Always Prowling For Ideas to Use Again," *New York Times* (January 5, 1996).

JASPER JOHNS & ROBERT RAUSCHENBERG

1 Calvin Tomkins, *Off the Wall: A Portrait of Robert Rauschenberg* (New York: Doubleday, 1980), 178.

2 Mark Stevens with Cathleen McGuigan, "Super Artist: Jasper Johns, Today's Master," *Newsweek* 90 no. 17 (October 24, 1977), 66–79.

3 Calvin Tomkins, "Moving Out," *The New Yorker* (February 29, 1964).

4 Jonathan Katz, "The Art of Code: Jasper Johns and Robert Rauschenberg," *Significant Others* (London: Thames and Hudson, 1993), 196, 200.

5 Interview with Billy Kluver, 1963, in *Jasper Johns: Writings, Sketchbook Notes, and Interviews* (New York: MoMA, 1996), 85.

6 Paul Taylor, "Robert Rauschenberg: 'I Can't Even Afford My Works Anymore,'" *Interview* 20, no. 12 (December, 1990), 146–8.

7 Discussion by Jonathan Katz, co-curator of Hide/Seek and Chair of the Visual Studies Doctoral Program at SUNY-Buffalo.

8 Ibid.

HELEN FRANKENTHALER & ROBERT MOTHERWELL

1 David Sylvester, *Interviews with American Artists* (New Haven, CT: Yale University Press, 2001), 76.

2 Robert Saltonstall Mattison, *Robert Motherwell: The Formative Years* (Ann Arbor, MI: UMI Research Press. 1987).

3 Robert Motherwell, *The Writings of Robert Motherwell (Documents of Twentieth Century Art)* (Berkeley, Calif.: University of California Press, 2007), 348.

4 Helen Frankenthaler quoted in "Helen Frankenthaler, noted Abstract painter dies at 83," *Washington Post* (December 27, 2011).

5 *Interviews*, 75.

6 Robert Motherwell, *The Writings of Robert Motherwell*, 348.

CHRISTO & JEANNE-CLAUDE

1 Burt Chernow, *Christo and Jeanne-Claude: A Biography* (New York: St. Martin's Press, 2002), 54.

2 They had worked on one installation together in1961, *Dockside Packages*. It was very visible but not obstructive in any way.

3 *Christo and Jeanne-Claude: A Biography*, 196.

4 http://www.christojeanneclaude.net/errors.

5 "Artist Jeanne-Claude Dies at 74," *The Guardian* (November 19, 2009).

6 Peter Simek, "Interview: Christo on the Freedom of Unnecessary Art," *Front Row: A Daily Review of the Dallas Arts* (February 24, 2011).

BERND & HILLA BECHER

1 Bernd Becher, interview, *Contacts: Portraits of Contemporary Photographers* 3, 2000, www.youtube.com/watch?v=6ZSLvFY1X6g.

2 Bernd and Hilla Becher interviewed by Heinz-Norbert Jocks, "The Birth of the Photographic View from the Spirit of History," *Bernd and Hilla Becher: Life and Work* (Cambridge, MA: MIT Press, 2007), Susanne Lange, ed., Jeremy Gaines, trans., 210.

3 Hilla Becher, "Notes from Her Travels," *Life and Work*, 180.

4 Blake Stimson, "The Photographic Comportment of Bernd and Hilla Becher," *Tate Papers* (Spring 2004).

5 Ibid., 210.

6 Michael Collins, "The Long Look," *Tate Magazine*, Issue 1 (September, 2002).

7 Hilla Becher, quoted in *Contacts*.

8 "Notes from Her Travels," 181

TOM DOYLE & EVA HESSE

1 Kirsten Swenson, "Machines and Marriage: Eva Hesse and Tom Doyle in Germany, 1964–65," *Art in America* (June/July 2006), 168–169.

2 Ibid., 169.

3 Phong Bui, "In Conversation: Tom Doyle with Phong Bui," *Brooklyn Rail* (May, 2008).

4 Catherine Zegher, *Eva Hesse Drawing* (New Haven and London: Yale University Press, 2006), 321.

5 Cindy Nemser, *Art Talk: Conversations with 15 Women Artists* (Boulder, CO: Westview Press, 1996).

ROBERT SMITHSON & NANCY HOLT

1 http://www.eai.org/title.htm?id=11675.

2 John Anthony Thwaites, quoted by Michael Lailach in "Beyond the White Cube," *Land Art* (Cologne, Germany: Taschen: 2007), Uta Grosenick, ed., 6.

3 Interview with Kelly Ann Wacker, "Nancy Holt: The Exterior World," *Convergence: Form, Meaning and Context in the Work of Alice Aycock, Nancy Holt, and Mary Miss* (Louisville, KY: University of Louisville: 2002), 38.

4 Robert Smithson, "A Sedimentation of the Mind: Earth Projects," *Art in Theory, 1900–1990* (Oxford, UK: Blackwell, 1992), Charles Harrison and Paul Wood, eds.

5 Ibid.

6 Nancy Holt, "Sun Tunnels," *Theories and Documents of Contemporary Art: A Sourcebook of Artists' Writings* (Berkeley, CA: University of California Press, 1996), Kristine Stiles and Peter Howard Selz, eds., 539.

NIKI DE SAINT PHALLE & JEAN TINGUELY

1 Niki de Saint-Phalle, *Niki de Saint Phalle: My Art-My Dreams*, (Prestel, 2003).

2 Marcel Duchamp, quoted by Calvin Tomkins in "Jean Tinguely," *The Bride and the Bachelors* (New York: Penguin, 1965), 148.

3 Daniel Abadie, "*Tinguely, l'oiseau de feu et le chapeau suisse*," *Beaux Arts* no. 2 (May 1983), 36 (here translated by D. R. Siefkin).

4 Bloum Cárdenas, quoted by Alan Riding in "For Tinguely and Saint Phalle, A Show Is a Posthumous Reunion," *New York Times* (September 2, 2006).

MARINA ABRAMOVIĆ & ULAY

1 Helena Kontova, "Marina Abramović and Ulay," *Flash Art* no. 80–81 (1978).

2 MoMA audio archive: http://www.moma.org/explore/multimedia/audios/190/1986.

3 Thomas McEvilley, *Art, Love, Friendship: Marina Abramović and Ulay, Together & Apart* (Kingston, NY: McPherson, 2010).

4 C. Carr, "A Great Wall," *On Edge: Performance at the End of the Twentieth Century* (Middleton, CT; Wesleyan, 1994), 47.

CLAES OLDENBURG & COOSJE VAN BRUGGEN

1 Janie C. Lee, introduction to *Claes Oldenburg: Drawings in the Whitney Museum of Art* (New York: Whitney Museum of American Art, 2002).

2 The term, coined by artist Allan Kaprow, refers to a genre of situational/performance art where there is no boundary between the audience and the art; thus the audience is the art. The form was very popular during the 1960s.

3 Carol Kino, "Coosje van Bruggen, Sculptor, Dies at 66," *New York Times* (January 13, 2009).

4 Janie C. Lee, op. cit.

5 Masked theater popularized in Italy during the sixteenth century.

6 Coosje van Bruggen, "Waiting for Dr. Coltello: A Project by Coosje van Bruggen, Frank O. Gehry, and Claes Oldenburg," *Sculpture by the Way* (Milan: Skira Editore, 2006), 219.

7 "Coosje's Journal," ibid., 225.

8 Carol Kino, op. cit.

DAVID McDERMOTT & PETER McGOUGH

1 Personal interview with Peter McGough, March 8, 2012.

2 Ibid.

3 Ibid.

4 Peter McGough interviewed by Bob Nickas in *Artforum* (March, 2003).

5 Personal interview, op. cit.

6 Wayne Koestenbaum, "Because of Him," *McDermott & McGough: Because of Him* (New York: Cheim and Read, 2008). Exhibition catalog.

BRUCE NAUMAN & SUSAN ROTHENBERG

1 Interview with Willoughby Sharp in *Please Pay Attention Please: Bruce Nauman's Words* (Cambridge, MA: MIT Press, 2005), 118.

2 Quoted by Dorothy Seiberling in "Art: Dutch Treat," *New York* 9, no. 18 (May 3, 1976).

3 Peter Scheldahl, "Julian Schnabel and Susan Rothenberg," *Hydrogen Jukebox: Selected Writings of Peter Schjeldahl, 1978–1990* (Santa Fe, NM: Lannan:, 1993), 72.

4 Calvin Tomkins, "Onwards and Upwards with the Arts: On Western Disturbances: Bruce Nauman's Singular Influence." *The New Yorker* (June 1, 2009).

5 Art21 short film *Susan Rothenberg: Bruce and the Studio*, art21.org.

6 Robert C. Morgan, *Bruce Nauman* (Boston, NY: PAJ Books, 2002), 136.

7 Calvin Tomkins, op. cit.

ILYA & EMILIA KABAKOV

1 Ilya Kabakov, interviewed by Katarzyna Bojarska in "A Conversation with Ilya and Emilia Kabakov," www.artmargins.com/index.php/interviews/176.

2 Nick Hackworth, "The Amazing Technicolor Dreamboat," *The Telegraph* (November 19, 2005).

3 Matthew Jesse Jackson, *The Experimental Group: Ilya Kabakov, Moscow Conceptualism, Soviet Avant-Gardes* (Chicago: University of Chicago Press, 2010), 244.

4 Bojarska interview, op. cit.

BIBLIOGRAPHY

Arp, Hans. *On My Way: Poetry and Essays, 1912–1947*. Documents of Modern Art. Robert Motherwell, ed. New York: Wittenborn, Schulz, 1948.

Bird, Jon. *Leon Golub: Echoes of the Real*. London: Reaktion Books, 2000.

Burke, Carolyn. *Lee Miller: A Life*. New York: Knopf, 2005.

Carr, C. *On Edge: Performance at the End of the Twentieth Century*. Middleton: Wesleyan, 1994.

Chadwick, Whitney and Isabelle de Courtivron. *Significant Others; Creativity and Intimate Partnership*. London: Thames & Hudson, 1993.

Chernow, Burt. *Christo and Jeanne-Claude: A Biography*. New York: St. Martin's Press, 2002.

Chipp, Herschel B. *Theories of Modern Art: A Source Book by Artists and Critics*. Berkeley: University of California Press, 1984.

de Kooning, Willem. *The Collected Writings of Willem de Kooning*. Madras: Hanuman Books, 1988.

Demetrios, Eames. *An Eames Primer*. New York: Universe Publications, 2001.

de Saint-Phalle, Niki. *Niki de Saint Phalle: My Art-My Dreams*. New York: Prestel, 2003.

Duberman, Martin B. *Black Mountain: An Exploration in Community*. New York: W. W. Norton, 1993.

Gianelli, Ida and Marcella Beccaria. *Claes Oldenburg and Coosje van Bruggen: Sculpture by the Way*. Milan: Skira Editore, 2006.

Gilot, Françoise. *Life with Picasso*. New York: McGraw Hill, 1964.

Gilot, Françoise. *Françoise Gilot Monograph: 1940-2000*. Switzerland: Editions Acatos, 2000.

Gruen, John. *The Party's Over Now: Reminiscences of the Fifties—New York's Artists, Writers, Musicians, and Their Friends*. New York: Viking Press, 1972.

Harrison, Charles and Dr. Paul J. Wood, eds. *Art Theory: 1900-2000, An Anthology of Changing Ideas*. Blackwell Publishing: 1992, 2003.

Hepworth, Barbara. *Barbara Hepworth: A Pictorial Autobiography*. New York: Praeger, 1970.

Herrera, Hayden. *Frida: A Biography of Frida Kahlo*. New York: Harper Perennial, 2002.

Hoberg, Annegret, ed. *Wassily Kandinsky and Gabriele Münter*. Munich: Prestel, 1994;repr. 2005.

Hughes, Langston. *Harlem: A Community in Transition*. New York: Citadel Press, 1964.

Hughes, Robert. *The Shock of the New*. London: Thames & Hudson, 1991.

Jackson, Matthew Jesse. *The Experimental Group: Ilya Kabakov, Moscow Conceptualism, Soviet Avant-Gardes*. Chicago: University of Chicago Press, 2010.

Kirkam, Pat. *Charles and Ray Eames: Designers of the Twentieth Century*. Cambridge: MIT Press, 1998.

Kligman, Ruth. *Love Affair: A Memoir of Jackson Pollock*. New York: William Morrow, 1974.

Kluver, Billy. *Jasper Johns: Writings, Sketchbook Notes, and Interviews*. New York: Museum of Modern Art, 1996.

Koestenbaum, Wayne. *McDermott & McGough: Because of Him*. New York: Cheim and Read, 2008.

Lailach, Michael and Uta Grosenick. *Land Art*. Cologne: Taschen, 2007.

Lanchner, Carolyn. *Sophie Taeuber-Arp*. New York: Museum of Modern Art, 1981.

Lange, Susanne. *Bernd and Hilla Becher: Life and Work*. Cambridge: MIT Press, 2007.

Lee, Janie C. Introduction. *Claes Oldenburg: Drawings in the Whitney Museum of Art*. New York: Whitney Museum of American Art, 2002.

Levin, Gail. *Lee Krasner: A Biography*. New York: Harper Collins, 2011.

Lynton, Norbert, ed. *Ben Nicholson*. London: Phaidon, 1993.

Mailer, Norman. *Portrait of Picasso as a Young Man*. New York: The Atlantic Monthly Press, 1995.

Mattison, Robert Saltonstall. *Robert Motherwell: The Formative Years*. Ann Arbor: UMI Research Press, 1987.

McEvilley, Thomas. *Art, Love, Friendship: Marina Abramović and Ulay, Together & Apart*. Kingston: McPherson, 2010.

Morgan, Robert C. *Bruce Nauman*. New York: PAJ Books, 2002.

Motherwell, Robert. *The Writings of Robert Motherwell: Documents of Twentieth Century Art*. Berkeley: The University of California Press, 2007.

Naifeh, Steven and Gregory Smith. *Jackson Pollock: An American Saga*. New York: Clarkson Potter, 1989.

Nemser, Cindy. *Art Talk: Conversations with 12 Women Artists*. New York: Charles Scribner's Sons, 1975.

Nemser, Cindy. *Art Talk: Conversations with 15 Women Artists*. Boulder: Westview Press, 1996.

Oropresa, Salvador. *The Contemporáneos Groups: Rewriting Mexico in the Thirties and Forties*. Austin: University of Texas Press, 2003.

Owens, Craig. *Beyond Recognition: Representation, Power, and Culture*. Berkeley: University of California Press, 1992.

Posner, Helaine, et al. *Nancy Spero and Leon Golub: War and Memory*. Cambridge: MIT List Visual Arts Center, 1995.

Rimbaud, Arthur. *A Season in Hell*. Delmore Schwartz, trans. New York: NewDirections, 1939.

Schjeldahl, Peter. *Hydrogen Jukebox: Selected Writings of Peter Schjeldahl, 1978–1990*. Santa Fe: Lannan, 1993.

Sharp, Willoughby. *Please Pay Attention Please: Bruce Nauman's Words*. Cambridge: MIT Press, 2005.

Smith, Joel. *Saul Steinberg: Illuminations*. New Haven: Yale University Press, 2006.

Smith, Joel. *Max Ernst: A Retrospective*. New York: Metropolitan Museum of Art, 2005.

Smith, Joel. *Steinberg at the New Yorker*. New York: Harry N. Abrams, 2005.

Spies, Werner. *Max Ernst: Dream and Revolution*. Ostfildern: Hatje Cantz, 2008.

Stevens, Mark and Annalyn Swan. *De Kooning: An American Master*. New York: Knopf, 2004.

Stiles, Kristine and Peter Howard Selz, eds. *Theories and Documents of Contemporary Art: A Sourcebook of Artists' Writings*. Berkeley: University of California Press, 1996.

Sylvester, David. *Interviews with American Artists*. New Haven: Yale University Press, 2001.

Szarkowski, John. *Alfred Stieglitz at Lake George*. New York: Museum of Modern Art, 1995.

Tanning, Dorothea. *Between Lives: An Artist and Her World*. New York: W.W. Norton, 2001.

Thomas, Barbara Earl and Sheryl Conkelton. *Never Late for Heaven: The Art of Gwen Knight*. Seattle: University of Washington Press, 2003.

Tompkins, Calvin. *Off the Wall: A Portrait of Robert Rauschenberg*. New York: Doubleday, 1980.

Tompkins, Calvin. *The Bride and the Bachelors: Five Masters of the Avant-Garde*. New York: Penguin, 1965.

Turner, Elizabeth Hutton, et al. *Jacob Lawrence: The Migration Series*. Urbanna: The Rappahannock Press: The Phillips Collection, 1993.

Wacker, Kelly Ann. *Convergence: Form, Meaning and Context in the Work of Alice Aycock, Nancy Holt, and Mary Miss*. Louisville: University of Louisville, 2002.

Wagner, Anne Middleton. *Three Artists (Three Women)*. Berkeley: University of California Press, 1996.

Weber, Nicholas Fox. *The Bauhaus Group: Six Masters of Modernism*. New York: Alfred A. Knopf, 2009.

Weber, Nicholas Fox. *Josef and Anni Albers: Designs for Living*. London: Merrell, 2004.

Whelan, Richard. *Alfred Stieglitz: A Biography*. Boston: Little, Brown, 1995.

CREDITS

Pablo Picasso, *Françoise, Claude and Paloma 2*, 1954. © 2012 Estate of Pablo Picasso / Artists Rights Society (ARS), New York. Photo: J.G. Berizzi / Réunion des Musées Nationaux / Art Resource, NY.

Man Ray, *Lee Miller in a Collar*. Musée National d'Art Moderne, Centre Georges Pompidou, Paris, France. © 2012 Man Ray Trust / Artists Rights Society (ARS), NY / ADAGP, Paris. Photo: CNAC / MNAM / Dist. Réunion des Musées Nationaux / Art Resource, NY.

Wassily Kandinsky & Gabriele Münter in Stockholm in the winter of 1916. Photo Credit: Staatsbibliothek zu Berlin, Stiftung Preussischer Kulturbesitz, Berlin, Germany.

Wassily Kandinsky, *Gabriele Münter Painting in Kallmünz*, 1903. © 2012 Artists Rights Society (ARS), New York / ADAGP, Paris. Photo Credit: bpk, Berlin Staedtische Galerie im Lenbachhaus, Munich, Germany / Lutz Braun / Art Resource, NY.

Gabriele Münter, *Kandinsky*, circa 1910. © 2012 Artists Rights Society (ARS), New York / VG Bild-Kunst, Bonn. Photo: Visual Arts Library / Art Resource, NY.

Wassily Kandinsky, *Almanach Der Blaue Reiter*. Study. 1911. © 2012 Artists Rights Society (ARS), New York / ADAGP, Paris. Photo: Philippe Migeat / CNAC / MNAM / Dist. Réunion des Musées Nationaux / Art Resource, NY.

Wassily Kandinsky, *Composition*, 1915. © 2012 Artists Rights Society (ARS), New York / ADAGP, Paris. Photo: Erich Lessing / Art Resource, NY.

Gabriele Münter, *Still Life with Vases No. 2*, 1914. Coll. Henri Nannen, Emden, Germany. © 2012 Artists Rights Society (ARS), New York / VG Bild-Kunst, Bonn. Photo: Erich Lessing / Art Resource, NY.

Robert Delaunay, *The Eiffel Tower*, 1911. Kunstmuseum, Basel, Switzerland. Photo: Erich Lessing / Art Resource, NY.

Robert Delaunay, *Windows Open Simultaneously 1st Part, 3rd Motif*, 1912. Tate Gallery, London, Great Britain. Photo: Tate, London / Art Resource, NY.

Sonia Delaunay, *Couverture*, 1911. © L & M SERVICES B.V. The Hague 20120302. Photo: CNAC / MNAM / Dist. Réunion des Musées Nationaux / Art Resource, NY.

Sophie Taeuber-Arp and Hans (Jean) Arp in Ascona, Switzerland, 1925. © 2012 Artists Rights Society (ARS), New York / VG Bild-Kunst, Bonn. Photo: Stiftung Hans Arp und Sophie Taeuber-Arp e.V., Rolandswerth.

Hans (Jean) Arp and Sophie Taeuber-Arp, *Symétrie pathétique*, 1916–17. Musée National d'Art Moderne, Centre Georges Pompidou, Paris, France. © 2012 Artists Rights Society (ARS), New York / VG Bild-Kunst, Bonn. Photo: Jacqueline Hyde / CNAC / MNAM / Dist. Réunion des Musées Nationaux / Art Resource, NY.

Sophie Taeuber-Arp, *Tête Dada* (Dada Head), 1920. Musée National d'Art Moderne, Centre Georges Pompidou, Paris, France. © 2012 Artists Rights Society (ARS), New York / ProLitteris, Zurich. Photo: Georges Meguerditchian / CNAC / MNAM / Dist. Réunion des Musées Nationaux / Art Resource, NY.

Hans (Jean) Arp, *Positiv-Negativ Figuren*, 1962. © 2012 Artists Rights Society (ARS), New York / VG Bild-Kunst, Bonn. Photo: Stiftung Hans Arp und Sophie Taeuber-Arp e.V., Rolandswerth.

Alfred Stieglitz and Georgia O'Keeffe at his family estate in Lake George, New York, 1929. Alfred Stieglitz / Georgia O'Keeffe Archive, 1728–1986, Yale Collection of American Literature, Beinecke Rare Book and Manuscript Library. © 2012 Georgia O'Keeffe Museum / Artists Rights Society (ARS), New York. Photo: Alfred Stieglitz.

Alfred Stieglitz, *Georgia O'Keeffe*, 1919. © 2012 Georgia O'Keeffe Museum / Artists Rights Society (ARS), New York. Image copyright © The Metropolitan Museum of Art. Image source: Art Resource, NY.

Alfred Stieglitz Photographing Georgia O'Keeffe, 1924. Arnold H. Rönnebeck, photographer. Arnold Rönnebeck and Louise Emerson Rönnebeck papers, Archives of American Art, Smithsonian Institution. © Estate of Arnold Rönnebeck.

Georgia O'Keeffe, *Music, Pink and Blue No. 2*, 1919. © 2012 Georgia O'Keeffe Museum / Artists Rights Society (ARS), New York. Whitney Museum of American Art, New York; gift of Emily Fisher Landau in honor of Tom Armstrong 91.90. Photo: Sheldan C. Collins.

Josef and Anni Albers, Black Mountain College, circa 1935. © 2012 The Josef and Anni Albers Foundation / Artists Rights Society (ARS), New York. Photo: Albers Foundation/ Art Resource, NY.

Josef Albers, *Factory*, 1925. © 2012 The Josef and Anni Albers Foundation / Artists Rights Society (ARS), New York. Photo: Tim Nighswander, Albers Foundation / Art Resource, NY.

Anni Albers, Study for Unexecuted Wallhanging, 1926. © 2012 The Josef and Anni Albers Foundation / Artists Rights Society (ARS), New York. Photo: Tim Nighswander, Albers Foundation / Art Resource, NY.

Josef Albers, Study for *Homage to the Square, 2 Grays Between 2 Yellows*, 1961. © 2012 The Josef and Anni Albers Foundation / Artists Rights Society (ARS), New York. Photo: Tim Nighswander, Albers Foundation / Art Resource, NY.

Anni Albers, Study for *DO II*, 1973. © 2012 The Josef and Anni Albers Foundation / Artists Rights Society (ARS), New York. Photo: Tim Nighswander, Albers Foundation / Art Resource, NY.

Frida Kahlo, *The Broken Column*, 1944. Fundación Dolores Olmedo, Mexico City, D.F., Mexico. © 2012 Banco de México Diego Rivera & Frida Kahlo Museums Trust, Mexico, D.F. / Artists Rights Society (ARS), New York. Photo: Schalkwijk / Art Resource, NY.

Frida Kahlo and Diego Rivera, Mexico City, 1933/1934, Gelatin Silver Print. © Estate of Martin Munkácsi, Courtesy Howard Greenberg Gallery, New York. Photo: Courtesy International Center of Photography (2007.110.209).

Frida Kahlo, *Self-portrait as a Tehuana*, 1943. © 2012 Banco de México Diego Rivera & Frida Kahlo Museums Trust, Mexico, D.F. / Artists Rights Society (ARS), New York. Photo: The Granger Collection, New York.

Frida Kahlo and Diego Rivera, 1931. Paul A. Juley, photographer. Chester Dale papers, Archives of American Art, Smithsonian Institution.

Diego Rivera, Detail from *The Dream of a Sunday Afternoon in the Alameda Park*, 1947–8. Hotel del Prado, Mexico City, D.F., Mexico. © 2012 Banco de México Diego Rivera & Frida Kahlo Museums Trust, Mexico, D.F. / Artists Rights Society (ARS), New York. Photo: Alfredo Dagli Orti / Art Resource, NY.

Lee Miller with Man Ray in her studio in Paris, 1931. © Lee Miller Archives, England 2012. All rights reserved. www.leemiller.co.uk. Photo: Theodore Miller.

Man Ray, *At the Observatory Time, The Lovers, (A l'heure de l'Observatoire, les Amoureux)*, 1934. © 2012 Man Ray Trust / Artists Rights Society (ARS), NY / ADAGP, Paris. Photo: Banque D'Images, ADAGP / Art Resource, NY.

Lee Miller, *Nude Bent Forward*, 1930. © Lee Miller Archives, England 2012. All rights reserved. www.leemiller.co.uk. Photo: Lee Miller.

Lee Miller Bathing in Adolf Hitler's Bathtub in Munich, Germany, 1945. Photo: David E. Scherman / Time & Life Pictures / Getty Images.

Barbara Hepworth and Ben Nicholson, 1933. © Tate, London 2012.

Ben Nicholson, *Profile*, 1933. Victoria and Albert Museum, London, Great Britain. © 2012 Angela Verren Taunt / All rights reserved / ARS, NY / DACS, London. Photo: V&A Images, London / Art Resource, NY.

Barbara Hepworth, *Two Heads*, 1932. © Bowness, Hepworth Estate. (BH 38), Pier Art Centre, Stromness, Orkney. Photo: David Lambert / Rod Tidnam.

Ben Nicholson, *White Relief*, 1935. Tate Gallery, London, Great Britain. © 2012 Angela Verren Taunt / All rights reserved / ARS, NY / DACS, London. Photo: Tate, London / Art Resource, NY.

Barbara Hepworth. *Tides 1*, 1946. © Bowness, Hepworth Estate. Photo: © Tate, London 2012.

Hepworth and Nicholson's Triplets—Simon, Rachel, and Sarah, circa 1943. © 2012 Angela Verren Taunt / All rights reserved / ARS, NY / DACS, London. Photo Credit: © Tate, London 2012. Photo: Ben Nicholson.

Ben Nicholson photographing Barbara Hepworth's reflection in a mirror, circa 1932. © 2012 Angela Verren Taunt / All rights reserved / ARS, NY / DACS, London. Photo Credit: ©Tate, London 2012. Photo: Ben Nicholson.

Gwendolyn Knight and Jacob Lawrence, 1979. © 2012 The Jacob and Gwendolyn Lawrence Foundation, Seattle / Artists Rights Society (ARS), New York. Lawrence and Gwendolyn Knight papers, Archives of American Art, Smithsonian Institution. Photo: Unidentified photographer.

Jacob Lawrence, *The Migration of the Negro #18 (The Migration Gained in Momentum)*, 1941. © 2012 The Jacob and Gwendolyn Lawrence Foundation, Seattle / Artists Rights Society (ARS), New York. Photo: The Jacob and Gwendolyn Lawrence Foundation / Art Resource, NY.

Gwendolyn Knight, *The Boudoir*, 1945. © 2012 The Jacob and Gwendolyn Lawrence Foundation, Seattle / Artists Rights Society (ARS), New York. Photo: Courtesy DC Moore Gallery, NY.

Yves Tanguy with Kay Sage (10 of 11), Connecticut, 1947. Copyright © by The Irving Penn Foundation. Photo: Irving Penn.

Kay Sage, *Tomorrow is Never*, 1955. Image copyright © The Metropolitan Museum of Art. Image Source: Art Resource, NY.

Yves Tanguy, *Multiplication of the Arcs*, 1954. © 2012 Estate of Yves Tanguy / Artists Rights Society (ARS), New York. Digital Image © The Museum of Modern Art / Licensed by SCALA / Art Resource, NY.

Yves Tanguy, *Je vous attends (I Await You)*, 1934. © 2012 Estate of Yves Tanguy / Artists Rights Society (ARS), New York. Digital Image © 2012 Museum Associates / LACMA. Licensed by Art Resource, NY.

Kay Sage, *Le Passage*, 1956. Private Collection.

Elaine and Willem de Kooning, 1953. © 1991 Hans Namuth Estate. Courtesy Center for Creative Photography, The University of Arizona. Photo: Hans Namuth.

Elaine de Kooning, *Portrait of Willem de Kooning*. © Estate of Elaine de Kooning. Photo: Doyle New York, Auctioneers & Appraisers.

Willem de Kooning, *Woman, I*, 1950–52. © 2012 The Willem de Kooning Foundation / Artists Rights Society (ARS), New York. Digital Image © The Museum of Modern Art / Licensed by SCALA / Art Resource, NY.

Elaine and Willem de Kooning, circa 1980s. © 1991 Hans Namuth Estate. Courtesy Center for Creative Photography, The University of Arizona. Photo: Hans Namuth.

Charles and Ray Eames at their home in the Pacific Palisades, circa 1970s. © 2012 Eames Office, LLC. (www.eamesoffice.com)

Ray Eames, *To Hofmann, Love Buddha*, 1940. © 2012 Eames Office, LLC. (www.eamesoffice.com)

Ray Eames, Room Installation design for "*An Exhibition for Modern Living*," 1949. © 2012 Eames Office, LLC. (www.eamesoffice.com)

Charles and Ray Eames, Eames House. © 2012 Eames Office, LLC. (www.eamesoffice.com) Photo: Tim Street-Porter.

Charles and Ray Eames Boarding a Plane for the American National Exhibition in Moscow, 1959. © 2012 Eames Office, LLC. (www.eamesoffice.com)

Charles and Ray Eames, Production Art from *Powers of Ten: A Film Dealing with the Relative Size of Things in the Universe, and the Effect of Adding Another Zero*, 1977. © 2012 Eames Office, LLC. (www.eamesoffice.com)

Jackson Pollock and Lee Krasner at their home in The Springs, New York, circa 1946. Jackson Pollock and Lee Krasner papers, Archives of American Art, Smithsonian Institution. © Pollock-Krasner House and Study Center, East Hampton, New York. Gift of the Estate of Ronald J. Stein. Photo: Ronald Stein.

Jackson Pollock, *Male and Female*, 1942–43. © 2012 The Pollock-Krasner Foundation / Artists Rights Society (ARS), New York. Photo: The Philadelphia Museum of Art / Art Resource, NY.

Lee Krasner, *Untitled*, 1949. © 2012 The Pollock-Krasner Foundation / Artists Rights Society (ARS), New York. Digital Image © The Museum of Modern Art / Licensed by SCALA / Art Resource, NY.

Jackson Pollock and Lee Krasner in Pollock's studio in The Springs, New York, 1950. Courtesy Center for Creative Photography, The University of Arizona. © 1991 Hans Namuth Estate. Photo: Hans Namuth.

Jackson Pollock, *Undulating Paths*, 1947. Galleria d'Arte Moderna Rome. © 2012 The Pollock-Krasner Foundation / Artists Rights Society (ARS), New York. Photo: Gianni Dagli Orti / The Art Archive at Art Resource, NY.

Lee Krasner, *Prophecy*, 1956. © 2012 The Pollock-Krasner Foundation / Artists Rights Society (ARS), New York. Photo: Courtesy Pollock-Krasner House and Study Center, East Hampton, New York.

Max Ernst & Dorothea Tanning (1 of 2), New York, 1947. Copyright © by The Irving Penn Foundation. Photo: Irving Penn.

Max Ernst, *. . . and the third time missed*, 1929. © 2012 Artists Rights Society (ARS), New York / ADAGP, Paris. Photo: Jacques Faujour / CNAC / MNAM / Dist. Réunion des Musées Nationaux / Art Resource, NY.

Dorothea Tanning, *Birthday*, 1942. © 2012 Artists Rights Society (ARS), New York / ADAGP, Paris. Photo: The Philadelphia Museum of Art / Art Resource, NY.

Max Ernst, *Bryce Canyon Translation*, 1946. © 2012 Artists Rights Society (ARS), New York / ADAGP, Paris. Photo: Bridgeman-Giraudon / Art Resource, NY.

Dorothea Tanning, *Self-portrait*, 1944. © 2012 Artists Rights Society (ARS), New York / ADAGP, Paris. Photo: The Dorothea Tanning Foundation.

Françoise Gilot and Pablo Picasso in Golfe-Juan, France, 1948. Robert Capa © International Center of Photography / Magnum Photos. Photo: Robert Capa.

Pablo Picasso and Françoise Gilot at his pottery studio in Vallauris with Picasso's sculpture *Head of Françoise*, 1953. Art © 2012 Estate of Pablo Picasso / Artists Rights Society, New York. Photo: ©edwardquinn.com.

Pablo Picasso, *La femme-fleur (Françoise Gilot)*, 1946. © 2012 Estate of Pablo Picasso / Artists Rights Society (ARS), New York. Photo: © Hans Hinz-Arthothek.

Françoise Gilot, *Le Thé*, 1952. Collection Dr. Mel Yoakum, California. © Françoise Gilot. Photo: Christie's / The Bridgeman Art Library.

Pablo Picasso, *Nature morte au crâne (Still Life with Skull)*, 1945. © 2012 Estate of Pablo Picasso / Artists Rights Society (ARS), New York. (72.7 x 91.8 cm). The Menil Collection, Houston. Photo: Hickey-Robertson, Houston.

Saul Steinberg & Hedda Sterne (2 of 2), New York, 1947. Copyright © by The Irving Penn Foundation. Photo: Irving Penn.

Saul Steinberg, *Autogeography*, 1966. © The Saul Steinberg Foundation / Artists Rights Society (ARS), New York. Photo: © Estate of George Platt Lynes.

Saul Steinberg, *Self-Portrait with Hedda Sterne in Cadillac*, 1947. © The Saul Steinberg Foundation / Artists Rights Society (ARS), New York. Photo: © Estate of George Platt Lynes.

Nancy Spero and Leon Golub in New York City. © Christopher Felver / CORBIS. Photo: Christopher Felver.

Leon Golub, *Gigantomachy II*, 1966. Courtesy Ronald Feldman Fine Arts, New York. Art © Estate of Leon Golub / Licensed by VAGA, New York, NY. Photo: Hermann Feldhaus.

Nancy Spero, Panels from *The Goddess Nut II*, 1990. Art © Estate of Nancy Spero / Licensed by VAGA, New York. Photo: Galerie Lelong, New York.

Leon Golub, *Napalm V*, 1969. Art © Estate of Leon Golub / Licensed by VAGA, New York, NY. Photo: Smithsonian American Art Museum, Washington, DC / Art Resource, NY.

Nancy Spero, Detail from *Torture of Women*, Panel III, 1993. Art © Estate of Nancy Spero / Licensed by VAGA, New York, NY. Photo: National Gallery of Canada, Ottawa.

Robert Rauschenberg in conversation with Jasper Johns, New York City, 1954. © Rachel Rosenthal. Photo: Rachel Rosenthal.

Robert Rauschenberg, *Untitled*, 1955. Art © Robert Rauschenberg Foundation / Licensed by VAGA, New York, NY.

Jasper Johns, *In Memory of My Feelings-Frank O'Hara*, 1961. Collection Museum of Contemporary Art Chicago, partial gift of Apollo Plastics Corporation, courtesy of Stefan T. Edlis and H. Gael Neeson, 1995.114 a-d. Art © Estate of Jasper Johns / Licensed by VAGA, New York, NY. Photo © Museum of Contemporary Art Chicago.

ACKNOWLEDGMENTS

First, I would like to acknowledge the homemade breadsticks at the restaurant Sorella in New York City. If it was not for those breadsticks, I do not know if I would have struck up the bond that I did with my editor, Katrina Fried. Prior to the breadstick days, I was just one of many writers that worked for her. If it were not for those conversations, we probably wouldn't have started discussing the subject matter contained in this book—one that Fried kept safe in her mind, waiting for the right day to launch it. Thanks to her and Lena Tabori for giving me the opportunity to work on this!

Thanks to the museums all over the world that my father took me to as a child. They are the reason I became so deeply interested in art. On the note of museums, thank you to the MoMA library for being a very nice place to go work. The staff there was incredible, specifically during the winter of 2012. Also, a big big thanks to the Nashville Public Library, which has an impressive collection of art history books. And when they did not have something, Vanderbilt Library swooped in to provide it. Thank you Vanderbilt Library for preserving the blissful creepiness of your art section. Fantastic environment to work in.

Thank you to all the writers I encountered (via their text) for their incredible investigations of the artists included in this book. The list of invaluable resources can be found in the included bibliography and footnotes. I especially enjoyed the writing of Anne Middleton Wagner (a gold mine), Jonathan Katz, Nicholas Fox Weber, Hayden Herrera, Werner Spies, Robert Motherwell, and Dorothea Tanning.

I'm very grateful to Christo for providing us with this amazing cover. I could not imagine a better one. I'm honored.

Massive thanks to Karen Broderick. If I try to imagine what this book would look like without her expertise, I just see a skull with a mouse crawling through an eye socket. Really. Thank you to the Kristen Sasamoto and Gregory Wakabayashi for the lovely design and handling the shift in schedule so smoothly.

Thank you Berlioz, the Greenwich Village cat, who sat next to me when I started doing the exhaustive research for this book. Thank you Margaret Garvin for keeping your 100-year-old cabin in such good shape. It is where I began writing all these stories. Good environments and good companions make all the difference. Which leads to me to the most major thank you of all the thank yous: Thanks to my close-knit circle of family and friends. Thanks mom!!!

Thanks Loney, my other, who read all my stories first. A process that could have torn us apart—but did not! In fact, it was quite the opposite.

—V. K.

ARTISTS IN LOVE

From Picasso & Gilot to Christo & Jeanne-Claude
A Century of Creative and Romantic Partnerships
By Veronica Kavass

Published in 2012 by Welcome Books®
An imprint of Welcome Enterprises, Inc.
6 West 18th Street, New York, NY, 10011
(212) 989-3200; fax (212) 989-3205
www.welcomebooks.com

Publisher: Lena Tabori
President: H. Clark Wakabayashi
Associate Publisher and Editor: Katrina Fried
Art Director: Gregory Wakabayashi
Designer: Kristen Sasamoto
Editorial Assistants: Emily Green; Alexandra Guillen
Art and Photography Research: Karen Broderick

If you notice an error, please check the website listed below where there will hopefully be
a posted correction. If not, please alert us by emailing info@welcomebooks.com and we will
post the corrections.

Library of Congress Cataloging-in-Publication Data on file

ISBN: 978-1-59962-113-5

First Edition
10 9 8 7 6 5 4 3 2 1

PRINTED IN CHINA

For further information about this book please visit online:
www.welcomebooks.com/artistsinlove